BRONZEVILLE

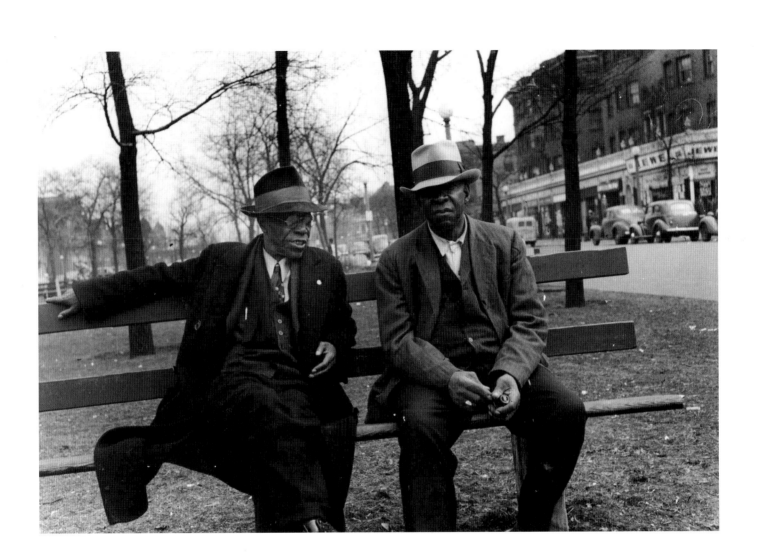

BRONZEVILLE

Black Chicago in Pictures, 1941–1943

Maren Stange

THE NEW PRESS ♦ NEW YORK

The accompanying exhibition, "Bronzeville: Black Chicago in Pictures, 1941–1943," was organized and presented at the International Center of Photography, New York, February 28 to June 8, 2003.

Published in the United States by The New Press, New York, 2002
Distributed by W. W. Norton & Company, Inc., New York

LIBRARY OF CONGRESS CATALOGING-IN-PUBLICATION DATA
Bronzeville: Black Chicago in pictures, 1941–1943 / [compiled by] Maren Stange. p. cm.
Includes bibliographical references.
ISBN 1-56584-618-4 (hc.)
1. African Americans—Illinois—Chicago—History—20th century—Pictorial works. 2. African
Americans—Illinois—Chicago—Social conditions—20th century—Pictorial works. 3. Chicago (Ill.)—
History—20th century—Pictorial works. 4. Chicago (Ill.)—Social conditions—20th century—Pictorial
works. 5. Chicago (Ill.)—Race relations—Pictorial works. I. Stange, Maren.
F548.9.N4 B74 2003
977.3' 1100496073—dc21 2002071894

The New Press was established in 1990 as a not-for-profit alternative to the large, commercial publishing
houses currently dominating the book publishing industry. The New Press operates in the public interest rather
than for private gain, and is committed to publishing, in innovative ways, works of educational, cultural, and
community value that are often deemed insufficiently profitable.

The New Press, 450 West 41st Street, 6th floor, New York, NY 10036

www.thenewpress.com

Printed in China
Book design by Lovedog Studio

2 4 6 8 10 9 7 5 3 1

For Charles and Clara

CONTENTS

ACKNOWLEDGMENTS

This book began in a conversation with the late Joe Wood, Jr., and it would have happened differently, or not at all, had I not had the good fortune to encounter Joe's energy and interest at that early moment. In the course of my work, I have benefited from the knowledge, expertise, and support of many others, and I shall do my best to thank them all here.

I completed a crucial stage of my early research as a short-term visiting fellow at the Anacostia Museum and Center for African American Culture and History, Smithsonian Institution, Washington, D.C., where Deborah Willis, then curator of exhibitions, was a generous sponsor and remains a cherished colleague. Mark Williams, then research specialist at the CAACH, and writer Lisa Page helped me begin to understand better the histories and meanings in the photographs I studied.

Encouraged by my colleague Atina Grossmann, supported by Dean John P. Harrington, and granted by President George Campbell, Jr., a leave from teaching duties at the Cooper Union in spring 2001 afforded me uninterrupted opportunity to finish the book. Cooper librarians Julie Castelluzzo, Dana Felder, and Claire Gunning were tireless and patient. Student extraordinaire Montana Cherney provided, simultaneously, intelligent clerical help and insightful comment.

In Chicago, Michael Flug, senior archivist of the Vivian G. Harsh Research Collection of Afro-American History and Literature of the Chicago Public Library, contributed his vast knowledge, limitless patience, and unflagging energy and cheer in countless ways that I hope the book may reflect. Not least, he introduced me to Susan Cayton Woodson, Grady Johnson, and Charles Walton, whose informed readings of the photographs enlivened crucial details. Documentary producer Rita Whack offered invaluable counsel, and Don and Isabel Stewart provided hospitality at an important moment. Colleagues Martha Biondi, Adam Green, Jim Hall, Colleen McDannell, and Bill Mullen have demonstrated the communality of this work.

At the Library of Congress, Manuscripts Division archivist Fred Bauman cheerfully chased down errant manuscript box numbers. Beverly Brannan, curator of photographs, Prints and Photographs Division, and Mary Ison, head of the Prints and

Photographs Reading Room, have been generous throughout, and I look forward to continued work together. The staff of the Library of Congress Photoduplication Service filled seemingly endless print requests. Cynthia Fredette, Christopher Phillips, and Brian Wallis at the International Center of Photography have taught me what an exhibition is all about.

It has been a pleasure working with André Schiffrin and Marc Favreau at The New Press, and I look forward to continuing our collaboration. Marc's sharp eye and sure hand have materially shaped this book. Friends and family to be thanked for astute readings, and much else, include Charles Hagen, Laura Newman, G. Robert Stange, and Alida Stange. Charles Hobson and Clara Stange Hobson know best why I need to thank them.

Introduction

BLACK CHICAGO IN PICTURES

Maren Stange

Chicago's "Bronzeville" was a "city within a city," the "second largest Negro city in the world" in the 1940s, St. Clair Drake and Horace Cayton wrote in *Black Metropolis*. The South Side, seven miles long and one-and-a-half miles wide, stretched from 22nd to 63rd Streets between Wentworth and Cottage Grove, its boundaries resolutely fixed by whites' intimidation and restrictive covenants. Supporting five hundred churches and three hundred doctors, it was the "capital of black America" in the 1940s, supplanting Harlem as the center of black culture and nationalist sentiment, home to such notables as Joe Louis, Mahalia Jackson, Congressman William Dawson, *Defender* newspaper editor John Sengstacke, *Ebony* magazine publisher John H. Johnson, and Nation of Islam leader Elijah Muhammad. Its flourishing literary and artistic circles constituted a "Chicago Renaissance" comparable to Harlem's earlier flowering.[1]

As African Americans had continued the northward migration begun in the teens, becoming more urban than rural by the 1960s, Chicago absorbed wave after wave of newcomers. The Depression years saw a 20 percent increase in the city's black population, who lived for the most part mercilessly overcrowded. Population density was seventy thousand per square mile on the South Side; the death rate exceeded the birthrate by 2 percent. The war years, a moment of renewed migration, saw some sixty thousand more new arrivals between 1942 and 1944, swelling the black population to 337,000, one-tenth of the city's total and double what it had been before World War II.[2] Buildings abandoned and condemned in the 1930s were rehabited during these years as the Black Belt remained, in Richard Wright's words, "an undigested lump in Chicago's melting pot."[3] Nevertheless, bolstered by relative affluence and increasing education, active in the struggle for civil rights, and attuned to new media and technologies, the postmigration generations Wright called the "first-born of the city tenements" enjoyed and produced a various and sophisticated culture now familiar worldwide.[4]

In April 1941, photographers Russell Lee and Edwin Rosskam spent two weeks on Chicago's South Side, eventually

producing more than a thousand documentary images. The photographers worked for a New Deal federal government agency, the Farm Security Administration (FSA), which supported a photography project to record and publicize conditions in rural areas and in the towns and cities that were the destinations of rural migration. Later that year, FSA photographer John Vachon also visited the South Side, and in 1942 Jack Delano, working for the federal government's Office of War Information (OWI), made hundreds more photographs there. The Lee-Rosskam coverage was spurred by plans for a book, *Twelve Million Black Voices: A Folk History of the Negro in the United States,* which appeared in October 1941 with text by Wright and photo-editing by Rosskam, who had been hired by the FSA's Historical Section–Photographic, as the photography project was officially titled, to work primarily on exhibition and book design. The later, more positive wartime coverage helped to bolster government claims for an inclusive American society with opportunity for all.

Presenting for the first time a major selection of the FSA/OWI South Side coverage, this book explores the interracial collaboration, and the larger historical and cultural contexts, that enabled it. These photographs, little seen until now, record a community at a moment when epochal social change encouraged a vision of a common American future.[5] At once commemorating and interrogating the struggles, styles, and structures of black urban life in segregated America, the pictures are compelling today just as they were in the 1940s, when Horace Cayton commended their "sharp and graphic terms."[6]

The immediate purpose for making and circulating FSA pictures was to publicize and build support for President Franklin Roosevelt's New Deal programs specifically combating rural poverty and promoting the resettlement of citizens displaced by agricultural depression, drought, and technological advance during the Great Depression. From the Section's very beginning in 1935, its director, Roy Emerson Stryker, attracted young photographers who would prove to be enormously inspired and talented. Including Walker Evans, Dorothea Lange, and the artist Ben Shahn, they envisioned an autonomous mandate that encompassed the creation of a visual record of the country as it emerged from depression and entered the Second World War. Stryker, trained in sociology and economics, was familiar with earlier social documentary photography and believed in its potential to reveal harsh social truths to an often-complacent middle class, provoking needed reform. Stryker and the Section photographers were advantaged by advances in camera technology and in mass-reproduction techniques; smaller, more flexible cameras and faster film allowed them to dramatize photography's truth claim with freshly spontaneous, seemingly immediate imagery, and they could circulate pictures to vast and appreciative audiences gathered by the new mass pictorial magazines.

Focusing initially on rural Southerners and Midwesterners, the photographers soon regularly visited farms, small towns, and cities throughout the country. One-fifth of images were "project shots," duly recording the benefits provided by government-funded initiatives ranging from the Shasta Dam to the Ida B. Wells Homes in Chicago, and the files include a considerable amount of industrial work, labor protest, and urban life.[7] When the Section was transferred to the OWI in 1942, the photographers helped to support the war effort; in the Section's final year, Stryker directed them to concentrate on "shipyards, steel mills, aircraft plants, oil refineries, and always the happy American worker."[8] The pictures, now stored at the Library of Congress and available to the public, total approximately two hundred thousand. They constitute an extraordinary archive, no

less today than when author Richard Wright praised it in 1941 as "one of the most remarkable collections of photographs in existence," its "comprehensive picture of our country" offering "quite an education."[9]

Stryker ensured that the project's photographs were used in museum exhibitions and in a notable series of photo-and-text books, as well as in more topical forms of journalism and government publicity. At its demise in 1942, the project could claim exhibition venues including the Museum of Modern Art and Grand Central Station, as well as regular appearances in periodicals including *Life, Look, Time, The New York Times,* and *Fortune,* and a dozen books illustrated with FSA pictures. In addition to *Twelve Million Black Voices,* these included James Agee's and Walker Evans's *Let Us Now Praise Famous Men,* Dorothea Lange's and Paul Schuster Taylor's *An American Exodus,* and Archibald MacLeish's *Land of the Free.*[10]

In recent years, scholarship has traced the project's institutional history, delineated careers of individual photographers, and debated both the project's and the photographers' contributions and limitations. Critiques have foregrounded the FSA's valorization of programmatic, government-engineered progress rather than grassroots initiative, and they have noted the ways that some Historical Section pictures cast their subjects as the passive objects of relief measures rather than active social agents. Nevertheless, the Section's work has remained a paradigm of documentary practices and aesthetics; it is seen to exemplify the use of photography as a way not only of "comprehending patterns of culture and social organization," as Sally Stein has written, but also of graphically revealing them to large audiences.[11]

The immediate circumstances of the United States in these years—including the ways that the public apprehended news and social facts just before television—have receded from popular memory, even as some Section images remain globally recognized icons. They stand out even now in our dense and pervasive visual culture, and we can readily imagine how powerfully they signaled a new visual aesthetic at the dawn of mass-circulated photojournalism in the 1930s. The vast majority of pictures in the FSA file, often less graphically arresting, remain richly informative about the country in those years. They bear witness not only to material conditions, but also to the photographers' determination to record and express important social and cultural truths, including the changes they perceived as industrialization and urban and suburban migration intensified, and defense industries expanded. Today we can trace these developments clearly in the pictures.

The Photographers, Their Assignments, and the Chicago Coverages

Richard Wright had wished for several years to address African American history "in terms of the urbanization of a feudal folk" when Rosskam approached him.[12] Rosskam for his part hoped to capitalize on the enormous success of Wright's recently published best-seller, *Native Son,* both by using Wright to compose the text for the new book and by presenting in photographs the conditions of the Chicago Black Belt described in the novel.[13] Wright had an abiding interest in photography and was an accomplished amateur; he visited Washington early in 1941 to select from FSA holdings, which covered most aspects of southern black agricultural life and labor, looking at thousands to choose the eighty-eight pictures used in the book. At some point in this process the extensive coverage of the Chicago Black Belt, where Wright himself had lived for ten years, was

decided on to provide images for the two final chapters on urban life. Meeting the photographers on the South Side in April, he provided guidance and advice during the shoot so that, Rosskam noted later, "I don't know if many white men had the opportunity to see it the way we saw it." Not only did "Dick Wright . . . [know] everybody in the Negro world of Chicago," so that the photographers "did everything from the undertaker to the gangster," but he was able as well to draw on the resources of his friend, sociologist Horace Cayton—then director of the Good Shepherd Community Center and an expert on housing and health conditions—to arrange many locations and contacts. (Wright later contributed the preface to Cayton and Drake's *Black Metropolis*.)[14]

Like *Black Metropolis,* the FSA pictures record social stratification and class differences. They show some of the poised, socially prominent figures often seen in newspapers such as the *Defender, Courier,* or *Chicago Bee,* and soon to be featured in *Ebony.* But they also include everyday life and everyday tasks in a variety of workplaces, as well as scenes of leisure, worship, and performance. The pictures do not gloss over the enormous problems caused by extreme overcrowding and employment discrimination long suffered on the South Side and worsened by the Great Depression; indeed, Cayton wrote upon viewing them, "I, who had helped to pick out the scenes and had worked with [the photographers] in Chicago, could not believe what I had seen." They were meant, however, to show not "an exotic nation within a nation" but rather "both poor and middle-class Americans during a period of economic hardship," suggests Chicago historian Larry A. Viskochil.[15]

These images greatly increased the FSA's holdings of both African American and urban subject matter—they were, in fact, the project's largest organized coverage of city life. However,

only nineteen Chicago pictures ultimately were used in *Twelve Million,* and most, apparently not circulated to media outlets, never appeared in print before the 1970s. Though unfortunate in its immediate result, these circumstances may actually enhance the pictures' value for us today. Because the coverage was apparently never intended for current publication, the photographers were relatively unconstrained by the racist strictures of prevailing media practices, which were dominated by stereotype when African Americans appeared there at all. The Chicago team could deploy photography in the service of social inquiry rather than racial prejudice.

Then-current stereotype was extensive and vicious. The number and variety of racist images in American culture attested to a "particularly American preoccupation with marginalizing black Americans by flooding the culture with an Other Negro, a Negro who conformed to the deepest social fears and fantasies of the larger society," writes Henry Louis Gates.[16] It was not only the ubiquitous negative caricatures appearing as cartoons, postcards, salt and pepper shakers, tea cosies, children's games, and dolls, but also the exclusion of African Americans from all white-controlled, purportedly objective mass-media visual content that executed that "preoccupation" into the mid-twentieth century.[17] Until the early 1950s, for instance, the New Orleans *Times-Picayune* ruled that "blacks were not to appear in photographs it published, not even as part of a background," writes journalism historian Ira Harkey.[18] Jesse Jackson recalls a hometown paper with "never a picture of a Black wedding" nor "a story about a local Black businessman" nor "a decent obituary,"[19] and in his memoirs of a 1950s' boyhood Gates remembers being "starved for images of ourselves," "search[ing]" the television and "devour[ing]" *Ebony* and *Jet* to find them.[20]

Unsurprisingly, images produced and controlled by African

Americans under segregation generally took pains to present the strongest possible contrast to such representation. African Americans have been photographers since the medium's invention in 1840, their early work attesting to ethnic and class diversities in American communities not necessarily represented elsewhere.[21] Nevertheless, such images, only a tiny proportion of those produced overall, were often private, family possessions, not intended to be published or publicly circulated. Commissioned portraits, more likely to appear in white-controlled public spheres of visual representation, presented an iconography "carefully chosen to counter in every respect the gross caricatures of blackness" so long familiar, as Camara Dia Holloway notes in her study of Harlem studio photographer James L. Allen.[22] Allen's urban achievers avoided broad gestures and assumed "serious facial expressions" as a "means of distancing themselves from minstrelsy." Striving to signify "civility, urbanity, and modernity," photographers posed sitters on the diagonal "to generate a dynamism that was associated with the bourgeois, i.e. respectable, subject," writes Holloway.[23] In the realm of photojournalism, "[w]e showed the productive side of our people," explained former Pittsburgh *Courier* city editor Frank Bolden, because "[s]howing people in squalor didn't contribute anything to the community."[24]

The FSA/OWI file contains about seventy-five hundred images of or relating to African Americans, a proportional figure exceeding that of any other federal government collection, and the agency employed at least one "race advisor" responsible for distributing material to the Negro press, whose editors relied on the Section for pictures that showed "improvement in black lives," as one information officer recalled.[25] Nevertheless, Roy Stryker, like other New Deal publicists intent on winning support for their programs, ultimately did little to challenge the larger society's racialized distinctions. Publicists saw their greater goal as demonstrating that government agencies could "put blacks to work" even while "reaffirming deeply entrenched economic and cultural structures," suggests historian Nicholas Natanson.[26] Though Stryker believed that the Historical Section had "always been interested in the negro [sic] problems" and had "[always] taken pictures portraying [them]," he seems often to have set aside such concerns in dealing with the media.[27] "Place the emphasis on the white tenants, since we know that these will receive much wider use . . . ," he had advised Dorothea Lange pragmatically in 1937.[28]

The FSA in the Field: From Scripts to Captions

Like other experienced FSA staffers, Russell Lee and Edwin Rosskam were experts at long-standing field procedures. They had learned to work skillfully from shooting scripts composed to direct attention to aspects of a region, activity, or topic. Developed for particular photographers undertaking specific itineraries or simply addressed to "all photographers," scripts might emphasize newsworthiness or a relevant upcoming governmental initiative, or they might outline "gaps in the file," as one script actually was titled. They directed photographers to background reading and to local authorities and experts, but they also reminded them of their prospective viewing audiences. The scripts encouraged photographers to envision a connective narrative thread for their coverages so that, later, the Section could easily offer picture sets as complete photo-essays to newspapers and magazines.

Scripts have generally been attributed to Stryker, though photographers themselves sometimes wrote them. Lee and Jack

Delano, for instance, suggested that the "American way of life" be covered with specific focus on "the average big-city dweller," including topics such as unions, churches, sports, and amusements.[29] Lee proposed in late 1941 to address the place of "mechanical things" in American life, calling for a range of subjects from "baby in father's lap in the driver's seat" to "child making model airplane," to "vocational training high school."[30] Working primarily as a Washington-based photo-editor concerned with building the file and photographing only occasionally, Rosskam recalls composing "well-researched" scripts of up to twenty pages.[31]

There does not seem to have been a script for the Chicago coverage; the logic of familiar FSA procedures, combined with Wright's and Cayton's guidance, apparently sufficed. Rosskam certainly, and Lee perhaps, had read early drafts of Wright's text. They agreed that urban life was the "terminal point" of migration and prepared, like Wright, to show similarities rather than differences among Americans.[32] (This idea Lee may have had in mind when he wrote Stryker just after the Chicago shoot that in his brief file captions he had "tried to avoid too much mention" of his subjects "being Negro.")[33] However, the coverage ultimately extended well beyond Wright's text, relying on materials furnished by Cayton, who wrote to Wright early on of his "outline of the broad fields of social life" and his efforts to "line up . . . appointments, individuals, . . . and scenes."[34] Cayton also provided data from the three years of fieldwork he had directed with sociologist Lloyd Warner on the South Side in the late 1930s, work that underpins not only *Black Metropolis* but also several studies published prior to it.[35] From the beginning Lee had no trouble finding a "wealth of subject matter" in "social and business activities," as he reported to Stryker mid-project, naming familiar topics "ranging from church life to taverns," and from "coffin manufacturing" to "5+10 cent stores."[36] The photographers' intense engagement paid off; they succeeded in representing the community in a way that "gives new insight to the thing [I] have been trying to say for years . . . ," Cayton wrote to Wright in late April 1941.[37]

As Cayton and Drake would argue in *Black Metropolis,* Bronzeville community life was "in flux" in the 1940s; as the country emerged from the Great Depression and entered the Second World War, blacks wondered whether this "crisis period in the history of Western Civilization" might bring a "flowering" of Bronzeville or merely more of the same.[38] Their eight-hundred-page book, hailed as "the best comprehensive description of black life in an American city ever written," studied the South Side according to then-current methods of community research.[39] The Cayton-Warner research, as this fieldwork was called, used a large staff of fieldworkers (including Wright, Katherine Dunham, and Fenton Johnson), who were paid by the Works Progress Administration (WPA) and were trained to view a community "not as an atomic sandpile of separate individuals, but as a set of interconnected human beings living in a vast web of vital relations," as Warner wrote. The workers investigated "all aspects of the life of a people to learn how the parts fit together and to understand how each of the interconnected parts functions in maintaining a social system and an ongoing way of life" (772, 770). In the case of Chicago, it was possible to study the "effects of subordination and exclusion" in an industrial "metropolitan area with great social complexity" (776). Thus the study "anatomizes" Bronzeville spatially according to various socioeconomic indicators, and it organizes its approach to recording life experience along five " 'axes of life' around which individual and

community life revolves" in every social class. These—some more amenable to visual representation than others—were: staying alive, having a good time, praising God, getting ahead, and advancing the race. Evidently, a decision was made not to visit major industrial sites outside the unofficial boundaries of Bronzeville, and perhaps access to workplaces such as the stockyards, steel mills, and Pullman works was difficult to obtain.[40]

Though not precisely consonant with these "lines of attention" that claim "the time and money of Bronzeville" (385), Rosskam's general captions, used to organize the photographs, are based on them. Picture captioning consumed "many long hours, [extending] far into the night," remembers Jack Delano.[41] Photographers generally sent their film to be developed and printed in Washington as they completed each assignment; work prints were then returned to them in the field for captioning, every photographers' responsibility. In addition to brief captions affixed to each image, many wrote longer general captions; often, like Rosskam's, they are detailed and colorful. Though stored separately from the pictures in Washington, they remain publicly available.

The General Captions

Despite a suggestion from Lee that Rosskam's general captions "ideally, should be filed with the pictures," they apparently were not, so that it is no longer possible to reconstruct fully his original groupings of the photographs.[42] Though the pictures probably were never viewed in these groups, and some, such as Lee's very extensive coverage of staff and patients at Provident Hospital (photograph 91) or Lee's workplace portraits of skilled craftspeople at the Chicago *Defender* plant (photographs 95 and

96), seem not to fit readily into Rosskam's headings, the captions offer invaluable context.

Rosskam provides an overview of the South Side in two lengthy general caption texts—"The Face of the 'Black Belt' " and "The Black Belt—An Environment" (page 3), offering historical statistics from the Cayton-Warner research and from the government's 1941 Tolan Committee Report on Migration. Here we read in brief outline the major features of the community's unbearably overcrowded, deteriorated, and expensive housing, 50 percent unemployment rate, and consequent omnipresent health hazards. Relevant are his and Lee's many, evocative exterior shots of houses and street life.

Specific captions—"Kitchenette" (page 23), "Railroad Worker's Family" (page 140), "Relief Family" (page 45), "Recent Immigrants" (page 34), and "Pattern for Growing Up" (page 33)—focus on home life, and additional sections—"The Day of a Negro Doctor" (page 56), "Night" (page 191), "Negro Church" (page 151), "Holiday" (page 170), and "Demonstration Area"—further organize the photographs. Some texts seem disappointingly self-evident, especially compared to the wealth of detail in Federal Writers' Project accounts. Rosskam's "Night," for instance, adds little to lively pictures such as Lee's "Saturday night in a barroom on the South Side" (photograph 149), but "Kitchenette" and "Pattern for Growing Up" present the kinds of detailed information and sociological perspective that the Cayton-Warner research established.

"Negro Religion" and "Holiday"

Quoting Wright's *Twelve Million Black Voices* in his caption "Negro Church," Rosskam emphasized the "tide of passion" that

lifted up a fundamentalist congregation; on Sunday it was "easy to hear fervent crescendoes issuing from three or four places within the same block." Spending Easter in Bronzeville, he and Lee observed not any Sunday, but a "Holiday" on which community tradition sanctioned display, the parishioners outside their churches observing codes of urbane self-presentation as intricate as the rituals of worship enacted inside. The occasion mandated not only worship, but festivity; the pictures show lily vendors lounging as they await a sale, children in line for a movie matinee, and elegantly bonneted parishioners, posing for each other, or perhaps for the society page photographer (see photographs 121–132). The Easter pictures constitute the largest coverage of a single Chicago topic; divided among four churches, they indicate a range of denominations and show the church's central role in communal life as sponsor or supporter of clubs, dances, radio broadcasts, and weekday as well as Sunday services.

During services at All Nations Pentecostal Church, and at a modest storefront Church of God in Christ, the photographers were permitted inside, if only briefly. Though Lee's lighting must have been distracting, the pictures seem unposed, the worship service and Bible study genuine (photographs 115–120). All Nations' remarkable founder and leader, Elder Lucy Smith (photograph 115), perhaps best known among leaders of working-class congregations and certainly best known among Chicago's women pastors, was a "healer" and regular radio personality. She had managed in a mere ten years to leave a storefront and establish her congregation in the large, modern church building shown in Lee's pictures.[43]

The Sunday pictures' greatest contribution, however, is their record of Easter observances among middle-class churchgoers. At distinctly fashionable St. Edmund's Episcopal, the photographers worked in the street with 35mm cameras before and during the processional "Blessing of the Bounds" ceremony (photographs 121–127). St. Edmund's sophisticated, socially prominent congregants were staples of the black press, Rosskam points out in "Holiday," but their resemblance to white "society" did (and does) not attract the attention white documentarians and photojournalists pay to the "ecstatic character" of fundamentalist worship. Among Baptists, the South Side's largest denomination, the photographers chose imposing Pilgrim Baptist, then one of Chicago's largest churches. Its sustaining membership was fifteen hundred, and it was home to renowned choirmaster, composer, music publisher, and "Father of Gospel" Thomas Dorsey. Photographing after a service, Lee caught parishioners as they stopped to chat outside the graceful Sullivan and Adler building, once a synagogue (photograph 133).[44]

Lamenting black-and-white photography's inability to portray the "rainbow of color in both men's and women's clothing," Rosskam pronounced himself "continually astonish[ed]" at the "high standard of appearance" even among kitchenette-dwelling South Siders. The holiday crowds offered opportunities for innovative street work. Relatively rare in FSA assignments, such casual urban scenes, caught by small cameras with sensitive film and sharp lenses, were familiar by 1941 in Henri Cartier-Bresson's much-published images, as well as in city photographs made by former FSA staff members Walker Evans and Ben Shahn. Lee's street images generally do not depart from his familiar straightforward style, but Rosskam evidently welcomed the chance to experiment with the relative spontaneity granted by the "miniature" camera. Many of his images place their unposed subjects in crowded or fragmented compositions, their off-kilter frames replete with now-iconic signs of a distinctly modern urbanity (photographs 11, 41, 65, 67, and 164).[45]

Family and Home

The sequences of family members at home were made by Lee, a master of then-novel synchronous flashlighting. They show that the photographers not only posed family members together but also asked them to undertake routine tasks such as laundry, ironing, or meal preparation; the resulting images—such as "Wash day of a family on relief"—unsparingly revealed the time-consuming drudgery of the most basic housekeeping in the South Side's often-wretched conditions (photograph 36).

Lee was more prolific and more often in the field than other FSA colleagues.[46] Hired in 1936 with a background in both science and art, he continued to work with Stryker at various non-FSA projects throughout the 1940s. So numerous are his pictures that his style stands almost as the generic face of the FSA; yet his well-documented methods and philosophy are distinctive—and different in most respects from Rosskam's. A Lee forte was the synchronously flashlit—rather than floodlit—interior. Motivated, he has explained, to show details such as "something on a dresser . . . [or] it might be on a bedside table . . . it could be a religious symbol or a portrait of their parents . . . [that] could tell you an awful lot," Lee overcame the technical difficulties that kept flashlighting relatively rare in these years.[47] Like several other male FSA photographers, Lee traveled with his wife, Jean, who managed equipment such as flashguns and helped to engage people in "friendly conversation," according to biographer F. Jack Hurley, and perhaps it is she that the family regards so intently in "Negro family living in crowded quarters" (photograph 22).[48] Lee used a midsized press camera yielding a 3¼ x 4¼

negative with one or more synchronized flashguns to achieve the combination of spontaneity and detail seen in such Chicago pictures. The "stark quality" of Lee's lighting "opened up" interior spaces, noted Louise Rosskam, so that "everybody could see" the details that might speak so eloquently: the pattern of a quilt, a thumbtacked Valentine, the lace on dresses, children's drawings on the wall, or the intricacy of a hairstyle (photograph 21).[49]

The "flat flash," as Edwin Rosskam called it, made its presence known in other ways as well, however; among them are the bulb's reflection in mirrors and windows as seen in a tavern shot, "Bartender and owner of a tavern on the South Side," (photograph 146), and the harsh shadows in other images. It is "used to eliminate all possible atmosphere, so that the picture becomes a bare, brutal kind of inventory of poverty, or . . . the picturesque," noted Rosskam, perhaps sounding harsher than he intended.[50] Though today we might associate this seemingly artless, un-atmospheric style with the 35mm camera's flexibility, only a few Lee images were made with one, and, except for those of a presumably already well-lit operation at Provident Hospital, these are all exteriors and street scenes.

Further suiting Lee for the Chicago teamwork was his penchant for photographic series, for work whose details were not only in the individual print but also in the coverage as a whole. "A taxonomist with a camera," in Stryker's later much-qualified phrase, Lee visually "takes apart and gives you all the details" of a subject; "he lays it on the table and says, 'There you are, sir, in all its parts.' "[51] Describing a photographer so attuned to the Cayton-Warner rhetoric of anatomizing and interconnecting, so responsive, it would seem, to Cayton's plan to "attach to each [photograph] the pertinent facts which I have in my files," Stryker's characterization sums up the qualities that—whether

by prescient choice or by FSA exigency—make Lee in retrospect the indispensable Chicago man.[52]

. The picture set titled "Relief Family" achieves the image-text synergy that Rosskam sought and Lee could manage so well. The sequence covered the family of eleven posed in "Family on relief" (photograph 31), focusing on their life in a small frame-house "in an extreme state of disrepair," as the pictures show, rather than an apartment. The father has had no job except occasional WPA work for seven years, so that all eleven live on his monthly relief check of about $25 ($300 today). "Four [of the family's nine] children sleep in two beds in an attic under the roof where the plaster has peeled off and the rain pours in," apparently shown in "Upstairs bedroom of a family on relief" (photograph 38), and "rats and vermin" are common.

Unable to eat healthily on their relief allocation—"How am I going to buy meat and green vegetables for eleven on one relief check?" exclaimed the mother—the malnourished children were often sick. Indeed, an exterior shot shows Dr. Arthur G. Falls at the door, where Lee's unusual exterior use of flash tellingly contributes a brilliant shine to the doctor's elegant shoes (photograph 42). Another picture places him at a sick child's bedside (photograph 43), linking this segment to "The Day of a Negro Doctor," which follows Dr. Falls, one of Bronzeville's three hundred black doctors, from housecalls, to his office, his rounds at Provident Hospital, and to his home, a new house in the so-called "Demonstration Area" along State Street in the South Nineties, which Rosskam describes as "a small Negro island in a lower-middle-class white community," comprised of "substantial stone houses recently built and beautifully kept, surrounded by smooth lawns and pretty gardens" (photographs 44 and 46).[53] Although the general caption mentions Falls's "difficulties [as] a Negro professional," noting that

because "a great majority" of his clients are on relief, he makes "barely enough to keep him going," the cross-referenced "Demonstration Area" pictures offer an opportunity to contrast his home with those of his patients, a juxtaposition that garners little sympathy for the doctor. The "consultations cash" sign in his office (photograph 45), and the information provided in the "Demonstration Area" caption that the area is "restricted by its own Negro residents to homes costing a minimum of $5,000" (about $150,000 in today's dollars) and that most have cost a great deal more, underscore the degree of contrast between Dr. Falls and many of his patients. Falls was, it should be noted, an advisor in these years to the activist Congress of Racial Equality (CORE).[54]

"This family is certainly not the only one on relief in this picture coverage," Rosskam notes dryly in "Relief Family." The situation in "Recent Immigrants" explains what happens when there is an addition to the family from the South. A family with several children was "augmented by two of the wife's sisters and their children and by the wife's brother," so that "now there are eleven people living in four rooms, all on the same relief check," Rosskam writes; "House in the Negro section" shows some of the family and their house (photograph 19). The city's three-year residence requirement barred any of the recent arrivals from public assistance. Despite "broken windows . . . attached with papers and cartons" and an "indescribable state of disrepair" including "leaking roof, rat holes in the floor, falling plaster, and a mattress with 'gaping hole,'" Rosskam notes a "decent and clean living room" and an older boy in high school, "making a strenuous effort to improve himself and the lot of his family"; he is shown holding a young relative in "Family on relief" (photograph 21). Linking this coverage to the images in "Pattern for Growing Up," Rosskam stresses there the burden on family life

of such unemployment and overcrowding, so that "the family, brought more or less intact from the rural South, may crack in the squalor and overcrowding of the city" (page 33).

Twelve Million Black Voices: "Sincere Art and Honest Science"

The idea of a photo-text collaboration was "still something kind of startling and new and exciting" to authors and readers alike in the 1940s, Rosskam told an interviewer, and the photographic book was still "in its infancy." Despite its cautious dealings with the press, the Section wanted to promote FSA photographs "in the area of what you might call 'art,'" a concern that supported undertakings such as the Chicago coverage and the book.[55] Born in Germany, Rosskam was a trained artist with extensive journalistic experience; he came to the FSA in 1938, bringing extensive publishing contacts. By 1940, he had edited several photo-text books for Alliance Press's "Face of America" series, and during his FSA stint produced *Home Town,* with FSA pictures and text by Sherwood Anderson.[56] Wright acknowledged that the crucial impetus for *Twelve Million Black Voices* came from Rosskam's suggestion that he "write the text for a group of [FSA] pictures," and the collaborators remained in touch throughout their compositional process. The text Wright fashioned is an early and positive statement of the African American migration narrative, and a complex yet clear articulation of urban African Americans' status as "representative modern people," in the words of literary historian John M. Reilly.[57] It was from the sociological studies of migration dynamics and adjustment to urban life then current at the University of Chicago, Wright has written, that he "drew the meanings" for this "documentary book" as well as for his novel *Native Son.*[58] His

acknowledgments show that concepts he found in the work of Chicago professors Robert E. Park, Robert Redfield, and Louis Wirth aided him to articulate—and encouraged him to valorize—the migrants' experiences, so that some of Wright's most lyrical and thematically central passages, as well as the inclusion of photography, thus appear as efforts to rework specific sociological concepts in a vernacular register. In *Twelve Million,* claims literary historian John Reilly, Wright's "amalgamation of his migrant's experience and his tutelage in science" form a "perfect metaphor" that "gives Black national consciousness expression."[59]

Emphatically historical, even though all of the photographs were contemporary, the book begins with an account of the slave trade set in the context of both African civilizations and the Western Renaissance and follows the course of slavery as an economic system to the point of the Civil War, when the inevitability of industrialization made slaves and the "inheritors of slavery" seem "children of a devilish aberration, descendants of an interval of nightmare in history, fledglings of a period of amnesia. . . ." Writing in the present tense to detail the share-crop system, African American life in the South, and the Great Migration, Wright closes the first chapter with one of the book's few statistics: "From 1890 to 1920, more than two million of us left the land." He sets the migrants' sharpest contact with "the brutal logic of jobs," the northern "world of *things,*" and "the beginning of living on a new and terrifying plane of consciousness" specifically during World War I.[60]

His third chapter, "Death on the City Pavements," shows the cramped and deteriorating "kitchenette" apartments that became home to migrants in the 1920s and 1930s: "Our death sentence without a trial" (107). The urban death-rate exceeded the birthrate, so that "If it were not for the trains and autos

bringing us daily into the city from the plantations, we black folks who dwell in northern cities would die out entirely over the course of a few years" (106). But in his brief concluding chapter "Men in the Making," Wright assigns his collective voice to "the children of the black sharecroppers, the first-born of the city tenements" (142), denoting not "African Americans as they were; but as they were becoming," as literary historian Kenneth Warren writes.[61] For the journey north over "the common road of hope" made by "thousands of poor migrant whites" (100), as well as by blacks, is the process necessary to bring black Americans into "the sphere of conscious history" (147).[62]

The book was well received; Stryker anticipated "an unusually fine piece of work," and FSA photographer John Collier wished for "such a publication every month."[63] Reviews were largely positive; *PM* magazine praised the book as "a study of Negro life from the inside, by one who has lived it, rather than a chock-full-of-dates textbook."[64] Ordinary readers wrote to commend Wright for "dignifying, analyzing, and depicting our suffering people in the stream of American life," as William P. Robinson said; to exclaim that "words can't explain how thrilled I was to see one of us write about our treatment and conditions"; to tell him "how deeply I was moved . . . you have said the things that I would have said if I were the author."[65] The book became an "instant Bible" for photographer Gordon Parks, who photographed Wright the same year and joined the FSA in 1942, and Langston Hughes taught it in creative writing courses.[66]

In the final stages of composition, Rosskam sent Wright "the pictures and dummy," insisting that Wright would be surprised "how the pictures will help" with his final draft of the two urban chapters, which, addressing current issues and social realities, "say the most important things in the whole book."[67] Indeed,

Rosskam's design ideas seem attuned to Wright's authorial intentions. In the first edition of the book, a luxurious gravure printing process brings out both the rich tones and the fine detail in the negatives, most, as we have seen, made with a medium format rather than a 35mm camera. The photographs are large, generally half-page to full-page size, and frequent double-page spreads or multiple-page sequences of photographs interrupt the text. Many images appear without captions and others bear brief captions in boldface that repeat phrases from the text. Even these minimal captions serve, like other repetitions in Wright's text, as emphasis rather than addition; this arrangement encourages us to be active viewers as well as readers, allowing each often-arresting and always interesting print to offer up its meanings over time, because we cannot rely on the quick fix of an anchoring caption. As in James Agee's and Walker Evans's *Let Us Now Praise Famous Men,* also published that year, with Evans's uncaptioned FSA pictures, an implication may be that the text as a whole "captions" each and every image, just as all the images amplify the whole of the text. "The book achieves an integration of photograph and text which is rare," wrote reviewer John Mulholland of *Twelve Million;* "The text escapes from being merely captions for pictures, and the pictures are far more than mere illustration," so that the book "promise[s] . . . a new literary form."[68] Russell Lee found the book "a very swell job," the text "excellent," and Rosskam's work doing "better than [to] illustrate it" because "the pictures fit in most homogeneously."[69]

The chosen Chicago pictures, however, are overwhelmingly grim. Unrepresentative of the coverage as a whole, they include only a few images of worship and leisure to suggest the home life and community that South Side residents struggled to create. Excluded were pictures of the city's emerging urban black middle

class (photograph 64); such fortunates were, Wright explains in his preface, only "fleeting exceptions" to the "plight of the humble folk who swim in the depth" (xix). Meant to represent features of northern urban life in general, just as the southern pictures in earlier chapters are metonymic of all southern rural life, the chosen photographs were selected and cropped to exclude sky, horizon, or recognizable landmarks (photographs 17 and 163). Portraits of families and of children or adults in various settings are in square or horizontal formats, usually shot head on, without monumentalizing angles, side views, or other evident formal manipulation (except for flashlighting) (photographs 22 and 23). As in other print versions of FSA images, pictures may be cropped—sometimes, as on page 108 of *Twelve Million*, eliminating a family member from the group portrait, or as Nicholas Natanson has noted, they may be slightly retouched to eliminate (perceived) flaws such as a child's protruding tongue, as in the reproduction of "Negro family living in crowded quarters" (photograph 22), on page 37.[70] The images in general are printed quite dark, so that in cityscapes, or images of walled-in spaces such as those on pages 10 and 225 of the book (photographs 4 and 41), backgrounds read as gray or gray-black tones; in other images, graphic contrasts of figure and ground replace the play of detail and gradation of shadow that might be seen in a differently made print. Comparing the FSA print titled "Members of the Pentecostal church on Easter Sunday praising the Lord" (photograph 117) to its reproduction on page 164 of the first edition of *Twelve Million*, for instance, we can see that Rosskam's decisions about cropping and printing have emphasized the dramatic tonal contrast between the singers' white robes and the brick wall of the church behind them, instead of bringing out any details, and that two distracting, dangling lightbulbs behind the singers have been removed in the darkroom.

Rosskam also decided to extend all images to the edges of the page, rather than to set pictures off with a white border, as is often done. This full-page bleed, as the style is called, which Rosskam used in all his books, has subtle but definite connotations. It further dissociates the images from the status of mere illustration, or specimenlike evidence, and the suggestion of indefinite extension, rather than specific containment, in the images' often-dark backgrounds implies the dialectics of placelessness and boundedness—the diasporic dislocations—that are posited in the verbal text. Rosskam's arty, informal layout and printing modes, like many of his images, emphasize photography's expressive and symbolic possibilities—the construction rather than transparency of even government-produced documentary work. They enhance the poetic qualities of Wright's text even as the book presented the South Side's misery and struggle.

John Vachon, Jack Delano, and Wartime Coverage

The Lee-Rosskam South Side coverage, innovative and extensive as it was, represented only indirectly the effects of a defense buildup that had begun with the outbreak of war in Europe and intensified with the attack on Pearl Harbor, doubling the South Side's population by 1944. Throughout the spring of 1941, Brotherhood of Sleeping Car Porters' leader A. Philip Randolph built support for a March on Washington by one hundred thousand African Americans demanding "the right to work and fight for our country"; in June of that year, as Rosskam and Wright completed text and picture selections for *Twelve Million*, Roosevelt deflected the proposed demonstration by issuing Executive Order 8802, mandating a national pol-

icy of nondiscriminatory hiring in defense industries and government work and instituting the Fair Employment Practices Commission (FEPC) to enforce such hiring practices.[71] Though a cumbersome bureaucracy impeded actual enforcement, and the FEPC lacked full administrative support, the much-celebrated victory encouraged activism such as that shown in John Vachon's July 1941 pictures of picketers at the Mid-City Realty Company and at Bowman Dairy (photographs 107–110). The pictures show organized protest. The well-dressed Mid-City picketers, in particular, whose ranks included black members of the Congress of Industrial Organizations' (CIO) United Office and Professional Workers as well as two or three white unionist supporters, seem calmly determined, presenting composed demeanors for the photographer, in contrast to the turbulence in some other FSA images of labor militance made elsewhere.

Though all of the South Side photographers must have encountered protests and agitation, and the FSA file as a whole contains many pictures of striking workers and militant demonstration, Vachon's pictures are the only records of overt militance in the FSA Chicago coverage that I have found. They remind us that it was only in time and through struggle that the war years did raise wages and lower unemployment, changes that represented a dramatic, though still inadequate, improvement in African Americans' standard of living and readied the ground for the sustained civil rights struggle of the postwar years.[72]

Vachon studied literature and hoped to be a writer; he took a clerical position at the FSA in 1937, assigned to write captions as prints entered the file. Learning thoroughly its strengths and weaknesses, he began photographing part-time in Washington and elsewhere to add needed subject matter, helped and encouraged by Ben Shahn, Walker Evans, and Arthur Rothstein.[73]

In 1941 he became an official staff photographer and worked extensively in midwest cities before making two summer visits to Chicago.[74] These stays were part of trips through the Midwest to photograph the "breadbasket's" massive food-production and distribution systems related to defense buildup; in July, he arrived there from Pittsburgh and went on to Wisconsin and Minnesota. Stryker urged him to get the "slaughtering houses" as well as "cattle, sheep, and hogs in pens," and "dressed turkeys in boxes, eggs in cases . . . [f]ruits and vegetables" at Chicago's stockyards and railroad hub.[75]

Though "slaughtering pix are absolutely tabu," Vachon wrote back to Stryker, he obliged with some stunning views of the stockyards stretching to the horizon, as well as the requisite foodstuffs.[76] He traveled alone and seems otherwise simply to have roamed the streets, visited bars, listened to music, and talked with people, carrying his 35mm Leica and photographing, as he wrote of an earlier such excursion, "only what pleased me or astonished my eye, and only in the way I saw it." His quiet image of a nighttime male windowshopper evokes the solitary urban rambles he described in letters to his wife, where he also compared himself to fictional Chicagoans Studs Lonigan and Bigger Thomas (photograph 78). Like Rosskam, Vachon saw in the small camera's flexibility a chance for both subjective inflection and the capture of ephemeral yet telling moments of everyday life once unnoticed by the photographic record.[77]

His photographic sensibility was shaped by both his knowledge of the subject matter in the file—he had devised its early organization—and his familiarity with its unifying conventions, gained as he added thousands of images to it. Vachon photographed full-time only as the Section shifted its function to war propaganda, requiring photographs that were "statements of our strength" in support of the war effort, as Stryker wrote to

photographers in May 1942.[78] The new situation precluded most opportunities for the relatively leisurely inquiries into Depression-related material that he had once enjoyed, and a sense of constraint apparently grew as Vachon later followed Stryker out of government service to work on the Standard Oil of New Jersey project. Assigned to photograph a graduation class in Nebraska for the OWI in 1942, Vachon recorded his dismay at a future in which "the boys who will have a chance to run things" showed a smug "complacency," illustrated in their "willingness, for instance, to leave the Negro situation as it is. Nothing about that moves them at all."[79] He had become fast friends with African American photographer Gordon Parks, who was with the FSA/OWI in 1942 and 1943, their friendship causing consternation in then deeply segregated Washington, D.C., according to Parks's autobiography.[80] Such experiences— in the capital city, no less—may have intensified Vachon's "clear-sighted" vision of the bases of modern America's culture of wealth and power, increasing as well his ambivalence about his own complicity in representing such achievements, suggests cultural historian Miles Orvell.[81]

Jack Delano joined the FSA in May 1940, the last photographer to do so before its transfer to the OWI. Initially assigned to follow migrant workers, he traveled through Georgia, South Carolina, and other parts of the South; twelve of Delano's pictures from this trip, and four others he had made in Washington, D.C., and Virginia, were used in the first three chapters of *Twelve Million*.[82]

Like Vachon, Delano has recalled a sense that defense-related patriotism and stress on immediate publicity usefulness constrained photographic ingenuity and creativity. By July 1942, the Historical Section had officially become part of the OWI, its sole purpose to produce government publicity material for internal and overseas use. However, pictures that showed "the increasing participation of blacks and various other groups in the war effort" were "frequently requested" by both government public-relations agencies and commercial white-controlled media, writes Delano.[83] The South Side pictures Delano made in spring 1942 (and a few made the following year) show that concerns to bolster patriotism at home and to promote a positive American image abroad extended as well to featuring "the contribution of blacks not only to the economy but also to American culture" generally. Delano remembers the federally funded, segregated Ida B. Wells housing project, completed in January 1941 on South Parkway between 37th and 39th Streets, as a place "where many black musicians and other artists lived," although his pictures there show no (immediately recognizable) artists or musicians, but rather rely on staple "project" subjects: singing, drawing, model airplanes, scouts, clinics, and community organizations (photographs 51–60).[84] Several exemplary families were named and covered extensively, and Delano posed 102-year-old Mrs. Ella Patterson, the project's oldest resident, with her great-grandson in photograph 52.

Retracing Lee's steps, Delano revisited the Metropolitan Barbershop and other stores; Provident Hospital; churches including Saint Edmund's (where he photographed inside); and Good Shepherd Community Center, recording there both a steelworkers' union meeting and the author Langston Hughes rehearsing members of his Skyloft Players theater company (photographs 84, 89, 90, 106, 134, 135, and 154).[85] He visited an interracial "group of young men . . . who live cooperatively in a large house on the South Side" (photograph 63), and at the production plant of the Chicago *Defender* he augmented Lee's series of deftly posed workplace portraits (photographs 93 and 97). As Delano must have known, the

circulation and power of black newspapers—"established institutions" and "by far the most important agencies for forming and reflecting public opinion," as Drake and Cayton wrote—were increased by the outbreak of war.[86] Nationwide, the black press carried on a wartime "Double V" campaign, insisting that democratic victory be achieved at home as well as abroad. Like the others, the *Defender,* oldest and best known of Bronzeville's several weekly newspapers, urged blacks to support the war, though it called as well for an end to racial segregation and discrimination in all areas of American life. Delano's images of calmly competent *Defender* workers may have served to counter the attacks, denunciations, and, eventually, investigations for sedition provoked by the Double V campaign.[87]

Delano's Chicago coverage shares with other "ethnic group" series of the war years an insistently celebratory tone and often-static, posed quality; but it shows as well new subject matter mandated by the times. Delano made extended sequences on two successful musicians and their families. Drummer Red Saunders was the well-known leader of the house band at the Club DeLisa, a South Side institution, for twenty-one years.[88] Delano posed him with his family in their comfortable Indiana Avenue apartment and strolling in the park, and he shot Saunders working at the popular, white-owned club. Another musician, drummer Oliver Coleman, was likewise shown as a hardworking family man earning a good living—perhaps, as with Saunders, family was included to clarify the men's draft-exempt status (photographs 47–50). Emphasized in the sequence is Coleman's proud membership in Local 208 of the American Federation of Musicians, then led by activist presi-

dent Harry W. Gray. Gray's "first official act in 1937," according to Chicago memoirist Dempsey Travis, was to demand, successfully, that the DeLisa brothers double the pay scale of the Red Saunders Orchestra.[89]

> When the sun went down on the FSA
> . . . Our agile Roy didn't mope and cry
> He shifted his payroll to OWI.
> Now his pictures are pretty; his farmers fat
> His colored folks gleam like grandpa's high hat.[90]

So ran a perspicacious Christmas greeting to Roy Stryker in 1942, its cynicism no doubt apt, its casual racism a reminder of the times. Looking beyond these sentiments, however, we can see the ways that Delano's sequences continue to delineate vital, sustaining links among family, work, and institutional life, just as Lee's coverages of the unnamed "Relief Family" and "Day of a Negro Doctor" had done.

Though FSA photography as a whole presented no immediate challenge to racialized stratification, the Chicago photographs signify the determined inclusion of African Americans in an explicit narrative of national progress and change. The pictures represent an urban society that is at once indicative of the "national black community taking imaginative shape in the collective life of Bronzeville," as historian Adam Green has written, and consonant with progressive visions of postwar American life in its totality.[91] Their success records unambiguously the extent to which the photographers shared Bronzeville's own vision of itself as a diverse and creative urban culture. The pictures remind us today of urban possibilities yet to be recognized and fulfilled.

THE FEDERAL WRITERS' PROJECT IN CHICAGO

Maren Stange

In the pages that follow, selected excerpts from the archives of the Federal Writers' Project (FWP) accompany the photographs. The FWP was part of the New Deal's massive Works Progress Administration (WPA), established in 1935 as an emergency program during the Great Depression to provide jobs in construction, clerical work, the professions, and the arts for more than eight million people. The Writers' Project, headed by Henry Alsberg, was a component of the WPA's Professional and Service Projects Division, "Federal One" for short, which included art, theater, and music projects as well as literature. Most project writers, including hundreds of African Americans, wrote, edited, and supervised material for the American Guide series, a collection of state travel guidebooks featuring regional folkways and histories in addition to standard fare. The project supported a limited number of individual undertakings by established writers.

Under poet Sterling Brown, its Negro Affairs editor, the Writers' Project undertook a variety of black studies projects, which became "perhaps the most pioneering of . . . [FWP] . . . subsidiary efforts," writes historian Monty Noam Penkower.[92] Besides contributions to the state guides, these included separate, full-scale studies of urban and rural black life and more than two thousand interviews of ex-slaves, conducted in eighteen states. The project employed a number of prominent and emerging African American writers, including Margaret Walker, Richard Wright, Willard Motley, Frank Yerby, Fenton Johnson, Arna Bontemps, Katherine Dunham, Ralph Ellison, Claude McKay, and Zora Neale Hurston.

The Illinois Writers' Project (IWP) was "one of the country's largest and most radical," its future luminaries including Nelson Algren, Studs Turkel, Jack Conroy, Wright, and Bontemps.[93] Largest of its black studies was the heavily documented "Negro in Illinois" project, headed by Bontemps and employing Wright, Johnson, and Dunham, among many others. Intended for publication but never published, the "Negro in Illinois" papers exist today as a massive archive of field research reports, interviews, historical narratives, and journalistic materials, stored in several libraries. The most complete holdings, at the Chicago Public

Library's Vivian G. Harsh Research Collection of Afro-American History and Literature, indicate a scope ranging from the eighteenth-century arrival in "Checagou" of French-African Jean Baptist Point du Sable, honored as the city's founder, to current accounts of socioeconomic conditions and events in the worlds of art, literature, theater, music, and sports.

This material, amassed over several years, provided research for other important publications. Richard Wright, of course, drew on his own and others' work for *Twelve Million Black Voices,* and Horace Cayton and St. Clair Drake relied extensively on FWP material as well as several other WPA-funded sociological studies in writing *Black Metropolis.* Under Bontemps's direction, FWP members provided research for many exhibits at the 1940 Negro Exposition held in Chicago and billed as the "First Negro World's Fair," and they published a companion volume, *Cavalcade of the American Negro.* In 1945, Bontemps and fellow project author Jack Conroy relied on "Negro in Illinois" material to write *They Seek a City* (later republished as *Anyplace but Here*), an account of African Americans' ongoing migration to urban centers.

In Chicago, the IWP operated among several overlapping groups supporting literature and the arts in this period. So active and influential on the South Side as to constitute a Chicago Renaissance, these groups included the John Reed Clubs sponsored in the early 1930s by the Communist Party, the South Side Writers group founded in 1936, the WPA-funded South Side Community Art Center and Federal Theatre Project, and the Rosenwald Fund, established by Sears, Roebuck company founder Julius Rosenwald in the 1920s to support African American education, art, and literature. The Rosenwald fund, in fact, supported the "Negro in Illinois" project for several months after federal funding ended in 1941.

The Writers' Project material that follows, a small fraction of that available, has been chosen as especially relevant to the photographs in this volume. Complete citations for each excerpt are listed in the sources (page 235).

ASPECTS OF THE BLACK BELT

Richard Wright

Since the year of 1860 there has been a steady influx of Negroes from southern to northern states. In 1900 over 10 percent of the national Negro population lived north of the Mason-Dixon line. Even before the abolition of slavery thousands of Negroes came northward via the "underground railway."

One of the main focal points of immigrant concentration was Chicago. The rate of influx can be seen from the following table:

1900	30,150
1910	44,103
1920	127,033
1927	163,800
1930	233,903
1935	235,000

These Negroes came mostly from the deep South. At least 46.3 percent of them came from the east Atlantic states; 17 percent came from the south Atlantic states.

As the above table demonstrates, the rate of influx increased with the passing of years. The peak, however, was during the World War period. During the decade from 1910–1920 the Negro population in Chicago increased 148.5 percent. One of the outstanding facts about this data for this period is that the large increase did not bring into existence any new colonies but resulted in the expansion and increased density of areas in which groups of Negroes had lived prior to 1910. During a period of eighteen months from 1917–1918 it is estimated that more than fifty thousand Negroes poured into Chicago. All of these, however, did not remain. Chicago was but a rerouting point, and many moved later to nearby cities and towns. The tendency was to reach those centers paying the highest wages and offering the most permanent prospects.

The causes of Negro migration to the North were mainly two, sentimental and economic. Each of these causes has a bearing on both the North and South.

In the eyes of millions of Negroes the North has long been a haven of opportunity and justice. Many of those who came

north did so to escape the sharp competition of southern white labor, to avoid the persecution of petty officers of the southern law and the persecution of the southern press, and to gain the long-denied right of franchise.

The above causes of Negro migration existed long before any exodus of Negroes took place. The more immediate and pressing causes were economic and social. The living standards of the southern Negroes were abnormally low. Wages were as low as 50¢ per day. Added to this were the boll weevil pests, floods, storms, all of which augmented the hazards of rural life. Other contributing factors were vicious residential segregation and a lack of school facilities.

These causes were for the most part latent and did not become strong and pertinent factors in migration until two events of deep significance took place. The first of these was the partial cessation of immigration from foreign countries. The second was the rapid expansion of northern industry caused by the World War. It was then that Negro newspapers made glowing appeals to their exploited race to come north. Northern industrial firms, faced with growing labor troubles, welcomed cheap, southern Negro labor.

In the beginning urban life had a retarding effect upon the Negro immigrant. Adjustments were slow and difficult. The steady influx brought about serious and exciting complications. The first and foremost of these were in the sphere of housing. At the beginning of the migration many of the Negroes lived in a limited area on the South Side, principally between 22nd and 39th Streets, Wentworth Avenue and State Street. State Street was the main thoroughfare. Prior to the influx of the Negroes to the South Side many vacant houses were to be seen in this area. Because of its proximity to the old vice district this area had an added undesirability to the whites. The newcomers gladly took these houses. But, as the rate of influx increased, a scarcity of housing followed, and the immigrants pushed vigorously southward and eastward.

It was at this period that the greatest excitement among the whites prevailed over the coming hordes of Negroes. A form of organized resistance to the moving of Negroes into new neighborhoods was the bombing of their homes and the homes of real estate men, white and Negro, who were known or supposed to have sold, leased, or rented local property to them. From July 1, 1917, to March 1, 1921, the Negro housing problem was marked by no less than fifty-eight bombings. Arson, stoning, and many armed clashes added to the gravity of the situation.

From the very beginning the Negroes were outspoken in their indignation over these conditions, but their protests had no apparent effect in checking the outrages. The repeated attacks made the Negroes firm in their stand.

Despite this, the general trend of the Negro population was moving steadily southward and eastward. In considering the expansion of Negro residential areas, the most important is the main South Side section where 90 percent of the Negro population lives. During the twenty years from 1910 to 1930 the increasing Negro population between 12th and 31st Streets was pushing east of Wabash Avenue and was stopped only by the Lake. To the south it reached to 49th Street. Negro families are now filtering into the Hyde Park and Englewood areas.

The second resulting complication of the Negro influx into Chicago raised itself in the fields of industry and labor. The Negroes' position in the industrial life of Chicago is so intimately connected with the changes due to the War that a summary of certain facts of common knowledge in connection with the

War will be helpful. With the coming of hostilities in 1914 many industrial plants doubled and trebled their labor forces. An outstanding example of this was the increase of the labor force of a stockyard plant from eight thousand to seventeen thousand workers. The War stimulated the demand for goods, and therefore for labor, and at the same time there was a sharp decrease in the available labor supply. Immigration from enemy nations had ceased, and there was a partial cessation of immigration from other countries. The labor shortage became acute when the United States entered the War and enlistments drew thousands from northern industries. A demand for Negro labor was the result.

According to the Fifteenth Census of the United States, Occupational Statistics, Illinois, the Negro was employed mainly in two forms of gainful occupation, industrial and domestic. When it is remembered that in 1910 the Negro population of the United States gainfully employed was 75 percent agricultural and domestic, it is evident that the northward migration involved a drastic transition of the southern Negro from rural labor to highly specialized industries of northern cities. It is estimated that two-thirds of the male Negroes in northern cities are gainfully employed in industry (1920 census).

In Chicago particularly there was a marked increase in Negro workers in industry. One of the reasons for this increase was that many firms employed Negroes to take the place of strikers. The Negroes' loyalty to employers, their ignorance of unionism, made them especially attractive to certain sections of basic industry where labor troubles were imminent. In many instances it was charged by union officials that some stockyard companies were importing Negro labor from the South to drive wages down. There are, however, no reliable facts or statistics to support this view. But it can be definitely stated that the influx of Negro laborers into many branches of industry did much to increase racial antagonisms between white and Negro labor. When Negroes were introduced into a plant during a strike and remained afterward, a period of strained relations most certainly ensued.

Another factor contributing to the Negroes' adjustment in Chicago arose out of a peculiar political situation. For largely sentimental reasons the Negro is predominately Republican in his politics. The large role played by the Negro vote in factional struggles aroused resentment against the race that had so conspicuously allied itself with the Big Bill Thompson faction of the Republican Party.

Another sphere in which Negroes have had a great deal of difficulty in making adjustments is the realm of daily personal contacts. From an extremely simple set of rural relations in the South, Negroes were transported to more complex relations based on more elaborate distribution of responsibilities. Thus it happens that contacts in the public schools, politics, business, industry, sport, colleges, clubs, and housing were points of contact making for friction, comment, antagonism, resentment, prejudice, or fear.

Chicago has not been without its open racial clashes. The first of any moment to occur was in February 1917. Its cause was the resentment felt by whites over the coming of Negroes into a contested neighborhood. A mob of young whites stoned several Negro families from their homes.

Another clash ensued in July of 1917 when a party of white men in an automobile fired into a group of Negroes. No one was hit. However, earlier that day a white man had been found dead in the rear of a saloon in the Negro district. It was thought that the whites were trying to avenge the death of the slain man.

In July and August of 1917, there were many outbreaks of a

minor nature between Negroes and recruits from the Great Lakes Naval Training Station. In some instances the recruits and in others the Negroes were the aggressors.

A saloon brawl which almost developed into a riot of serious proportions occurred on May 27, 1919. A Negro attempted to be served in a saloon catering to white trade. He was refused and kicked out of the door. The Negro armed himself and gathered about him some friends and attempted to regain entry to the saloon. Negro plain-clothes policemen stopped the trouble before it spread.

On July 27, 1919, there was a clash of major proportions between white and black. It began as a brawl at a bathing beach and resulted in the drowning of a Negro boy. This, in turn, led to a race riot in which 38 lives were lost—23 Negroes and 15 whites—and 537 persons were injured. After three days of mob violence, affecting several sections of the city, the state militia was called out to assist the police in restoring order. It was not until August 6 that the danger of further clashes was regarded as past.

There is no doubt but that the greater part of the fury manifested in this race riot had been long gathering momentum over a period of years. The multitude of maladjustments resulting from housing and labor troubles now had an opportunity to vent their pent-up energies.

Of late, however, the Negro has ceased to invade Chicago in great numbers. A measure of relative stability has been attained. The decline of migration has tempered the anxiety of the whites.

Part One

HOUSE AND HOME

From Edwin Rosskam, "The Face of the 'Black Belt,'" FSA/OWI General Caption. RA/FSA/OWI Written Records.

THE FACE OF THE "BLACK BELT"

The casual visitor, driving through the "Black Belt" may well get the erroneous impression of a prosperous and comfortable community. South Parkway between the Forties and the Sixties is a broad thoroughfare between substantial stone houses; 47th Street is a busy and prosperous-looking shopping street; evidently these cannot be slums.

In fact even these ultra-respectable-looking housefronts in the "best" area of the "Black Belt" are merely shells enclosing slum living. The population density here is 70,000 per square mile compared to 34,000 per square mile in equivalent housing in the white district, a couple of blocks away, across Corrage Grove.

This Negro area, taken over fairly recently—mostly since 1919—from a white population has not yet had time to deteriorate *outwardly*. Inside, lack of maintenance plus incredible overcrowding has already created conditions of filth, lack of sanitation, and decay, which make living a definite hazard.

If the South Parkway section between the Forties and Sixties is a slum in the process of becoming (even here there are occasional buildings which already show outward signs of their actual deterioration), many other districts have long given in to the naked exposure of their true squalor. Miles of LaSalle, Dearborn, and Federal Streets, a huge area around Maxwell and many other "core spots" look as if they had been bombed. Leaning tenements stare blindly through broken, boarded, or papered windows past sagging wooden outside stairways upon empty lots where children play on the bricks and rubble of a decade's collapse and demolition and in months-old piles of garbage.

Another kind of slum consists of former single-family housing which has been subdivided into "apartments." It is common to find four to six persons in one or two rooms; eight to eleven tenants in a "two-room kitchenette" are not unusual. (See caption "Kitchenette.") Thus a single-family house may well contain from forty to sixty people.

In such districts facilities are at a minimum. "Cold water flats" are common; a coal stove stands beside a cold radiator. One toilet for five families seems to be a good average (Cayton, "Negro Housing"). In many cases even the water has been turned off and must be fetched from another house or a hydrant. And, to quote Cayton, "many of the above cases pay a substantial rent. In other communities they would, for the same rental be able to secure more space and to enjoy healthful and sanitary surroundings."

A few housing projects, privately financed, such as the Rosenwald project, or government financed such as the Ida B. Wells Homes, can accommodate too few tenants to affect conditions substantially. The real obstacle is the restriction, imposed on a growing community, which prevents adequate expansion in space.

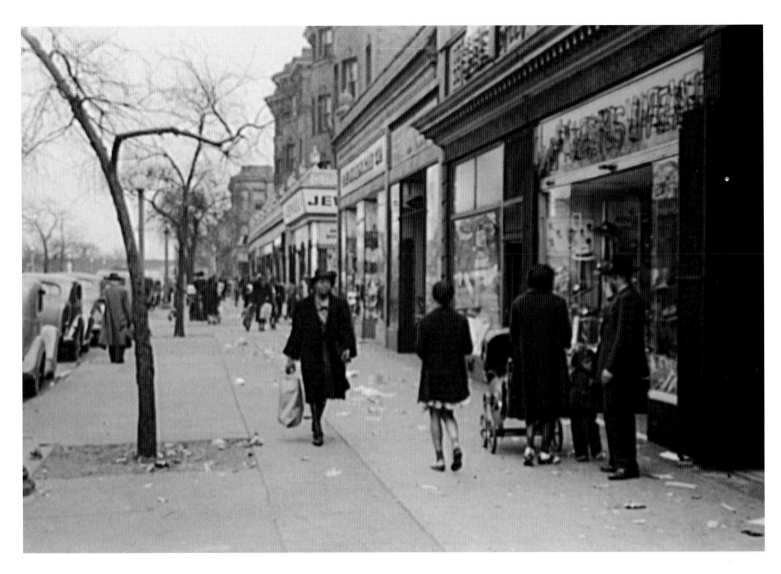

1. Street in the Negro section. *Russell Lee, April 1941.*

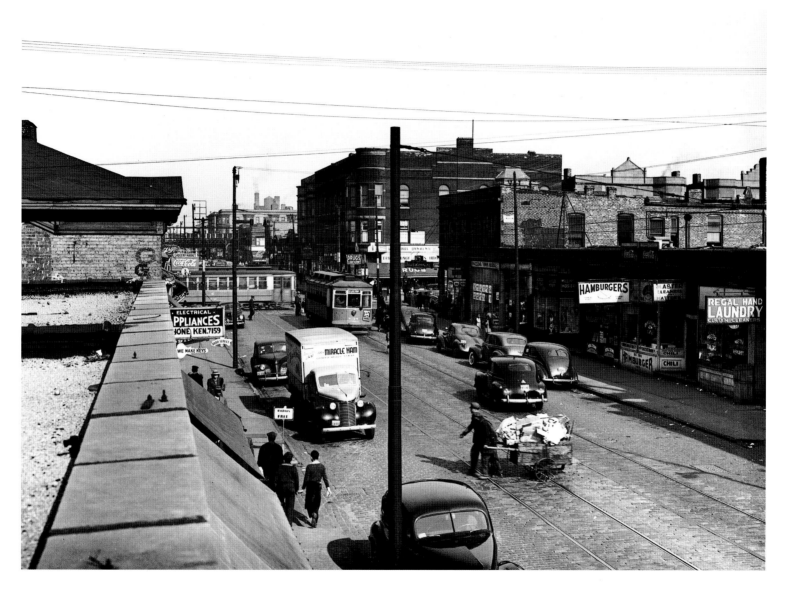

2. 47th Street. *Russell Lee, April 1941.*

From O. Winkfield, *"Short Tour of Points of Interest on the South Side: 26th to 47th Streets,"* Federal Writers' Project: Negro Studies Project.

SOME POINTS OF INTEREST ON THE SOUTH SIDE

One in Chicago's Loop who may wish to get an observation of the social, industrial, and cultural life of Chicago's South Side at a glance may conveniently go by automobile south on Michigan Avenue for about twenty-five blocks. . . .

At 2900 South Michigan you reach the Dunlop Tire Company, a four-story building with economic sale display which is conducive to motor tourists. From this point on, the way is devoted mostly to private homes. Here and there for the next ten blocks are wrecked buildings, piles of debris, schools, hotels, public homes, or undertaking parlors. Before leaving this block, you observe the Bernice Hotel at 2945 which is a five-story Kitchenette Apt. Building with a hundred-person living capacity with rates which are asked that are entirely reasonable. . . .

At 31st Street you are near the 31st Street "L" station. Stores and shops for many blocks east and three blocks west run without interruption and create a congestion of street shoppers, principally of colored people since you are well into the Black Belt by now. A few whites yet reserve and inhabit their beautiful well-built homes along Thirty-first, Thirty-second, Thirty-third, and the Thirty-fourth blocks on Michigan Avenue. . . .

The National University of Music, 4556 Michigan Avenue, would claim your attention. Here are about one hundred fifty talented colored children, men, and women, many very gifted, who engaged in the study of the voice or the various musical instruments. Tourists and visitors are welcomed and entertained at this school. Pauline James Lee is founder and president.

I almost forgot to have you stop at the Martha Washington Home on Michigan Avenue at 4448, which was established for dependent crippled children. It was founded in May 1926 by the Martha Washington Club and aims to save dependent crippled children and to give them physical and educational training and convalescent care.

The Forty-sixth block, west side of Michigan Avenue, is occupied entirely by the Michigan Boulevard Garden Apartments in which reside many colored characters of national reputation such as Joe Louis, the heavyweight fighter; Nelson

E. Woodley, chemistry instructor; and Florence B. Price, the pianist and composer. These apartments are noted for good construction, modern conveniences, and accommodation. They cover, including the inner garden, the entire block—a space of six acres. They have the longest roof promenade of any building on the South Side and the best cultured group of tenants in this section of Chicago.

You are now at 47th Street and may desire to return most conveniently to the "Loop." Turn east on 47th and continue for four blocks and you will be on South Parkway Avenue which is an excellent drive-way for motorists Loop-bound. You will note the traffic, and many shoppers, chatters, and bustle and hurry in general in the atmosphere on 47th and South Parkway Avenue. There is a true liveliness and happy-go-luckiness in the air. This intersection is called by many "Negro Heaven." It is the life vein of the Black Belt.

From William M. Page, "A Short Tour of Points of Interest on the South Side," Federal Writers' Project: Negro Studies Project.

47TH AND SOUTH PARKWAY

A point easily accessible from the Loop by bus, elevated train, and streetcar is 47th Street and South Parkway. Tourists will find the South Center Building on the southeast corner of 47th Street and South Parkway a very entertaining spot. They will see the South Center Department Store, a real commercial community center with colored and white salespeople, managers, etcetera, working together throughout the store. Also in this building is the Regal Theater, one of the largest and finest on the South Side. Near the Regal Theater is the Savoy Ballroom, where there are boxing matches, wrestling, basketball, and dancing. Tourists will travel west on 47th Street to Michigan Avenue, where they will come to the beautiful "Michigan Gardens Apartments." The $2,700,000, modern apartment building was erected by the late Julius Rosenwald for colored people. From this point the tour will turn south on Michigan Avenue and stop next at 48th and Michigan Avenue at the Cleveland Hall Public Library which sits on the southeast corner. From here the tourist will go on to State Street and see one of the city's latest high school buildings covering an entire city block, the De Saible High School. From here they will go south on State Street to Garfield Boulevard and travel eastward on this beautiful drive to South Parkway past Schultz Bakery at Wabash Avenue. Under the elevated R. between Prairie and Calumet Avenues and the Jas. C. King Home for Men at South Parkway and Garfield northwest corner. Turning south on South Parkway the tour will go to 60th Street and east on 60th to Cottage Crove Avenue, and north on Cottage Grove to 55th Street. This route affords a beautiful drive all the way to this point, a sort of semicircle of Washington Park. At this point stands the 124th Field Artillery Armory of Illinois National Guard. Open to visitors.

From here travel on Cottage Grove Avenue north to 51st Street and west on 51st Street to Vincennes Avenue. Where they may visit the Provident Hospital—the largest hospital operated by colored people in this city, where numbers of colored doctors and nurses take their training and practice. From here they journey west to South Parkway and four blocks north on the beautiful boulevard to 47th Street, the starting point.

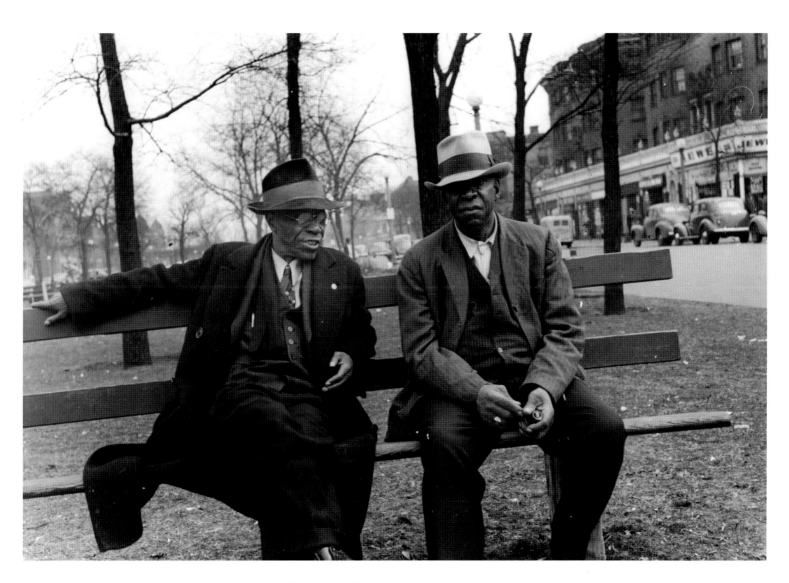

3. Men sitting on a park bench. *Russell Lee, April 1941.*

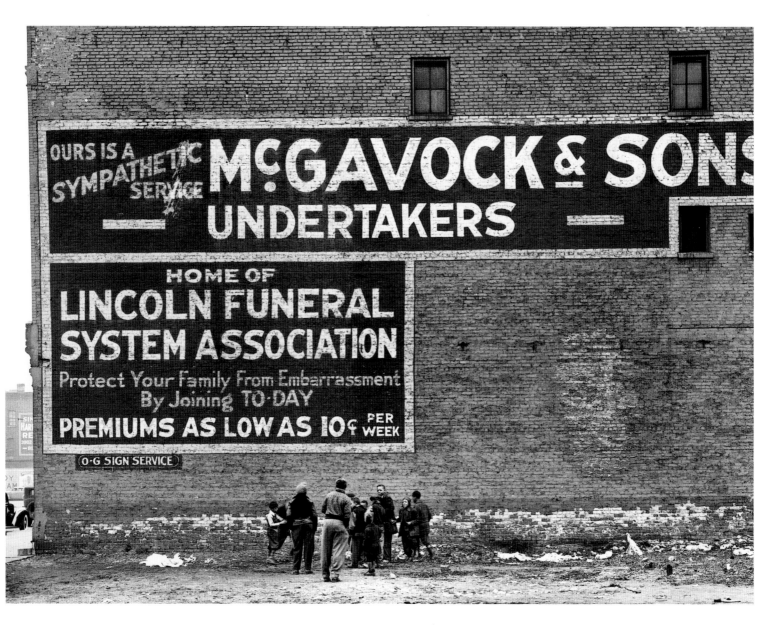

4. Sign. *Russell Lee, April 1941.*

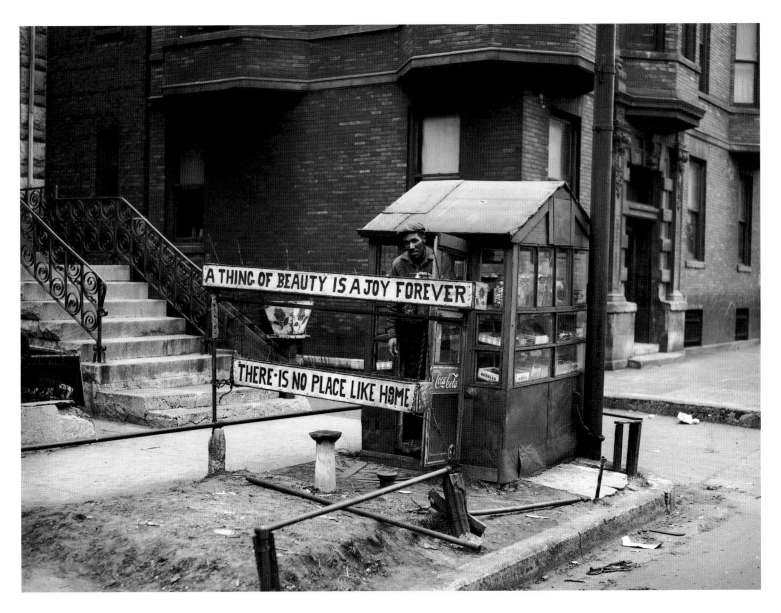

5. Candy stand run by a Negro on the South Side. *Russell Lee, April 1941.*

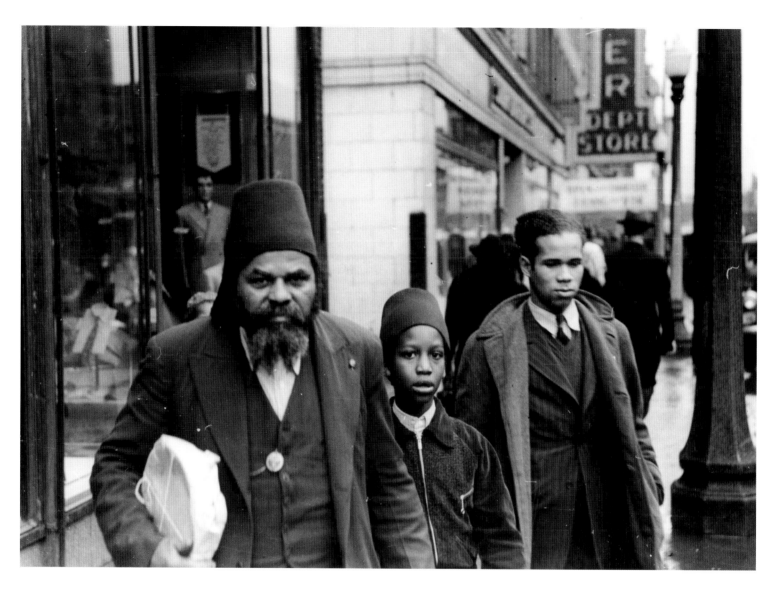

6. Members of the Moors, a Negro religious group of Chicago. *Russell Lee, April 1941.*

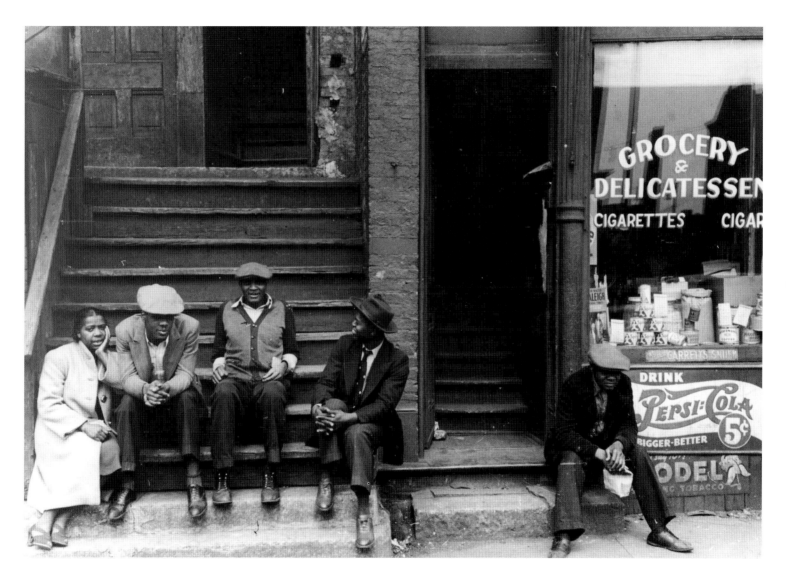

7. People sitting on front porches in the Negro section. *Russell Lee, April 1941.*

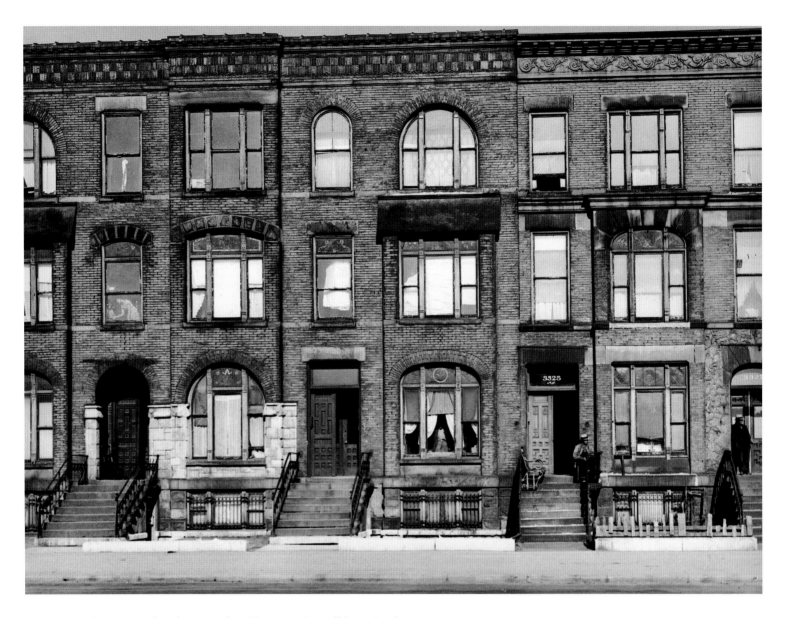

8. Apartment houses rented to Negroes. *Russell Lee, April 1941.*

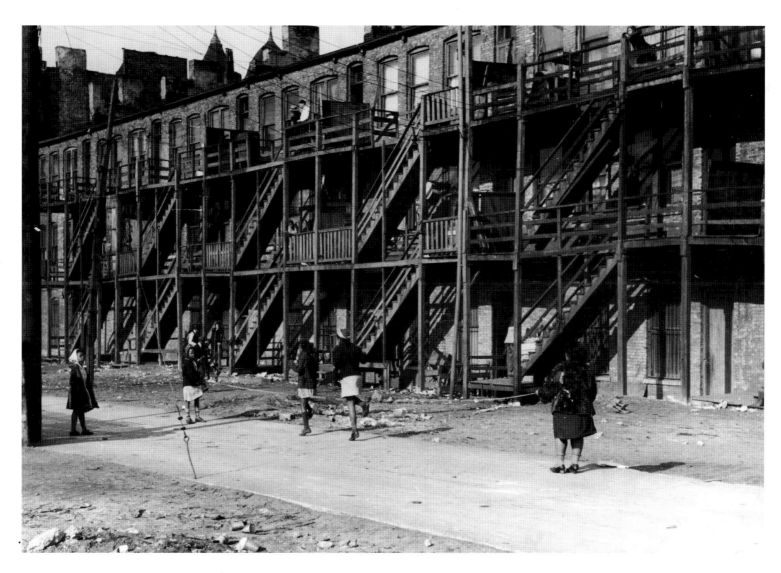

9. Apartment building in the Negro section. *Russell Lee, April 1941.*

From O. Winkfield, "Housing Conditions, 31st Street to 63rd Street S., State Street to Wentworth Avenue W.," Federal Writers' Project: Negro Studies Project.

SOME HOUSING CONDITIONS

From 31st Street south, traversing Dearborn, Federal, LaSalle, and Wentworth Avenue, the scene is a spectacle of sympathy for many blocks.

At 31st Street and LaSalle Street we look back on a block of derelict, abandoned houses, save one small apartment building at 29th and LaSalle Street across from which stands the old Salem Missionary Baptist Church and Community House, marking the center of a once-popular colored community.

Through the stretch of . . . territory to 35th Street not over a half dozen steam-heated buildings can be found. Lamplight is popular and stove heat is used, often the cookstove serves the twofold purpose—heating and cooking.

In many of the old houses the light condition is bad because either the panes or half-window glass having been broken are replaced by boards or cardboards or old rags. The tenants get plenty of air but it is improperly received under doors, through broken glasses, or holes in the wall. Along this immediate way basements, upper flats of from three to seven rooms have rentals of from $5.00 to $22.50 per month.

Except the Weca Building at 34th Street and State Street the buildings are all one-, two-, and three-story and mostly frame and old, and at that they are inhabited even from the basements up.

The old Provident Hospital at 36th and Dearborn is vacant because of its ruined condition, but repeated efforts have been made to remodel and turn it into an apartment house because of the scarcity of housing quarters.

The Progressive Missionary Baptist Church, located at 37th and LaSalle Street, is the center of an unusual, large community group. This church's membership is six thousand, most of whom live in the immediate community. Whereas the church edifice is improved or remodeled to modern conveniences, the average home thereabout is wanting for the first sign of adequate or decent living conditions. Through this section, the one-, two-, and three-story frame shacks, badly aged, are dark and the basements are damp. Smoke and cinders from coal yards and passing locomotives make them very undesirable and unfit for living in.

On the east side of State Street in the Thirty-eighth block we come to several three- and four-story buildings, the first stories of which are given for business rentals. The upper stories are arranged as living apartments; however these large, old flat-apartments have recently been turned into kitchenettes for quick rentals to small families.

Along 39th Street from State to Wentworth Avenue except at the corners of 39th and State are a gang of business shacks—one and two stories high; regardless how small or the nature of the business, these places serve for living quarters also.

Wentworth Avenue from 31st Street to 45th Street is a common mixture of one- and three-story frame shacks with a few two-, three-, and four-story brick buildings here and there in the block and brick buildings on the corners. The first story is generally devoted to business and the upper floors to living quarters. The tenants are principally white and colored. Wentworth Avenue marks well the general line of division between the living quarters of white and colored racial groups, for few or no colored people live west of Wentworth Avenue. However, the housing conditions for both races along the writer's territory are poor.

From 55th Street or Garfield Boulevard to 63rd Street, we find slight improvements in the housing conditions, including sanitary conditions and ventilation. Some places are steam- or oil-heated, and repairs are better kept.

On State Street, in the Sixty-first and Sixty-second blocks most of the buildings are delapidated and unoccupied save by a few gypsies who live in storefronts and otherwise there are a few stores/businesses. But throughout the territory every building that is tolerable at all is occupied and many are congested with tenants.

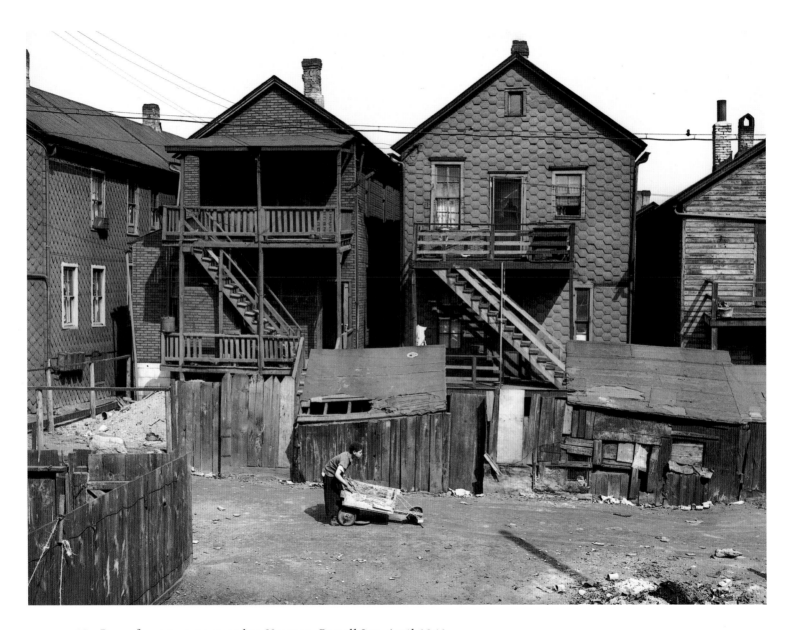

10. Rear of apartments rented to Negroes. *Russell Lee, April 1941.*

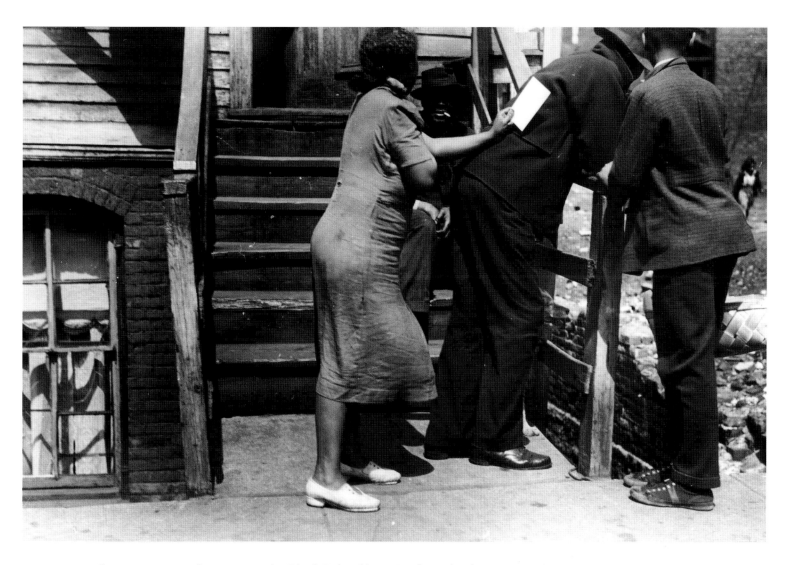

11. Conversation on the street in the Black Belt. *Edwin Rosskam, April 1941.*

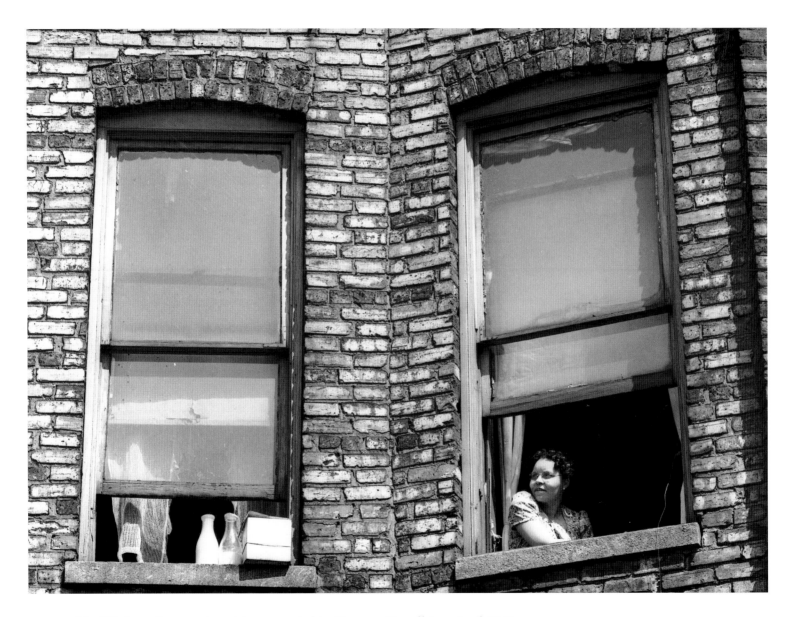

12. Window of an apartment house rented to Negroes. *Russell Lee, April 1941.*

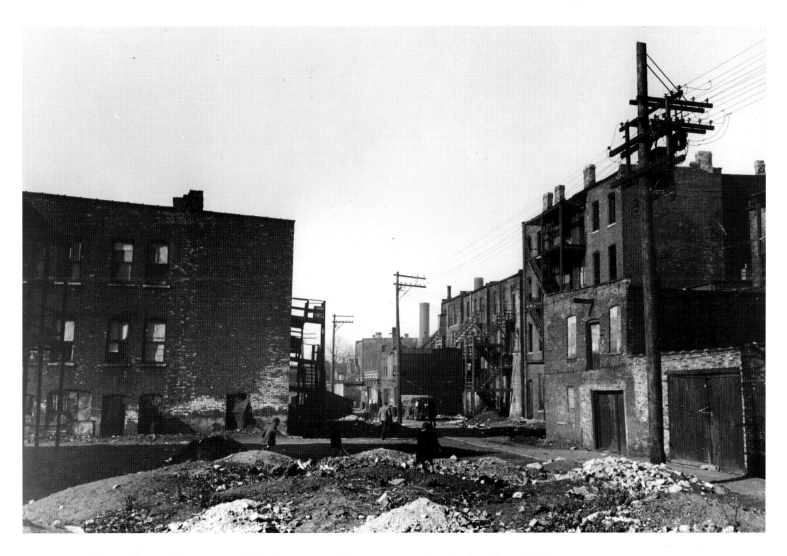

13. Vacant lots and apartment buildings in the Negro section. *Russell Lee, April 1941.*

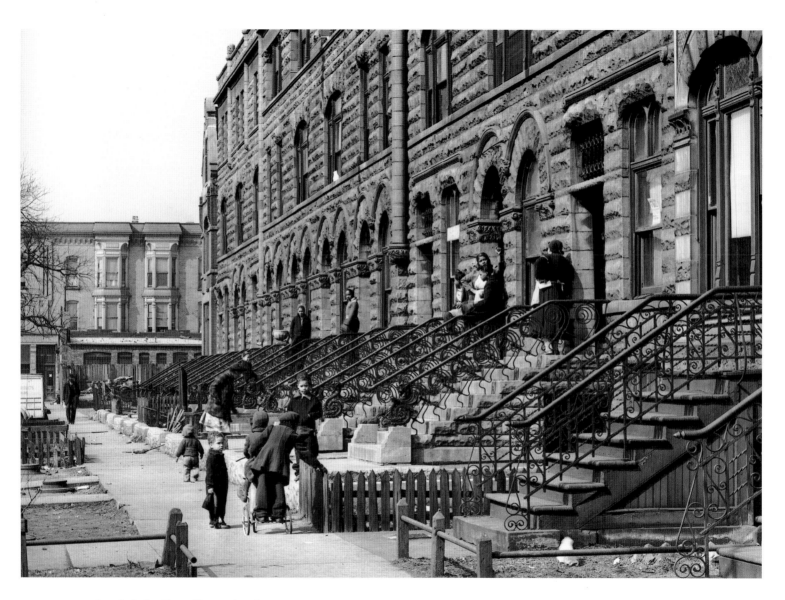

14. South Side. *Russell Lee, April 1941.*

*From Edwin Rosskam, "Kitchenette," FSA/OWI General
Caption. RA/FSA/OWI Written Records.*

KITCHENETTE

"Kitchenette apartments have sprung up with the needs of this overcrowded area . . . kitchenettes are one-room apartments. A large seven-room apartment may be cut up into as many separate apartments for seven different families all of whom use the same bath and toilet facilities. A gas burner for cooking purposes is usually installed in the closet of each room. The demand for space in the Negro community has made the kitchenette a gold mine for all kinds of owners. . . . Kitchenettes are a menace to health and to morale. In most instances they violate all the provisions of health, safety, and building codes" (from Cayton, "Negro Housing in Chicago").

From the report of a staff member of the Chicago Relief Administration: "Deaths of three children from tuberculosis recently occurred in a family living in a basement flat . . . a fourth member of the family is now in the tuberculosis ward of Cook County hospital. . . . The temperature is kept unusually high as the pipes necessary to heat fifty or sixty flats in the building pass through this basement apartment. The family has had difficulty in getting other quarters because of scarcity of vacancies. Many families live in a building in the thirty-nine hundred block on Michigan Avenue which houses about one hundred persons in twenty-six kitchenettes. One typical situation is that in which a family of seven pays $24.00 per month for a two-room kitchenette. Four of the children sleep in one of the two family beds. The apartment has no pantry and food is prepared in a room which is also used for sleeping."

From data collected by Metropolitan Housing Council of Chicago, 1939 (addresses omitted):

> Fifteen people in five one-room apartments, six of them children. One bathroom.
> A mother and six children in one room.
> Water for drinking and cooking comes from bathroom.
> One toilet for six apartments.
> Five families using one toilet. One advanced case of tuberculosis in this dwelling.
> No toilet facilities, water obtained from neighbors.

" 'Black Belt' housing, 90 percent absentee owned, was mostly old before Negro occupation. Landlords, sure of tenancy at high rents regardless of condition, do little in the way of repairs or improvements to prevent complete deterioration. Final result of this policy plus overcrowding is demolition, collapse, or destruction by fire and thus the further reduction of available facilities" (Cayton).

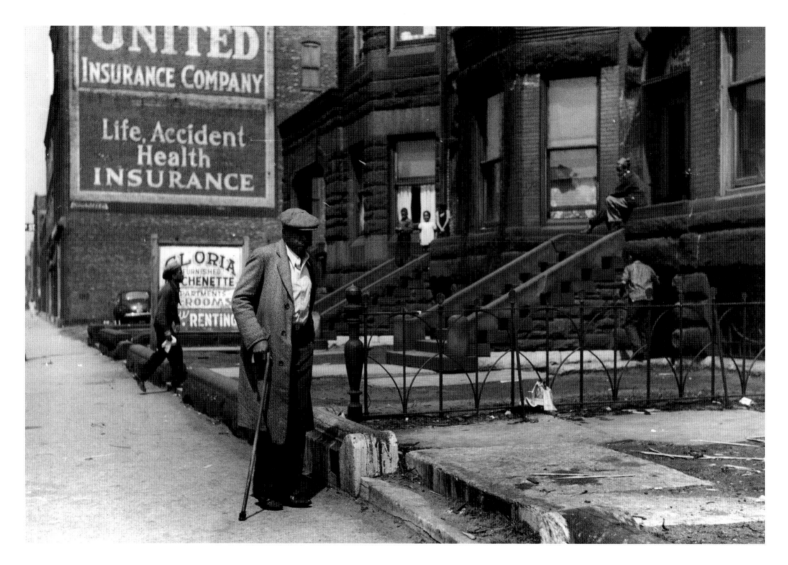

15. The kitchenette apartment house area on South Parkway, a formerly well-to-do avenue.
Edwin Rosskam, April 1941.

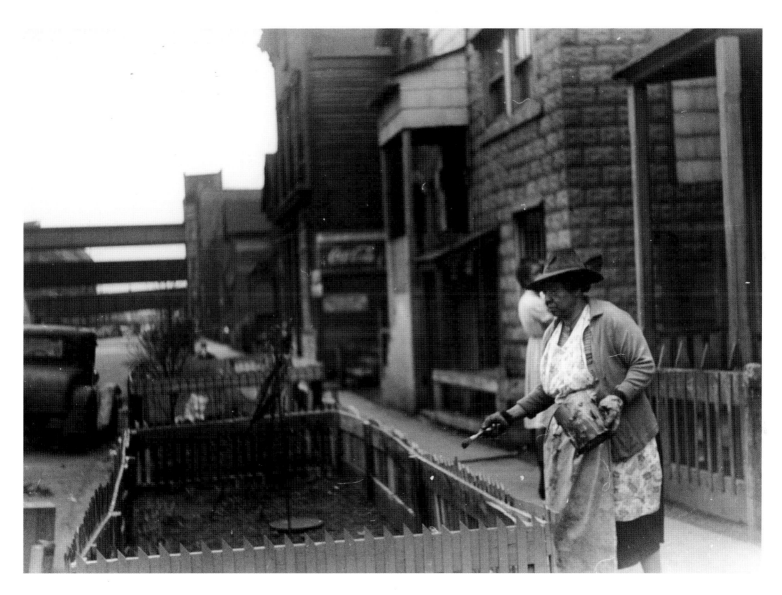

16. Negro woman painting the fence on her pavement garden in the Black Belt. *Edwin Rosskam, April 1941.*

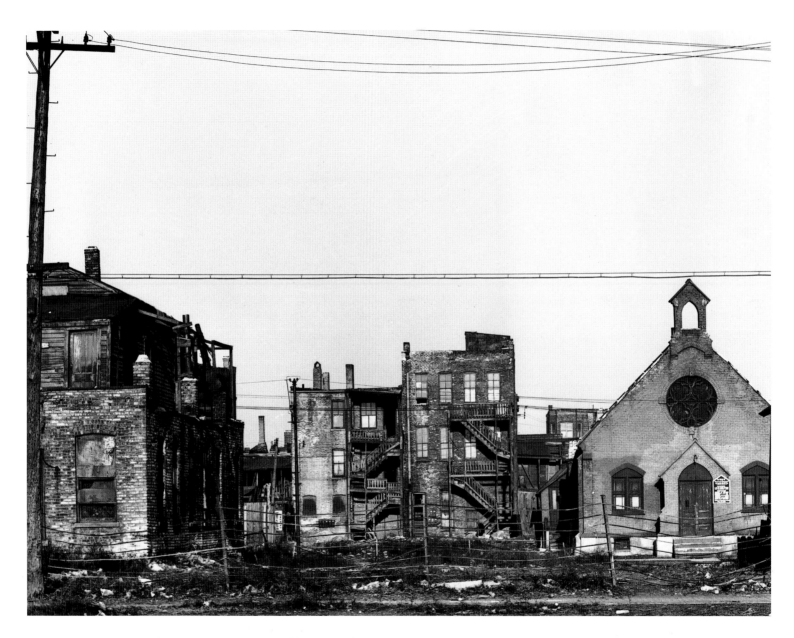

17. Scene in the Negro section. *Russell Lee, April 1941.*

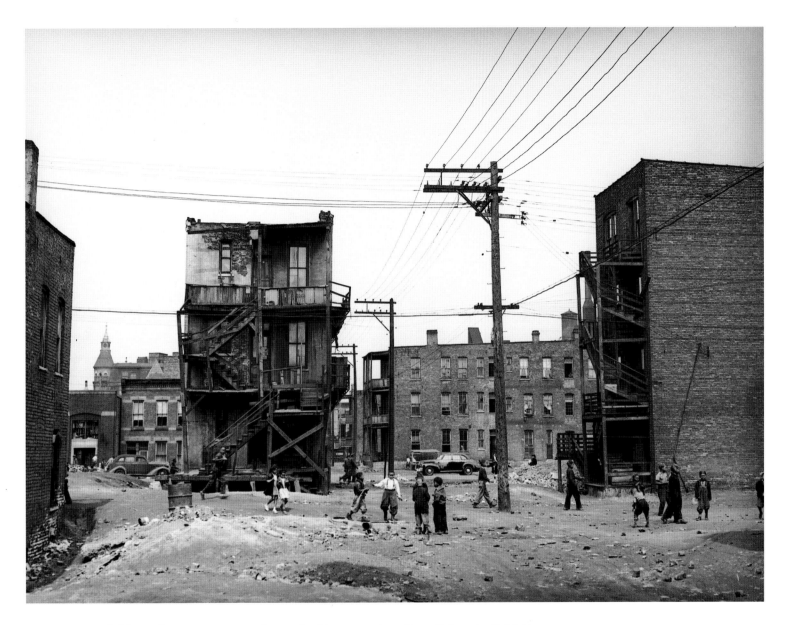

18. Children playing in a vacant lot in the Negro section. *Russell Lee, April 1941.*

From J. Bougere, "Houses," third draft of an essay summarizing IWP research on African American housing, "Negro in Illinois" Papers, Harsh Collection.

HOUSING IN THE GREAT DEPRESSION

The Depression was graphically reflected in Chicago's housing situation. Finding rents hard to collect, many owners agreed to condemnation and demolition of run-down houses as the cheapest way out. The consequent loss of living units in the sections resulted in further doubling-up of dislodged families. Between August 11 and October 31, 1931, the Renter's Court in Chicago heard 2,185 eviction cases, 831 of them involving Negroes. The Welfare Committee found whole families leading a nomad existence, sleeping in city parks; small children were "tied-up like bundles of newspapers against the cold."

In 1930 militant Negroes joined neighborhood Unemployed Councils, said to have been led by Communists. Meetings were held in Washington Park on the South Side, meetings at which plans to "do something" were proposed. These groups resisted evictions by putting the furniture of the dispossessed back into their former homes as soon as the bailiffs had departed; in some cases officers were vigorously restrained from even beginning the job. A young Negro radical, active participant in these scrapes, reported in behalf of his organization:

> We put hundreds of families back into their homes. Sometimes we put them back before the law had taken all the furniture out. Occasionally, bloody fights ensued. We used to have night and day meetings in Washington Park. The men who put the furniture back into homes included whites and Negroes. We started out by putting Negroes back into their homes but the practice later spread to white neighborhoods. After relief was organized, the fight was carried to the relief stations.

The climax of this resistance occurred August 3, 1931, when the police stopped a group of Negroes and one or two whites

attempting to put the possessions of a seventy-two-year-old colored woman back into her house. Three Negroes were killed, three more wounded. Several bystanders were also shot. The *Chicago Tribune* reported: "Reds Riot; Three Slain by Police—South Side Crowds Attack Squads in Eviction Row—City Acts to Avert New Outbreaks." Mayor Anton J. Cermak, out of the city at the time, instructed the chief bailiff to halt all eviction orders. He promised that upon his return he would arrange to give aid to those evicted in the future.

The Councils of the Unemployed clamored for a moratorium on all evictions, and the colored ministers of the city launched a fight against "Communist propaganda." The following statement by members of the Negro clergy appeared in the *Tribune:*

> The Communists are signing up our people by the thousands. They guarantee that, if any member of the party is evicted, the vigilance committee will replace his furniture in his home.
>
> They call it a rent strike. . . . They charge a dollar dues and get members from among the unemployed. At the rate they are going, not a landlord in our district will be able to collect rents before long.
>
> . . . when put out of one dwelling, [they] look around the block for the nearest vacant flat, break the locks, and move in.
>
> Although they are without lights, gas, or water, the squatters remain in their new quarters until evicted again.

The press aided in heightening the hysteria that had seized many South Siders. It was claimed that "the Reds who have been holding daily meetings in Washington Park . . . have been instructed by leaders in Moscow to resist efforts of their landlords to put them out for nonpayment of rent." The mayor was reputed to have requested the governor to "send money or bullets." Realtors and property owners in the Negro community were especially alarmed. Many of them refused to pay taxes to the city. As soon as the tenseness of the situation subsided, the bailiff's office resumed the practice of serving eviction writs and the Unemployed Councils renewed their efforts to frustrate the evictions. As late as 1933 the League of Struggle for Negro Rights moved the furniture of an evicted colored family back into the home. . . .

There was very little building construction in Chicago following 1928, and less on the South Side than elsewhere. New business establishments further decreased the number of living units. Demolition, as noted, took its toll. Between 1934 and 1940 twenty-seven hundred dwellings were lost to the Negro community, thanks to the wreckers' bar and pick.

Meanwhile, families forced from their homes were required, because of restrictive covenants—written agreements between white property owners to refuse to sell or lease their buildings to Negroes—to seek new quarters only within confines of the already crowded area. As Horace Cayton, director of Good Shepherd Community Center, has said: "The Negro's only mobility is within the boundaries of the area of 'concentration.'" In 1930, a member of the Chicago Housing Authority estimated that 80 percent of the city was covered by such covenants.

During the early years of the present century 20 percent of Chicago's Negro population lived in areas where whites constituted 95 percent of the total. The area of greatest concentration

was one in which they comprised between 60 and 69 percent of the total. Thirty years later 90 percent of all the Negroes in the city lived in areas in which they constituted more than 50 percent of the total. Covenants have been far more effective than terrorism.

In order to pay exorbitant rentals and at the same time make ends meet, Chicago Negroes were often compelled to rent rooms. In some instances they rented [out] all sleeping rooms and lived in the dining room or parlor. The Negro home without a "Room to Rent" sign was rare.

Such conditions also perpetuated the kitchenette evil. Large buildings and old mansions were divided into numerous one- and two-room "apartments." A gas burner in the closet and a sink which doubled as wash basin provided the "conveniences." Toilet and bath facilities were the poorest features; usually they were located in a hallway, equally accessible to strangers from off the streets. The Chicago Housing Authority, investigating 140 kitchenette buildings, reported that seven six-flat buildings had been cut up to make 161 small apartments. Other buildings had yielded a proportionate number of smaller units. The survey disclosed that the kitchenette was commonly infested with vice and crime, not to mention rats, mice, roaches, and vermin. Proprietors had often violated laws requiring fire escapes and other health and safety measures. There were blocks where 90 percent of the buildings had been converted into such kitchenette apartments. Yet a survey of seventy-eight kitchenette families revealed that 44.9 percent were spending 31 to 50 percent of their income for rent. It further disclosed that these buildings were let out twice as fast as the conventional flat or apartment building.

The Chicago Negro community did not accept exorbitant rentals without protest. Rent strikes have frequently been threatened. Special committees to hear rental charges have been appointed by the Illinois State Senate and the Chicago City Council. . . .

In 1937 Carl A. Hansberry and Harry H. Pace, Negroes, purchased houses in Washington Park Subdivision. They were instructed to move by court order. The State Supreme Court, to which they appealed, sustained the lower court. However, the United States Supreme Court reversed the state tribunal in 1941. A *Defender* headline joyfully proclaimed: "Hansberry Decision Opens 500 New Homes to Race." The majority of the houses were in excellent condition and rentals had ranged from $55 to $85, a few even higher. As soon as Negroes came in, rents were increased from 25 to 50 percent. Home ownership among Negroes in Chicago has been estimated at 7.4 percent, the percentage being very high in the neighborhoods at the southern extremity of the city. . . .

The Federal Housing Authority has answered some of the pleas of Negroes for adequate housing facilities. In 1933 the State Housing Act made provisions for the creation of the Illinois State Housing Board to consist of seven members appointed by the governor. This board eliminated many of the obstacles preventing local communities from participating in the program established by the United States Housing Act of 1937. In January 1938 the Chicago Housing Authority leased from the United States Housing Authority the Jane Addams Houses, the Julia C. Lathrop Homes, and the Trumbull Park Homes. All three of these low-rent projects accepted some Negro tenants.

In 1941 the Ida B. Wells Homes, a project built expressly for the colored citizens of Chicago, were completed and "Wellstown," the area occupied by the project, extends from 37th Street on the north to 39th Street on the south, and from South Parkway to Cottage Grove Avenue. These modern, fireproof, brick and steel structures comprise 1,662 units, 868 in apartment buildings, and 794 in row houses and garden apartments. Units consisted of from two to six rooms, all equipped with electric refrigerators, modern gas ranges, cupboards, two-part laundry sinks in kitchens, and built-in bathtubs. There is a central heating plant for all the buildings.

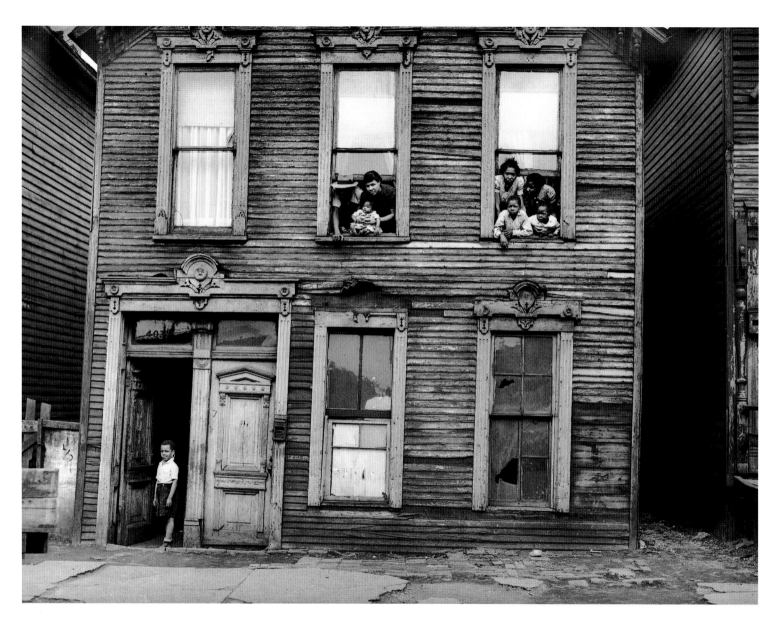

19. House in the Negro section. *Russell Lee, April 1941.*

From Edwin Rosskam, "Pattern for Growing Up,"
FSA/OWI General Caption. RA/FSA/OWI Written
Records.

FINDING A ROOM AND A WAGE

When the Negro family comes out of a sharecropper's existence into the crowded pocket of Chicago's "Black Belt," it faces a complete readjustment of ways of living, of habits, morals, and standards. An interesting index is the commonly seen attempt to grow little vegetable gardens on sidewalks or on empty lots.

[Other] general captions have probably indicated the difficulties the new arrival has in finding a place to live. The following quote from the Tolan Committee Report on Interstate Migration may give an idea about another difficulty—that of finding a job:

Q. Have you been able to get any work in Chicago?

A. Not worth anything. Just a job here and a job there. That is all I have been able to do.

Q. How long would these jobs last?

A. I would probably get one that would last three weeks. Maybe the next one would last a month and like that.

Q. Out of the little over two-and-a-half years you have been here, have you had work half the time, do you think?

A. No. I have not had work half the time.

This witness testified that he had applied for relief; but because of the three-year settlement law required, he had not qualified. He stayed with some friend when he was "broke."

Another (expert) witness stated that many newly arrived migrants from the South seek odd jobs: "A migrant is not accustomed to go to the steel mills or to the meatpacking plants. He just walks down the street looking for a job."

The danger to morals and the whole structure of the family from unemployment and overcrowded slum living is evident. "It is important to note that juvenile delinquency, like infant and adult death rates, is increased where there is the most overcrowding . . ." (Cayton, "Negro Housing in Chicago").

Frequently the social and sex habits of the young are determined entirely by their environment. The same poverty which may lead to crime often leads to casual "common law" marriages based simply on the possession of a room by one party and of a relief check by the other and subject to dissolution the moment either party loses room or wage. Love or affection are thus thrown into the pot which contains the rent money and the food, and the family, brought more or less intact from the rural South, may crack in the squalor and overcrowding of the city.

From Edwin Rosskam, "Recent Immigrants," FSA/OWI
General Caption. RA/FSA/OWI Written Records.

RECENT IMMIGRANTS

This family (photographs 19 through 21) is not untypical of the many which have received recent additions from the South. Two members of the family, husband and wife, came to Chicago some years ago, directly from Arkansas. They have several children. Husband works intermittently on WPA. They are now on either relief or WPA, with the husband's check the family's only income. Within the last year the family was augmented by two of the wife's sisters and their children and by the wife's brother; now there are eleven people living in four rooms, all on the same relief check.

Because of the three-year-residence requirement none of the newcomers have any prospects of any income from public funds for the next two years. Occasionally one of them finds a day's work as a domestic. Yet the older boy is going to high school, making a strenuous effort to improve himself and the lot of his family.

The living room looks decent and clean. The rest of the apartment is in an indescribable state of disrepair, with leaking roof, rat holes in the floor, falling plaster. The place is almost empty of furniture (with the exception of the living room). Broken windows are attached with papers and cartons. The mattress on the one bed on which three children sleep has a gaping hole in it. There is no bath and the toilet is in a bad state from overuse and lack of repair. The landlord refuses all maintenance in spite of a high rent.

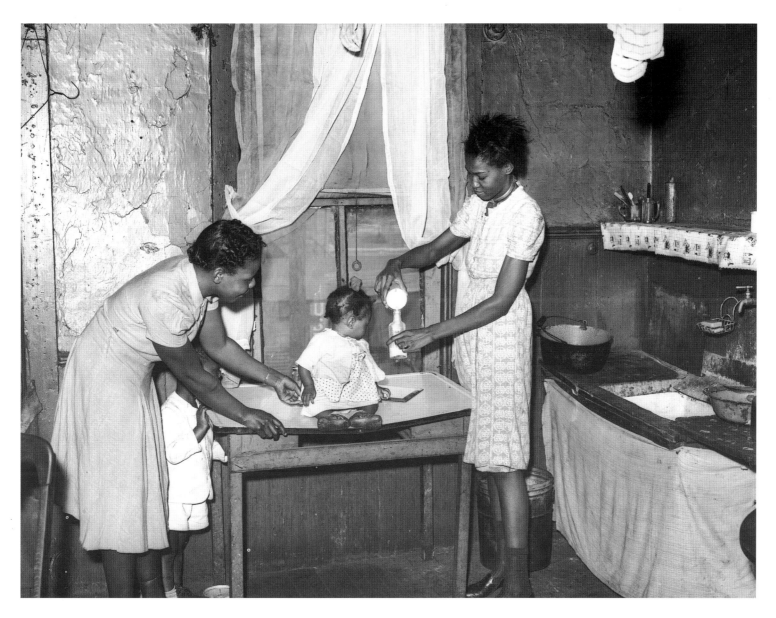

20. Preparing milk for the baby. This family is on relief. *Russell Lee, April 1941.*

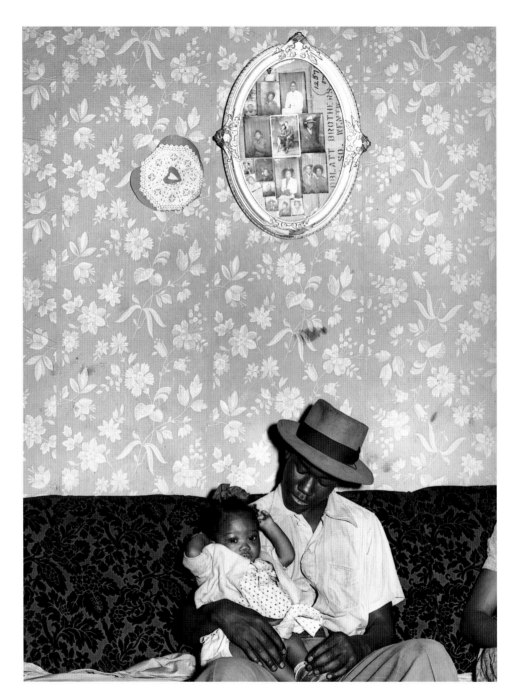

21. Family on relief.
Russell Lee, April 1941.

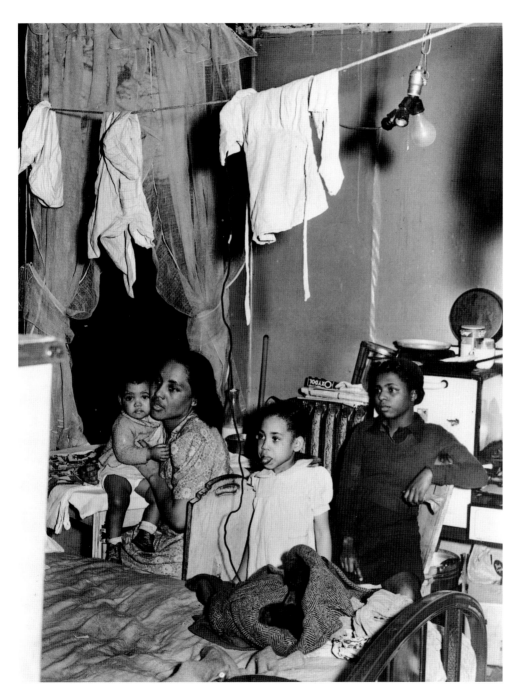

22. Negro family living
in crowded quarters.
Russell Lee, April 1941.

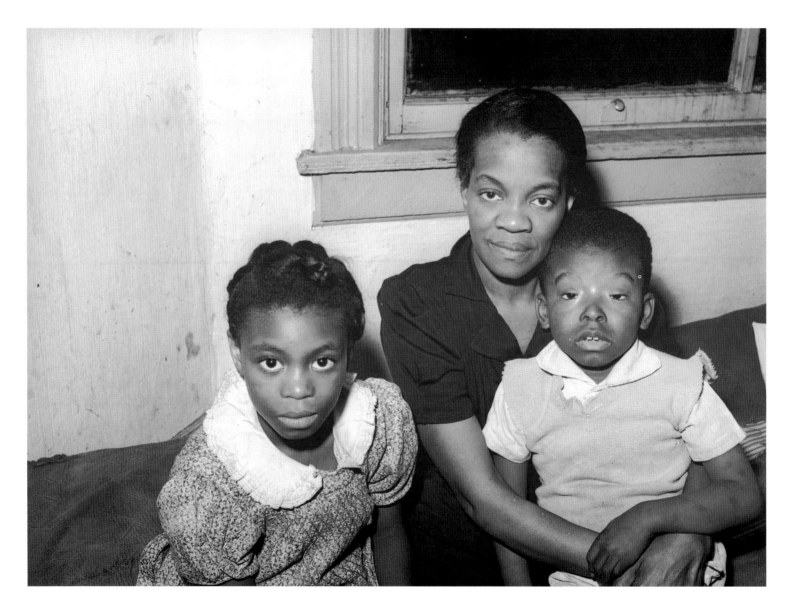

23. Mother and children who are relief clients. *Russell Lee, April 1941.*

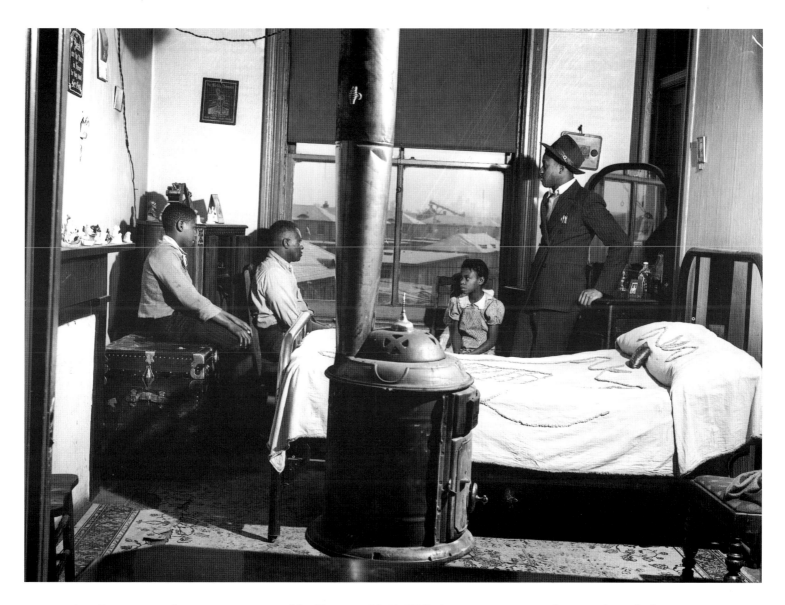

24. Front room of an apartment rented by Negroes. Ida B. Wells housing project can be seen through the window. *Russell Lee, April 1941.*

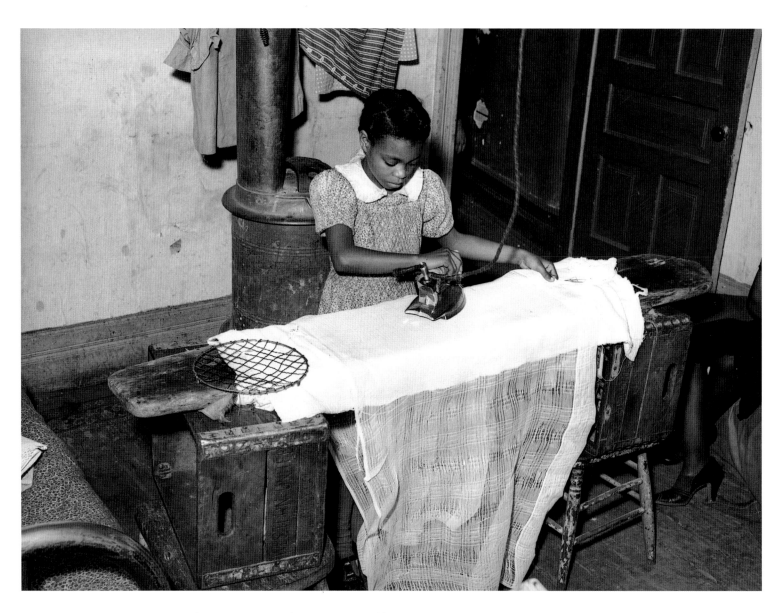

25. Little girl, whose family is on relief, ironing. *Russell Lee, April 1941.*

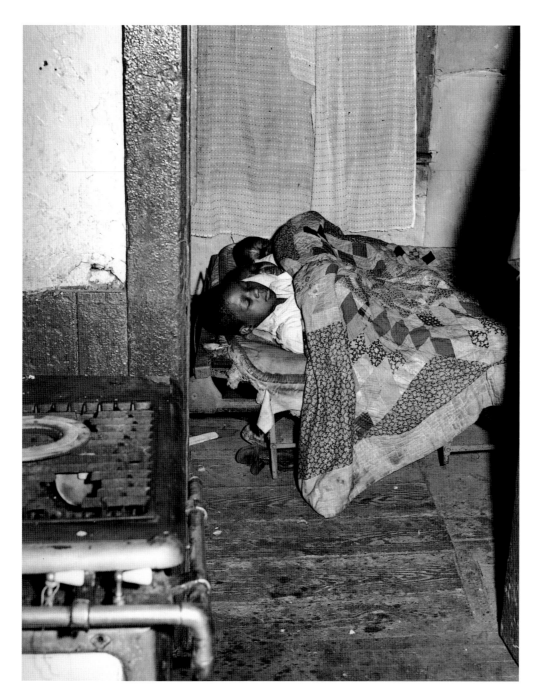

26. Sleeping children.
Russell Lee, April 1941.

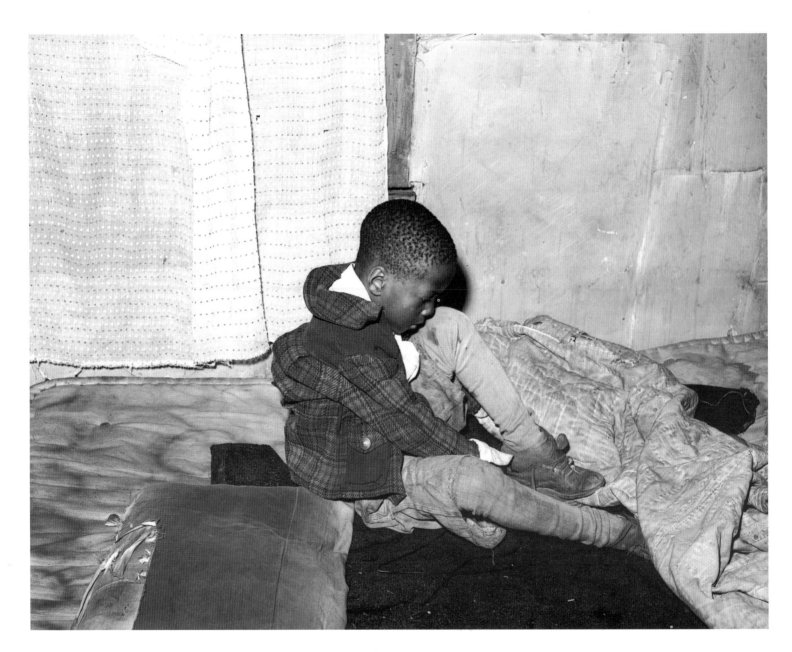

27. Little boy putting on his shoes. *Russell Lee, April 1941.*

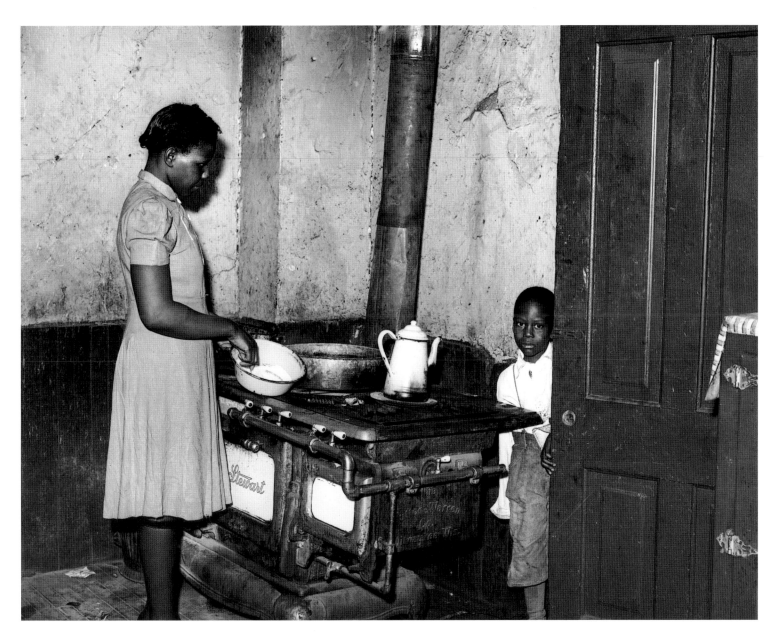

28. Corner of a kitchen of an apartment rented to Negroes. *Russell Lee, April 1941.*

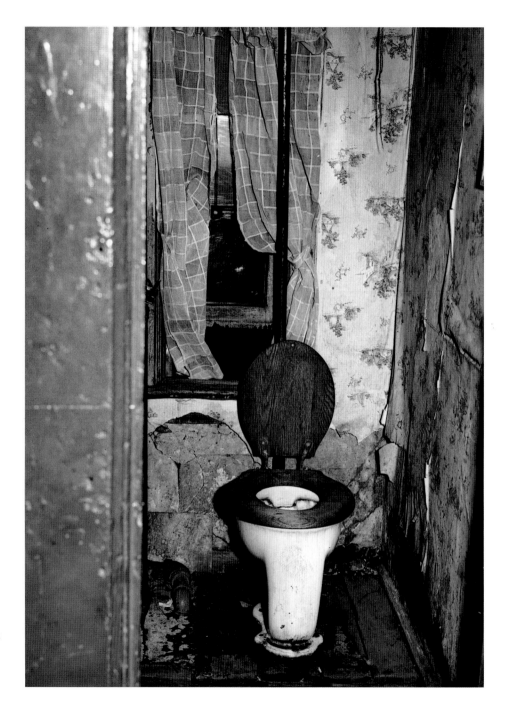

29. Toilet in the home of a family on relief. *Russell Lee, April 1941.*

From Edwin Rosskam, "Relief Family," FSA/OWI General Caption. RA/FSA/OWI Written Records.

RELIEF FAMILY

This family (photographs 31 through 39) is certainly not the only one on relief in this picture coverage. The majority of interiors contain unemployed, many of them on relief or at work for some emergency relief agency such as WPA. This family was selected for more complete coverage because it is fairly typical of families occupying small houses rather than apartments or kitchenettes.

The father, a former house painter, has had no work except occasional WPA work for seven years. He and his wife have nine children. All of them live on the father's relief check. According to Dr. Falls (see "Day of a Negro Doctor") someone in this family is sick continuously. The mother has diabetes. All of the children suffer from some form of malnutrition resulting not so much from undernourishment as from the unbalanced diet. Says the mother: "How am I going to buy meat and green vegetables for eleven on one relief check?"

The house, a small wooden two-story frame building, is in extreme state of disrepair. Four children sleep in two beds in an attic under the roof where the plaster has peeled off and the rain pours in. Rats and vermin are as common to this house as they are to kitchenettes and tenement apartments.

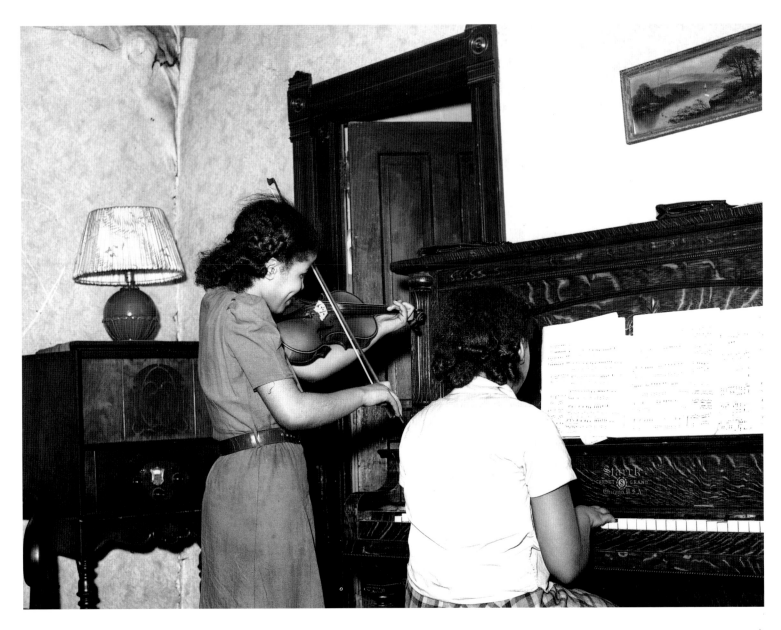

30. Children of a family on relief. *Russell Lee, April 1941.*

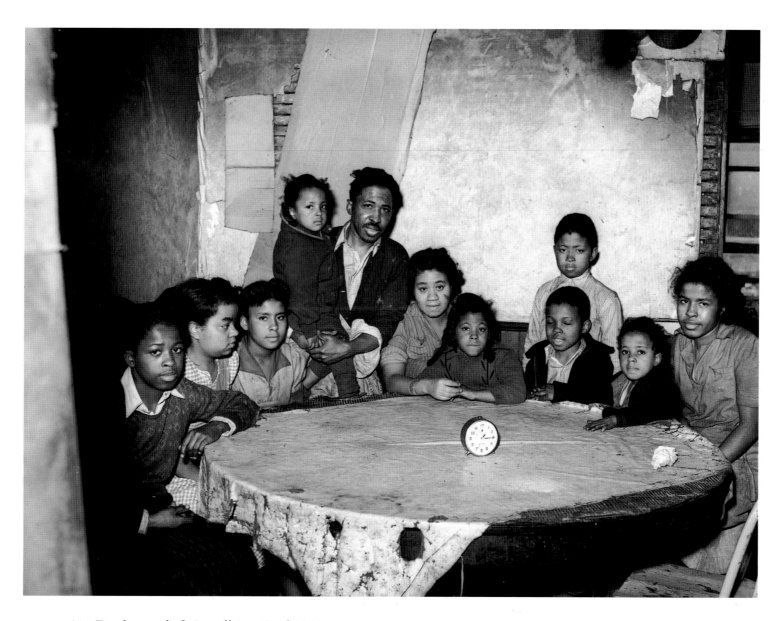

31. Family on relief. *Russell Lee, April 1941.*

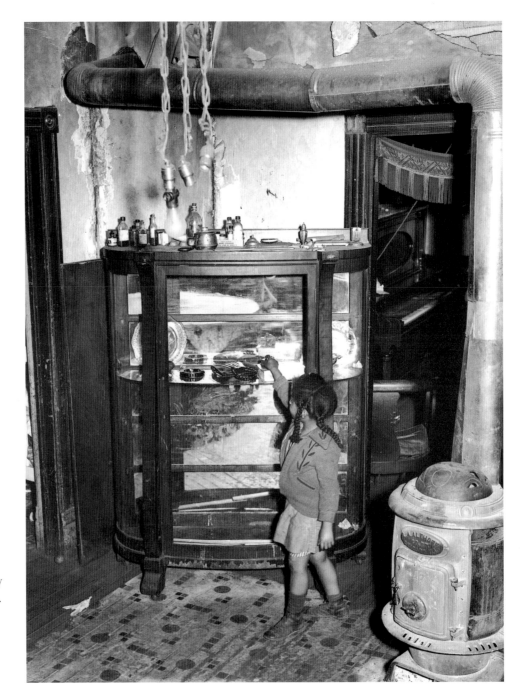

32. Dining room of a Negro family on relief. *Russell Lee, April 1941.*

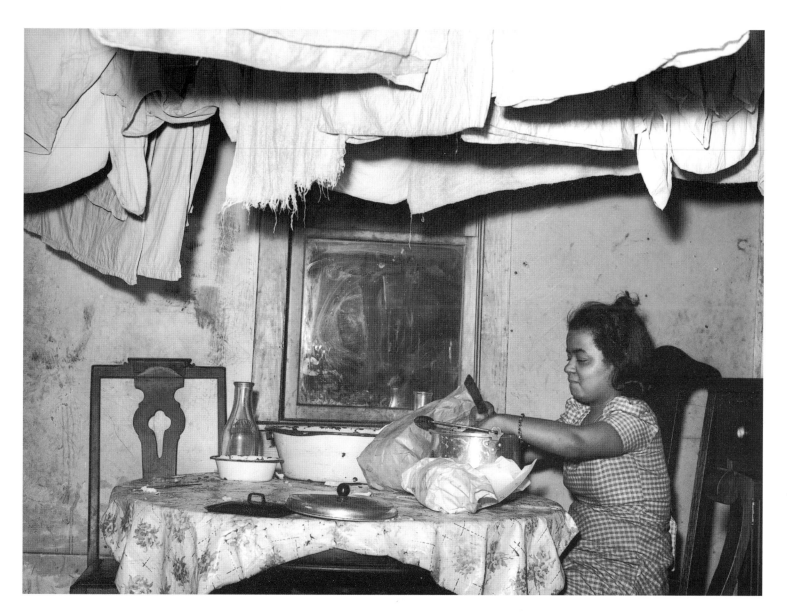

33. Preparing the evening meal in the home of a family on relief.
Notice the laundry hanging near the ceiling. *Russell Lee, April 1941.*

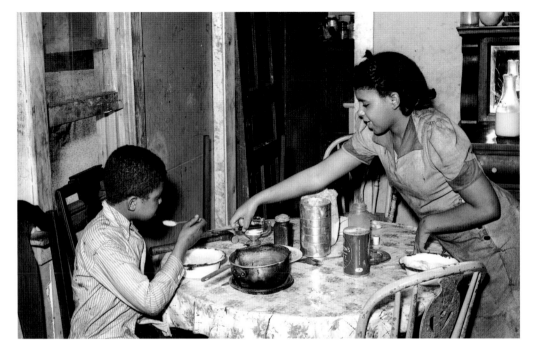

34. Children that are members of a family on relief.
Russell Lee, April 1941.

35. Children eating biscuits. This family is on relief.
Russell Lee, April 1941.

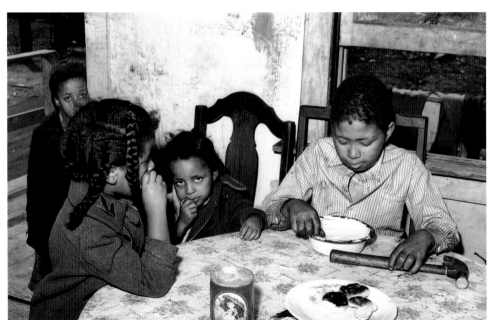

37. Home in the Negro section.
Russell Lee, April 1941.

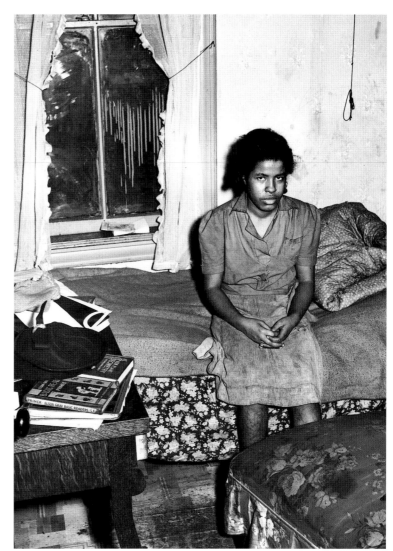

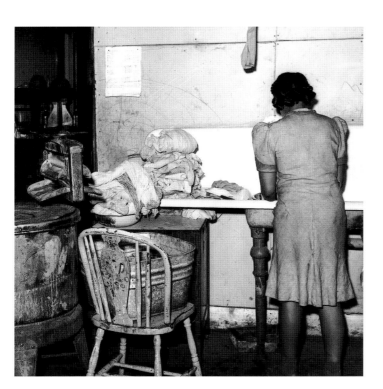

36. Wash day of a family on relief. *Russell Lee, April 1941.*

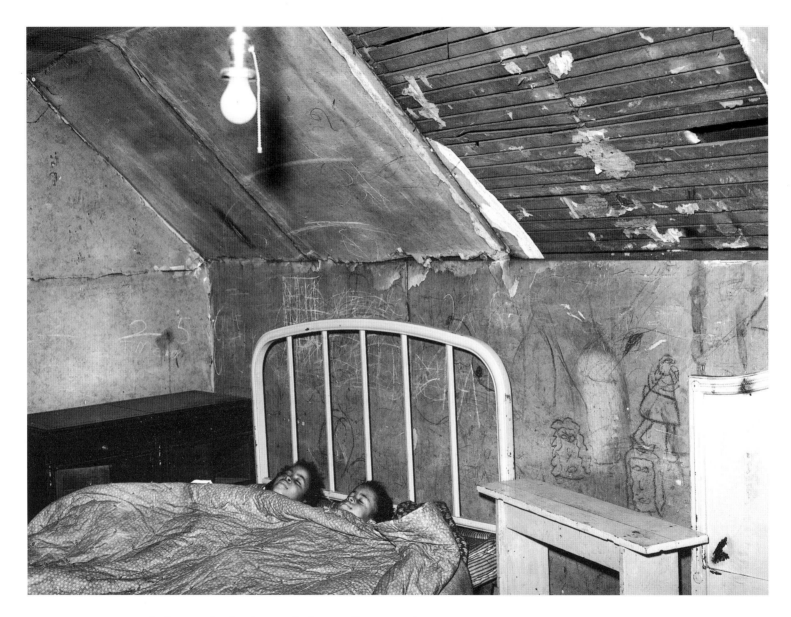

38. Upstairs bedroom of a family on relief. *Russell Lee, April 1941.*

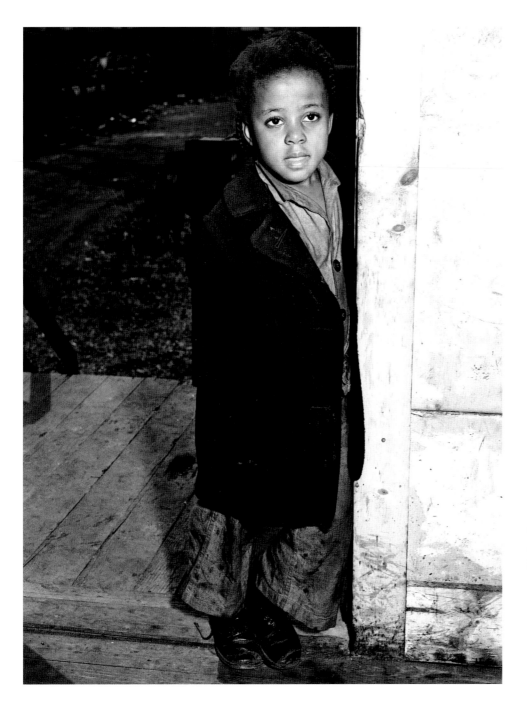

39. Little girl standing in the doorway of a family on relief. *Russell Lee, April 1941.*

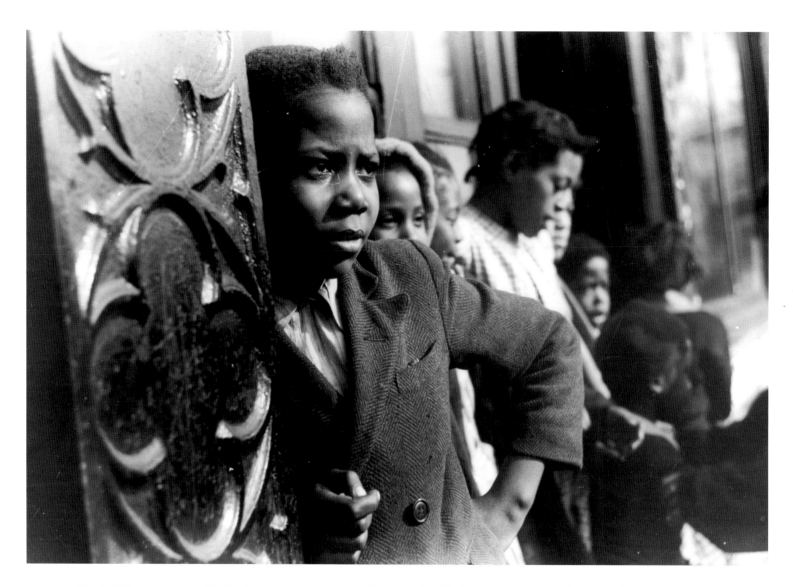

40. Children in front of a kitchenette apartment building in the Black Belt. *Edwin Rosskam, April 1941.*

41. Black Belt. *Edwin Rosskam, April 1941.*

From Edwin Rosskam, "The Day of a Negro Doctor,"
FSA/OWI General Caption. RA/FSA/OWI Written
Records.

A DOCTOR'S DAY

This coverage is the result of a day spent with a Negro doctor of high standing, a staff member of Provident Hospital and a general practitioner. Like most Negro doctors he finds himself financially unable to devote himself exclusively to his specialty, general surgery. A great majority of the clients are relief cases, and the remuneration from such a practice is barely enough to keep him going. There is a thin sprinkling of upper- and middle-class Negroes in this clientele (from $1,500 to $4,000 annually) and a few white patients. According to him, white doctors in the Negro neighborhood offer intense competition.

For the difficulties of the Negro professional the following quotation from "Races and Ethnic Groups in American Life" by Woofter will give an idea: "Negro physicians have considerable difficulty in finding suitable places for internship. The one hundred graduates each year are practically forced to choose from among the ten Negro hospitals approved by the American Medical Association, all of which are limited in size and facilities. Once engaged in private practice the Negro physician comes in competition with the white doctor who is making an effort to attract Negro trade. Sometimes the less-educated people of his own race prefer a poorly trained white man to a well-trained Negro doctor. The mass of people are so poor that outside of the large cities the Negro practitioner can scarcely hope to make an adequate living."

The conditions with which a Negro doctor in Chicago, or for that matter in any large city, must deal are contained in the following quotations: "The incidence of illness in the Negro section is greater than in any other section of the city. . . . All diseases which result from filth and overcrowding may be said to flourish here. The infant mortality rate is 2 to 1 as compared to other sections of the city" (Doctor John W. Lawlah, Medical Director of Provident Hospital, from Cayton: "Negro Housing in Chicago").

"Tuberculosis is known to attack without any racial preferences. The small differences observed among the various divisions of mankind in regard to their liability to tuberculosis are traceable to social and economic causes" (Fishberg, pulmonary tuberculosis). "It has been found that infant mortality is especially sensitive to the economic status of the parents. Race apparently has little effect. . . . Certain measurable conditions were found to accompany mortality above the average. Included were low-earning power of the family, employment of mothers away from home during pregnancy or the early months of an infant's life, housing below standard in point of sanitary equipment and room congestion, short intervals between births, and the bearing of many children" ("Races and Ethnic Groups in American Life" by Woofter).

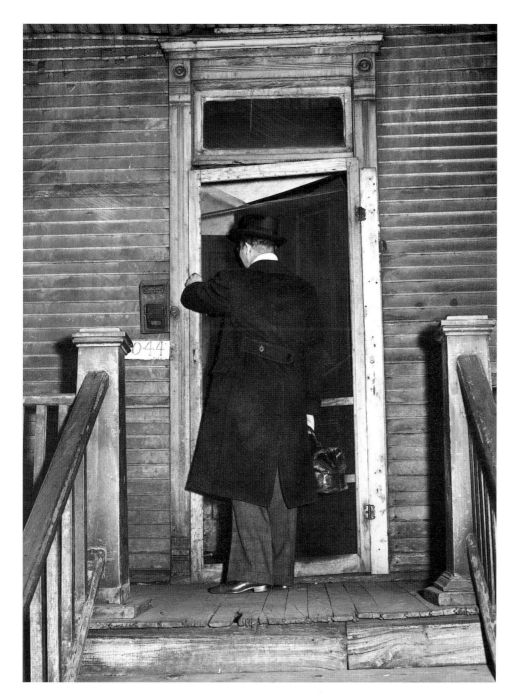

42. Doctor [Arthur G. Falls] entering
the home of a family on relief.
Russell Lee, April 1941.

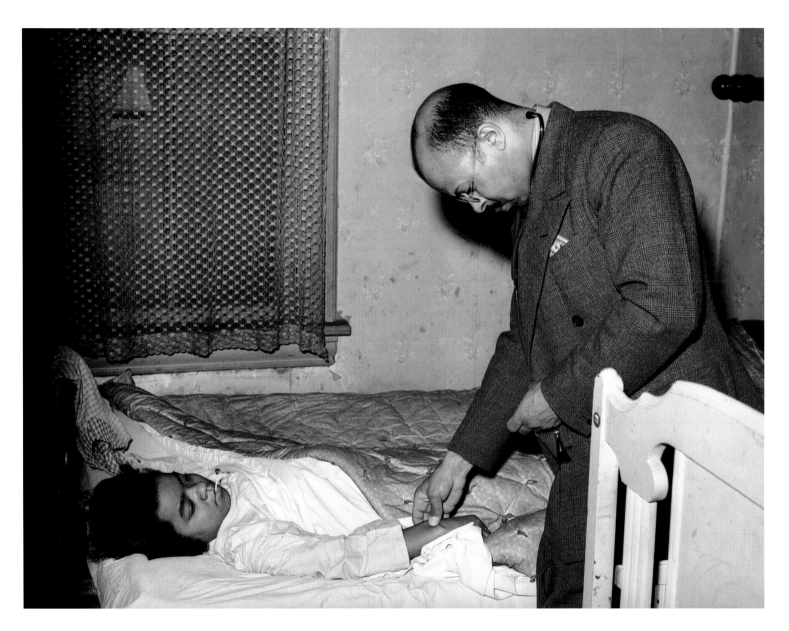

43. Doctor examining a patient in her home. The patient is on relief. *Russell Lee, April 1941.*

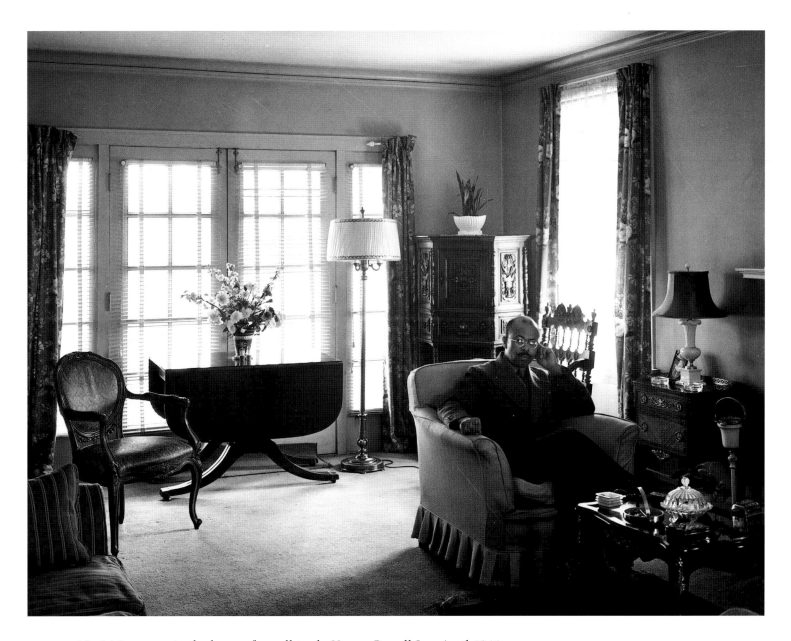

44. Living room in the home of a well-to-do Negro. *Russell Lee, April 1941.*

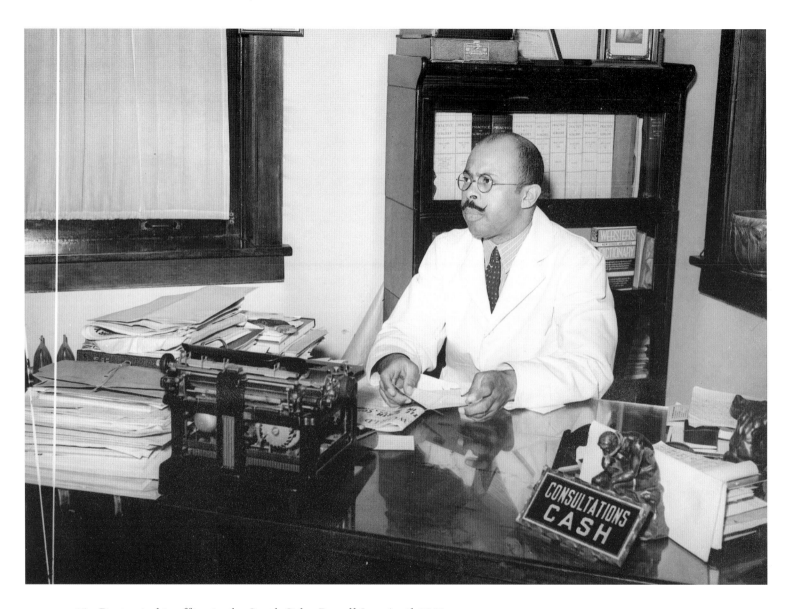

45. Doctor in his office in the South Side. *Russell Lee, April 1941.*

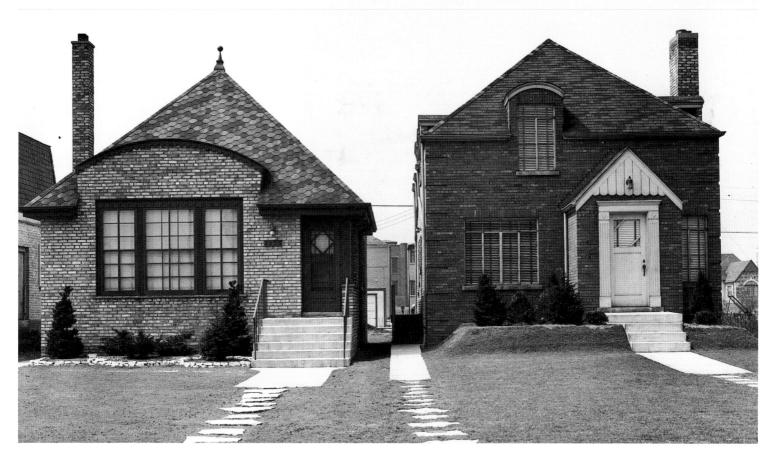

46. New houses built by Negroes in a better residential section of the South Side. *Russell Lee, April 1941.*

47. On a Sunday afternoon at home, [musician] "Red" [Saunders] and his wife read the comics to their children and puppy whose name is "Blitz." *Jack Delano, April 1942.*

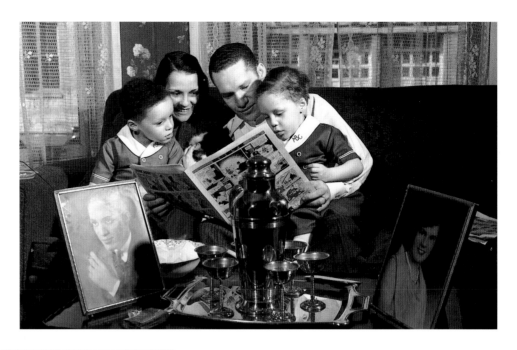

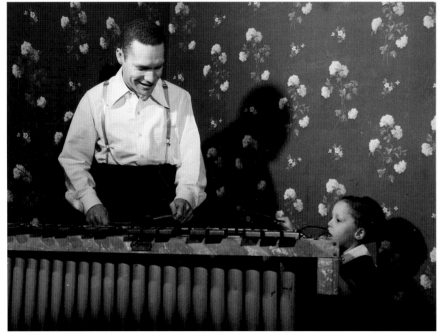

48. At home, "Red" practices on the vibraharp with the assistance of his son Edmund. *Jack Delano, April 1942.*

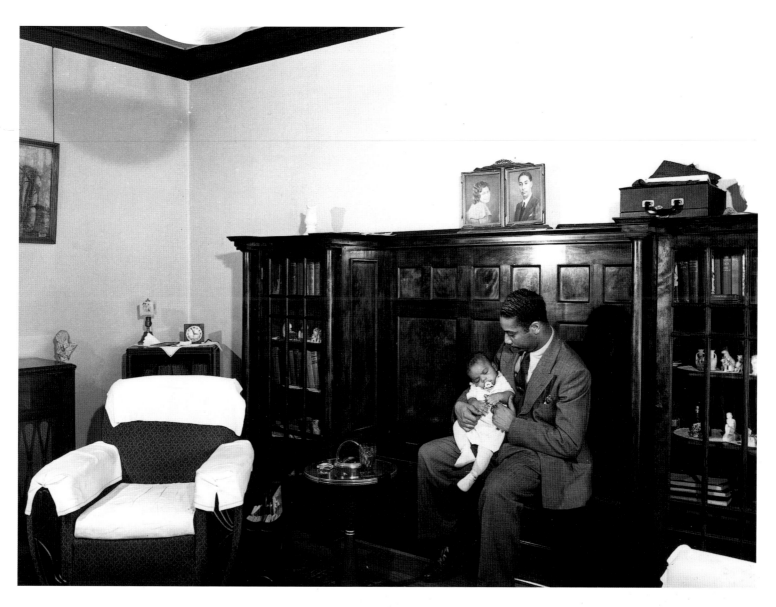

49. [Musician] Oliver Coleman with his five-month-old son, in the living room of his apartment on Indiana Avenue. *Jack Delano, April 1942.*

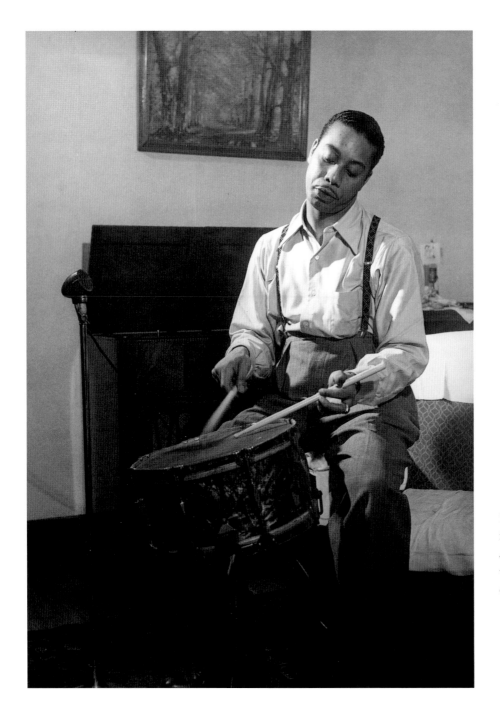

50. Oliver Coleman has apparatus for recording in his home on Indiana Avenue. He uses it to record the work of his students and his own drumming. *Jack Delano, April 1942.*

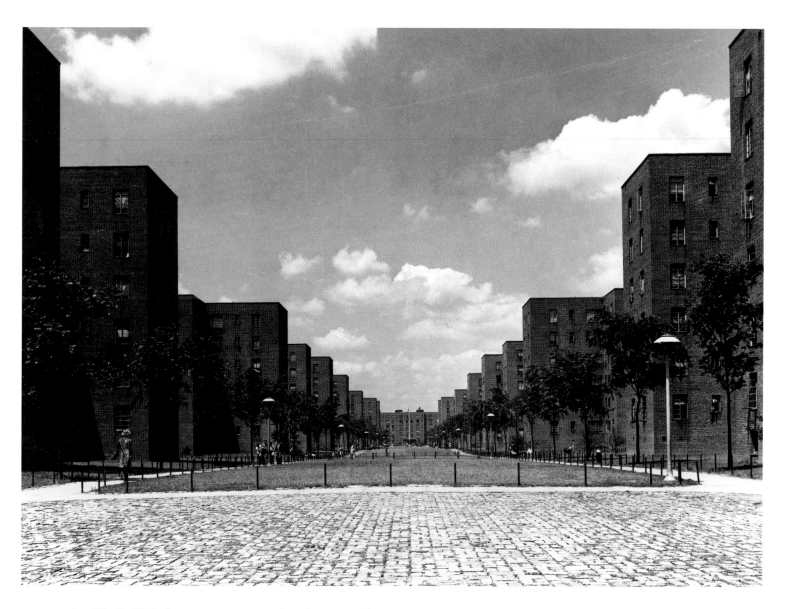

51. Ida B. Wells housing project. *Jack Delano, March 1942.*

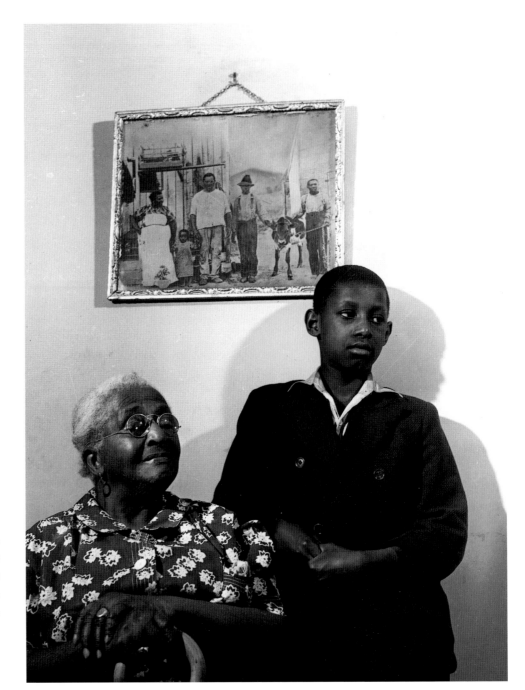

52. Ida B. Wells housing project. Mrs. Ella Patterson, 102 years old, the oldest resident at the project, and her great-grandson. *Jack Delano, March 1942.*

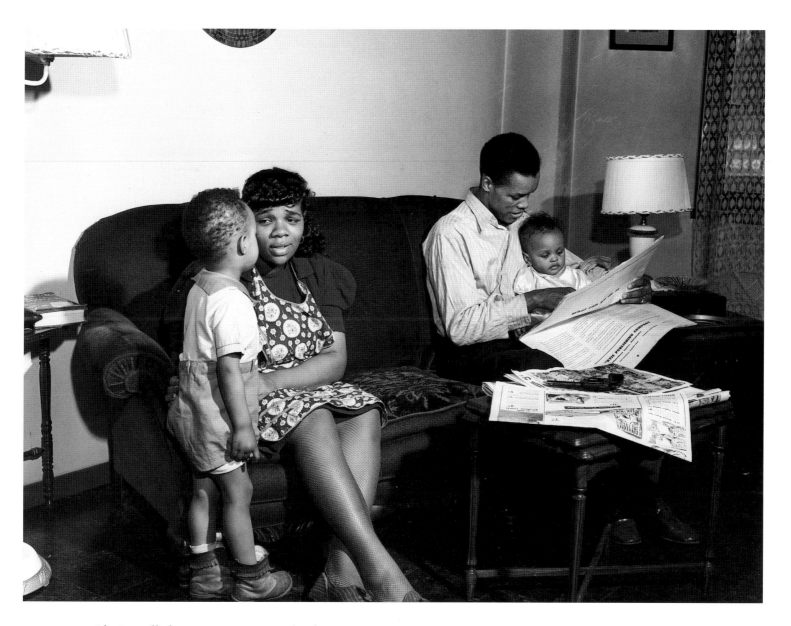

53. Ida B. Wells housing project. Family of Mr. Edward Vaughn, living in one of the apartments.
Mr. Vaughn is doing work for the War Department. *Jack Delano, March 1942.*

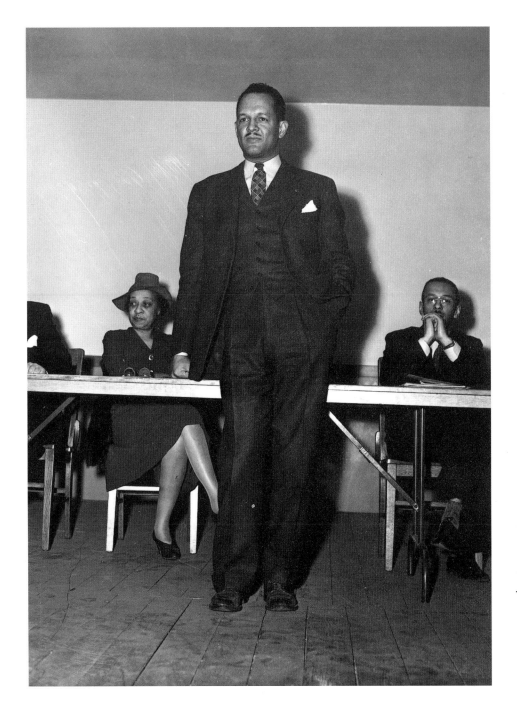

54. Ida B. Wells housing project.
Mr. Shaw, superintendent.
Jack Delano, April 1942.

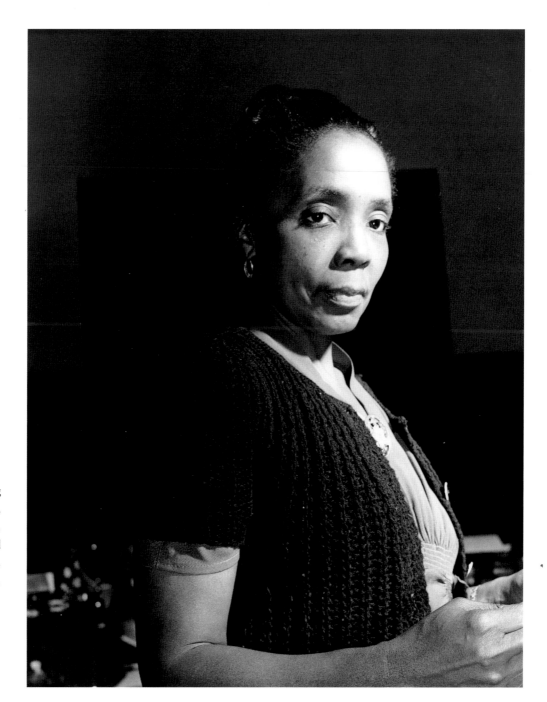

55. Ida B. Wells housing project. Mrs. Hallie L. Mills, editor of the *Community News,* the newspaper published by and for the tenants. *Jack Delano, March 1942.*

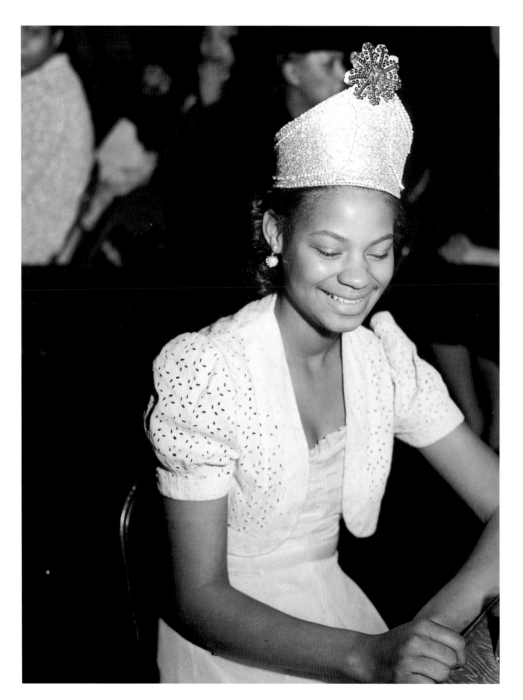

56. Ida B. Wells housing project.
Queen of Wellstown.
Jack Delano, March 1942.

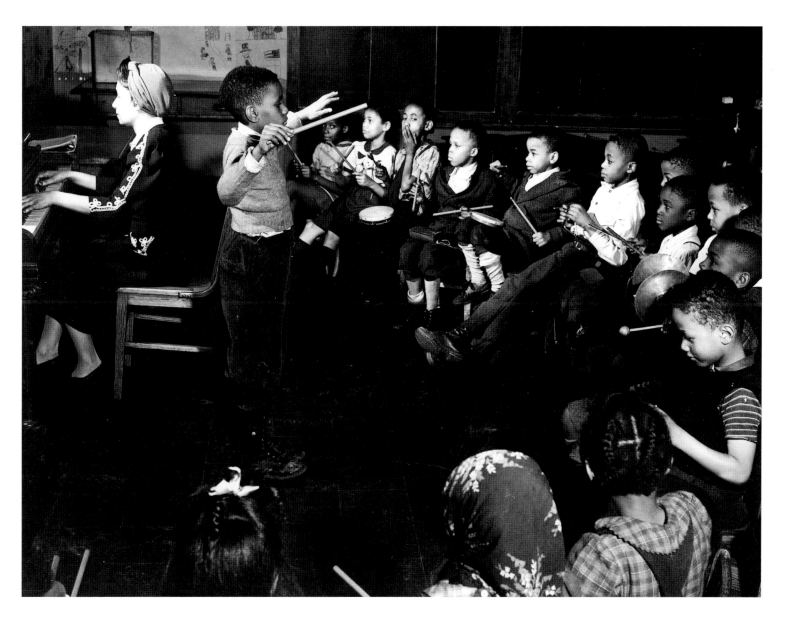

57. Ida B. Wells housing project. A children's rhythm band in a music class. *Jack Delano, March 1942.*

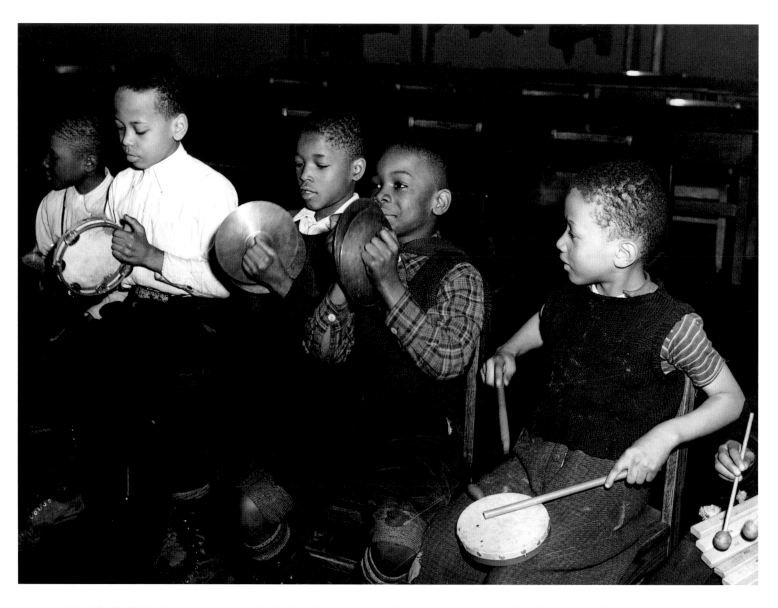

58. Ida B. Wells housing project. A children's rhythm band in a music class. *Jack Delano, March 1942.*

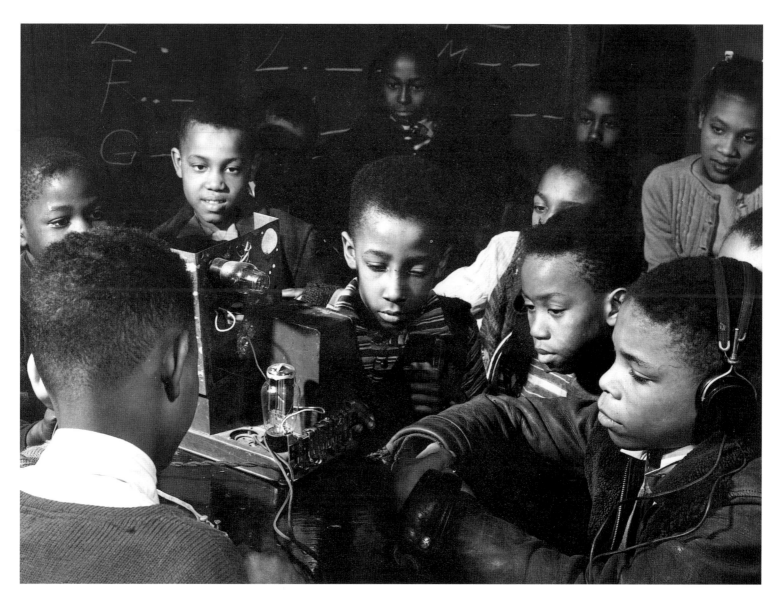

59. Ida B. Wells housing project. A class in radio for youngsters. *Jack Delano, March 1942.*

60. Ida B. Wells housing project.
Jelna Carr, age 13, mayor of
Wellstown and president
of the youth government.
Jack Delano, March 1942.

61. Little girl at a nursery.
Russell Lee, April 1941.

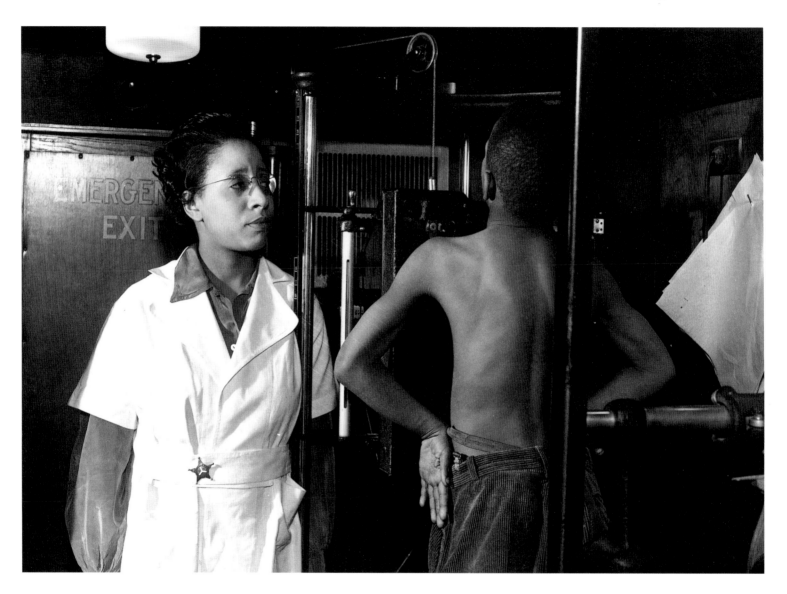

62. X-ray clinic at the hospital of the Ida B. Wells housing project. Miss Marion Rhodes, a graduate nurse from Meharry Medical College, Nashville, Tennessee, assisting in the X-raying of one of the children in the project. *Jack Delano, March 1942.*

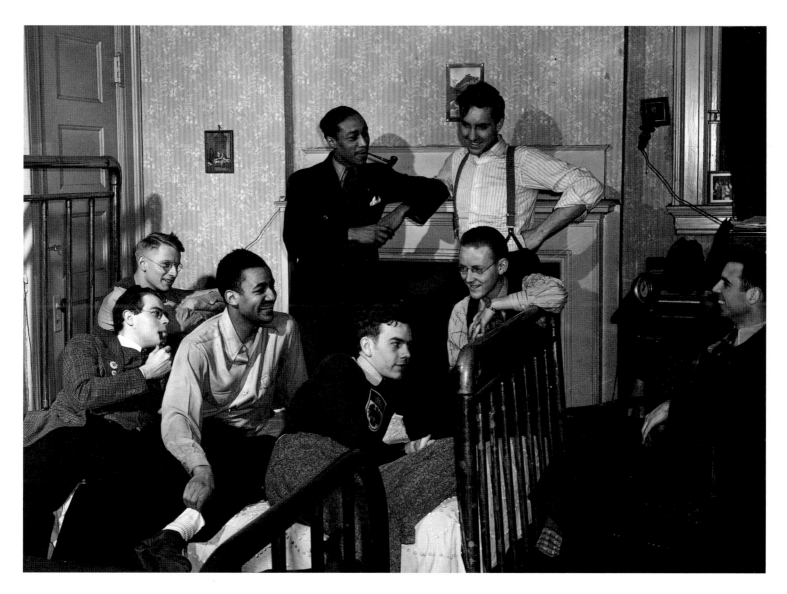

63. A group of young men, most of them students at the University of Chicago,
who live cooperatively in a large house. *Jack Delano, April 1942.*

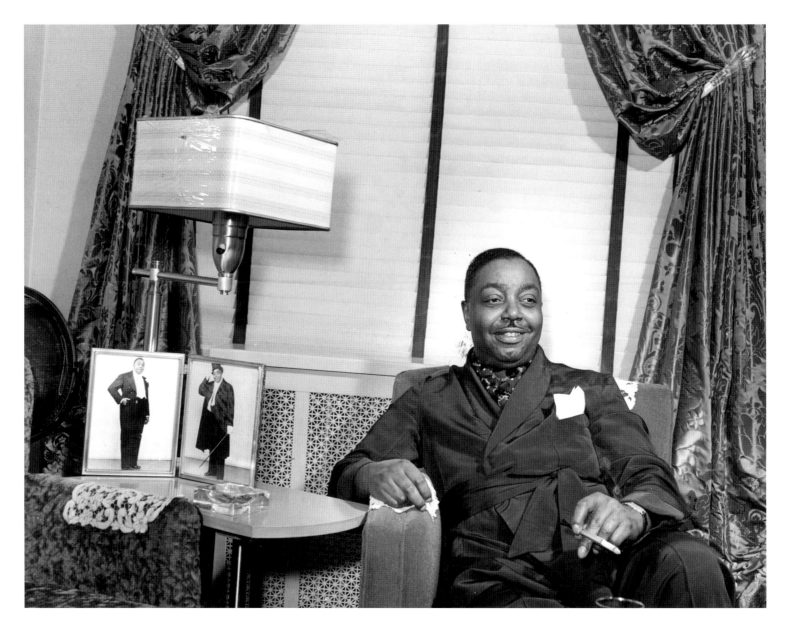

64. A prosperous Chicagoan [Reverend Clarence Cobb] spending an evening at home. *Russell Lee, April 1941.*

Part Two

WORK

From Grace Outlaw, "Negro Business in Chicago,"
Federal Writers' Project: Negro Studies Project.

BUSINESSES: BEAUTY, BURIAL, BUILDING, AND BEN FRANKLIN

Negro business in Chicago has increased in the past three years. It has not reached the peak of 1929, but is progressing rapidly. Strangely enough, the Depression had much to do with the increase in business. Because the Negro is usually "first to be fired and last to be hired" in an economic crisis, he was forced to use his initiative to survive.

A survey made by the United States government in 1936 revealed interesting facts regarding Negro business enterprises started since 1929. Among other things it was learned that the Negro had become engaged in such small business as collection of junk, peddling vegetables, selling from door to door various articles like hosiery, lingerie, dresses, cosmetics, etc. Another popular type of business is barbecue stands, many of which were made from old boxcars, discontinued streetcars, even pushcarts assembled from varied sources. A few boot black stands were started but had not proven very successful. Small coal and ice dealers are still numerous.

One of the most lucrative fields for women, especially, is beauty parlors. Every community has an ample supply of competent beauty operators.

Two large beauty schools, nationally known and established in the major cities of the country, are located in Chicago. One is Poro College, established by Mrs. Anna Malone, formerly of St. Louis, Missouri, now of Chicago. The other is the Mme. C. J. Walker College of Indianapolis, Indiana. Mrs. Malone has moved her business from St. Louis to Chicago. The latter is her main plant, while the main plant of the C. J. Walker Company is still in Indianapolis. However, the latter has a very large school in Chicago and students attend from all over the country. Graduates from these two schools establish themselves in and out of Chicago, but Chicago offers the greater opportunity for them, because of the large number of Negroes in the city. There are smaller schools of beauty culture, but [they] are not as widely known or patronized.

The undertaking business is a very good business among Negroes. There are many men engaged in this field and a few women. Outstanding in this field are W. T. Brown, Charles Creek, and the Jackson Funeral Home. The latter is the oldest undertaker in Chicago. Three generations have conducted the business. The W. T. Brown establishment is the most modern in equipment and furnishings. The Charles Creek Funeral Home is about on the same level.

A rather new business among Negroes in the past ten years is burial associations. Many undertakers have organized this form of business and have found it very remunerative. Other undertakers not so organized have persistently fought these organizations, but to date they have not succeeded in putting them out of the business.

The burial association is something like an insurance. There are no monetary death benefits but the deceased is guaranteed a burial up to a certain amount according to the amounts paid weekly. This form of business has met with popular approval and is a thriving one.

There are many restaurants operated by colored folk and a few are outstanding. Morris Eat Shop located at 408–10 East 47th Street has recently enlarged their place. The modernistic scheme in furnishings and decorating is very unique. The food is excellent and the place is immaculately kept. It is by far the most popular eating place on the South Side. The Palm Tavern dining room is also a very well-patronized eating place. The Poro Dining Room is recognized for its atmosphere and good food.

Employment bureaus among the group are successful but not so numerous. There are very few grocery stores in comparison with the number of Negroes in the city. At one time there was a large number of drug stores operated by Negroes, but at the present time there are a very few. One finds Negro workers in almost every place of business on the South Side where there are many Negroes in the community. This condition was brought about by a campaign fostered by a Negro newspaper, urging the Negroes to ask employment of the merchants in their immediate neighborhoods. The plan was very successful.

There are a few rather successful building contractors in the group. Outstanding among them are the firm of Rousseau and Douglass.

One Negro architect, Charles Duke, now serves on the housing committee of the Federal Housing Program.

The manufacture of cosmetics is not a very popular business but there are several such concerns, outstanding among them is the Overton Hygienics Company, which has been in the business for more than forty years. Marguerita Ward cosmetics have been on the market for the past twenty years and the woman who manufactures the articles has lived to see them become recognized. Mme. Marguerita Ward, as she is known, has had the tenacity to hold on to her product and believe in its ultimate success.

The only business of its kind in Chicago owned and operated by a Negro is the White Paper Company, located at 206 East 49th Street. They manufacture all kinds of wrapping paper, paper bags, letterheads, every kind of paper, and they also convert paper and make wrapping cord; the only Negro firm to have so complete a paper plant. Their equipment is all modern and there are large, five-ton trucks to deliver material. There is a personnel of ten regularly employed with added personnel when the business demands. The business has thrived and is outstanding in its field. There is no other Negro firm like it or as thoroughly equipped.

There are three successful hotels operated by Negroes but the property is owned by them only in the case of the Vincennes Hotel. The latter was at one time purchased on contract by Mrs. E. Barnett but was later placed in the hands of receivers. She has, however, maintained her position as manager of the hotel and in the past five years has made the place popular again. The Grand Hotel is operated by a colored man and is one of the most successful hotels in the city.

Small dress shops and millinery stores have been operated by colored women for some time but none of them are especially outstanding.

The latest and most elaborate business development on the South Side is the Jones brothers' Ben Franklin Store, selling articles from five cents to a dollar. It is located at 436–44 East 47th Street. The building, formerly the Bowman Milk Dairy,

was purchased by the Jones brothers, thoroughly renovated, and modernly equipped with the best and most elaborate fixtures. The soda fountain alone is said to have cost $10,000. This store gave employment to nearly sixty people.

It is a new field for Negroes and is being watched with keen interest. The entire personnel is colored except the general manager, who is to serve for one year with a Negro man acting as an assistant. The latter is to become the manager at the expiration of the year.

From 1922 to 1931 there were two well-organized Negro banks, one a Federal Reserve Bank. These banks failed along with many others during the most serious part of the economic depression. Both have paid regular dividends since being in receivership.

Two old-line legal-reserve insurance companies survived the Depression, namely the Victory Life Insurance Co. and the Supreme Liberty Life Insurance Co. They are each housed in their own buildings and are progressing nicely.

Real estate dealers were rather numerous among Negroes from about 1920 to 1928 but there are only about five real firms now in operation. Many Negroes are operating kitchenette businesses in rented property with much success. Since housing is a problem in the district, this is a profitable business.

There are three weekly newspapers published by Negroes. The leading paper from the point of circulation and advertising is the Chicago *Defender,* published by the Robert S. Abbott Publishing Co., at 3435 Indiana Avenue. The other papers are the Chicago *Bee* and the Chicago *World.*

Recently many Negroes have opened cleaning and pressing shops with much success.

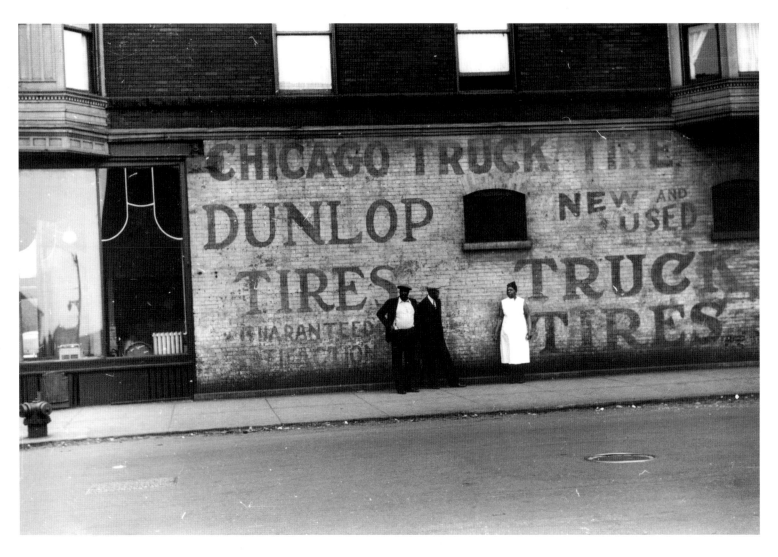

65. Black Belt. *Edwin Rosskam, April 1941.*

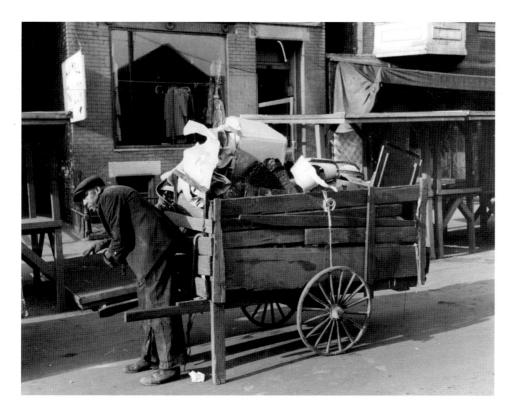

66. Junk cart on the South Side. *Russell Lee, April 1941.*

From Fenton Johnson, "A Negro Peddler's Song," Heritage Press Collection, Harsh Collection.

PEDDLER'S SONG

The pattern of this song was sung by a Negro peddler in a Chicago alley.

Good Lady,
I have corn and beets,
onions, too, and leeks,
and also sweet pota-ty.

Good Lady,
buy for Mary and John—
and when the work is done
give a bite to Sadie.

Good Lady,
I have corn and beets,
onions, too, and leeks,
and also sweet pota-ty.

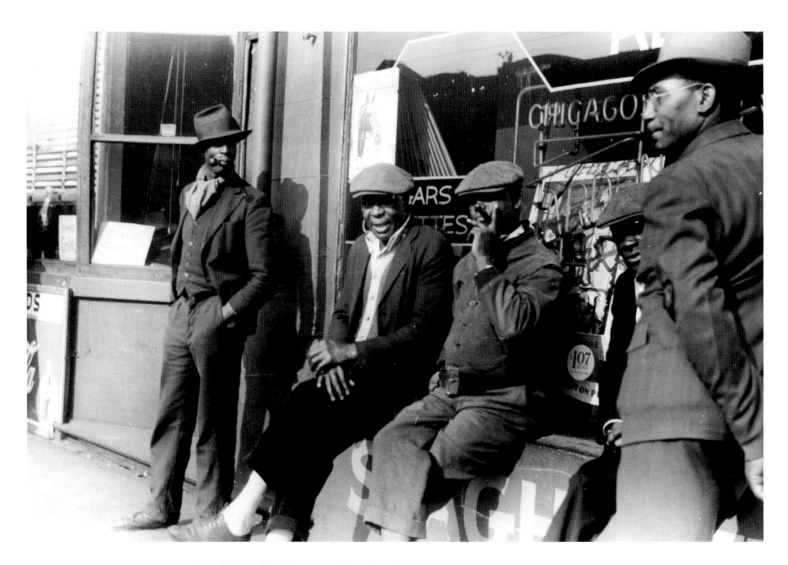

67. Street corner in the Black Belt. *Edwin Rosskam, April 1941.*

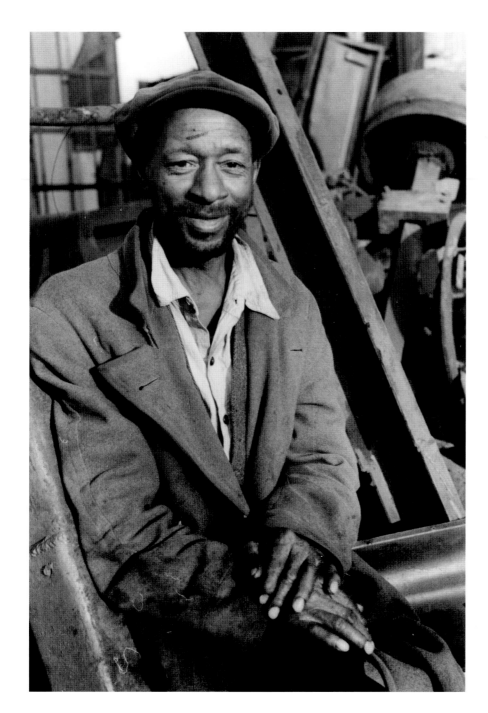

68. Resident of the South Side.
Russell Lee, April 1941.

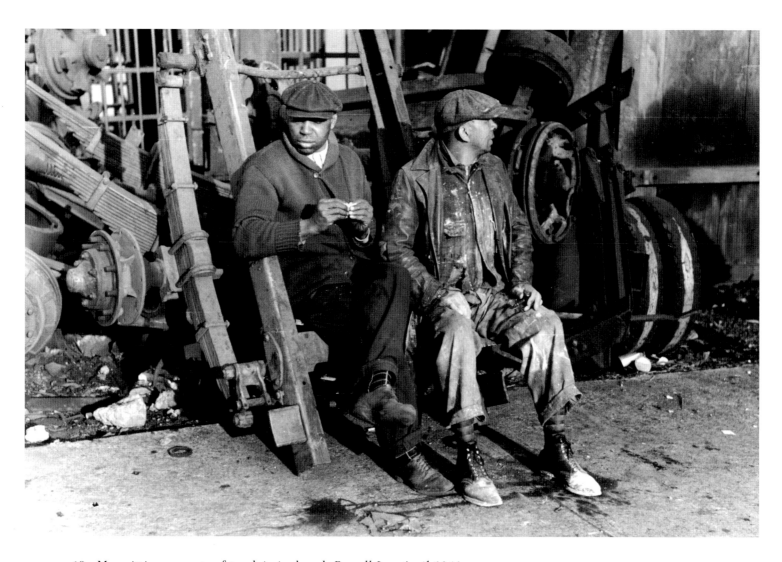

69. Men sitting on parts of truck in junkyard. *Russell Lee, April 1941.*

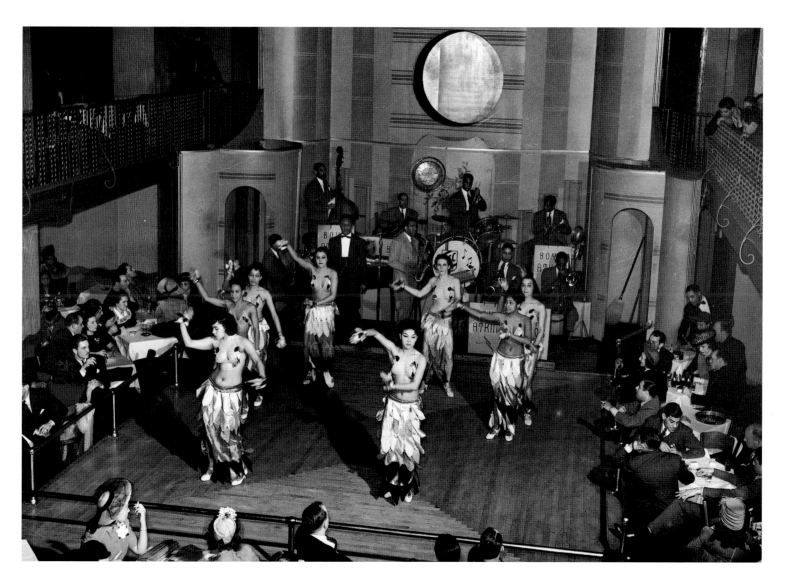

70. Negro cabaret. *Russell Lee, April 1941.*

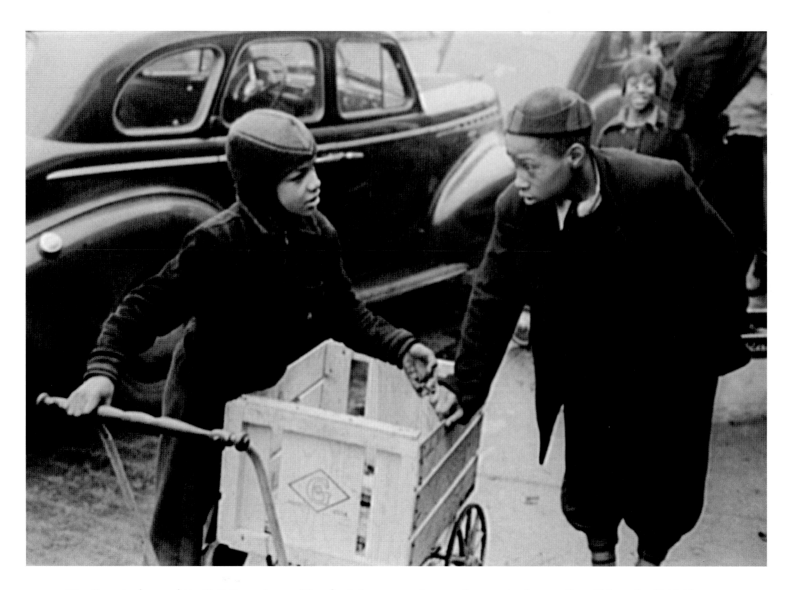

71. Boys in front of the A & P market waiting for jobs to cart shoppers' groceries home. *Russell Lee, April 1941.*

72. South Side. *Russell Lee, April 1941.*

73. Untitled. *Edwin Rosskam, April 1941.*

74. Activity around newsstand on street corner.
Russell Lee, April 1941.

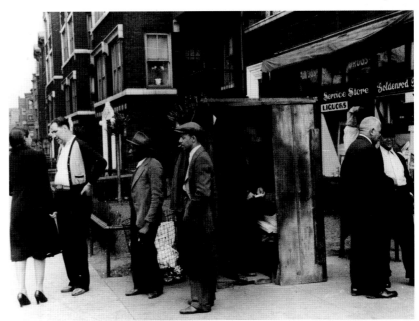

From [author unknown], "Number of businesses operated by Negro and white proprietors on 47th Street between State and Cottage Grove, 1938," "Negro in Illinois" Papers, Harsh Collection.

BUSINESSES ON 47TH

Number of businesses operated by Negro and white proprietors on 47th Street, between State and Cottage Grove, 1938.

	Negro	White
Food stores	3	45
Business services	4	15
Automotive	1	3
General merchandise	1	16
Clothing stores	8	49
Furniture and household appliances	0	15
Hardware stores	0	4
Prepared food	8	13
Drug stores	0	9
Other retail stores	7	22
Personal service	42	36
Bookies	1	1
Repair services	2	7
Miscellaneous	6	2
Totals	**83**	**237**

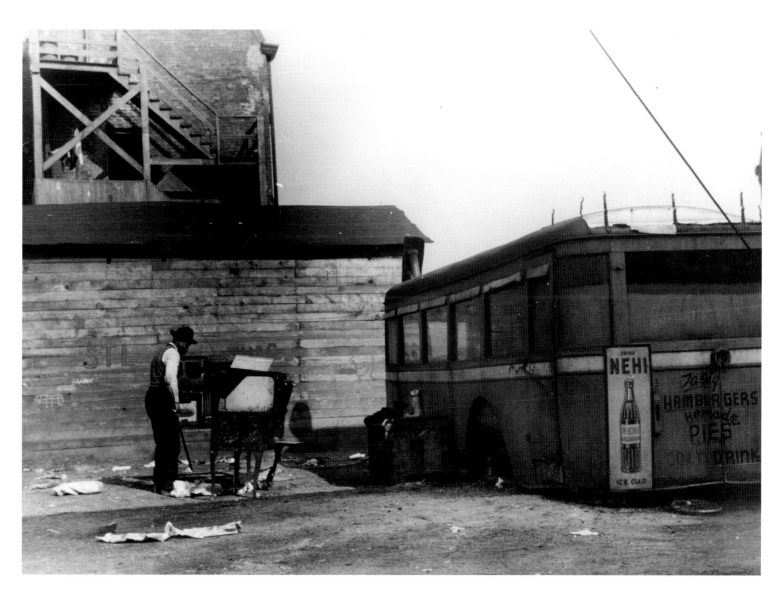

75. Lunch wagon for Negroes. *Edwin Rosskam, April 1941.*

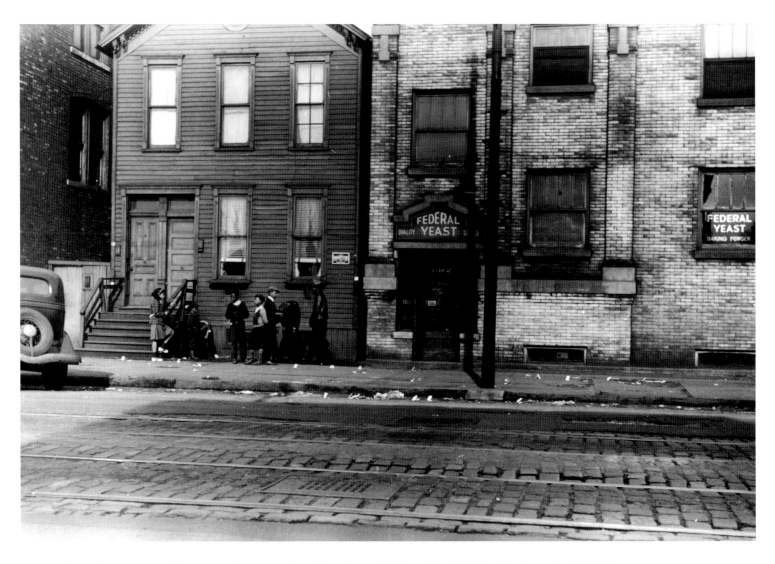

76. Street scene. The papers littering the sidewalk are "policy slips." *Edwin Rosskam, April 1941.*

From H. Clayton, "Local Policy Barons," and "Miscellaneous Facts About Policy," "Negro in Illinois" Papers, Harsh Collection.

MISCELLANEOUS FACTS ABOUT POLICY

1. On the South Side there are reputed to be about 4,200 policy stations.

2. About 15,000 persons make a living off of policy.

3. Odds on the game are said to be 7,776 to one.

4. It is estimated that nearly 100,000 persons play policy on the South and West Sides.

5. According to records on file in the office of Attorney General Homer S. Cummings, one city policy operator takes in annually $2,016,000, of which 30 percent is profit, from the wheels, $70,080 from policy stations, and $36,800 in rents, exclusive of the proceeds of a chain of fourteen handbooks allegedly owned by him.

6. Julius Benvenuti was the first policy operator in the history of Illinois. His Inter-State-Springfield Wheel, the first station, is at LaSalle and West 29th Streets.

7. The game of policy had its origin twenty-four years ago in the city of New York. It was first introduced among the Cuban and Spanish elements employed by the Schwartz Brothers and Baer tobacco factory, located at 81st Street and Avenue A.

From [author unknown], Federal Writers' Project: Negro Studies Project.

CHOOSING A GIG

Policy players have various ways of choosing a gig. Civic, social, and political events play an important part in the choice of a "gig."

In a recent political campaign in Chicago the policy players were busy thinking up a good gig to win. The following is an example of the manner in which it is done.

Mrs. Jones entered the policy station very excited. "Has the writer for the Black-and-White book left with the drawings?" she asked.

The young girl in the station said, "Guess you are, he just left about fifteen minutes ago."

"Just my luck . . . here, Kelly wins and I cain't get my gig in . . . it'll fall sure as the devil cause I didn't play it . . . been playing it for a month, too."

"Wouldn't you want to play it in any other book, Mrs. Jones?"

"No, it's bad luck to play it in another book . . . let's see though . . . now I might play it in the North and South book, 'cause for the first time in Chicago the Second Ward went democratic . . . let's see. I tell you, play my gig in the North and South and I want it like this . . . fifty cents on the first sixes 'cause it's the first time the Second Ward did it . . . now put a quarter on the last sixes and a quarter on my other gig, the Black Man, cause black folks went democratic."

"You'll make a killing if you hit, Mrs. Jones."

" . . . Telling me," Mrs. Jones said as she left the station.

M. Bunton, from "Policy: Negro Business," "Negro in Illinois" Papers, Harsh Collection.

ROOTED IN POLICY

Edward White, fifty, uneducated, Mississippian-born Negro, is one of the few persons who has established a business which might be said to be deeply rooted in policy. He was impressed one day a few years ago by the large number of rolls of paper he saw being taken into a policy wheel. Why, thought Mr. White, didn't a Negro have a paper company to supply policy business. After all, Negroes ran it and the players were almost exclusively Negro.

A few months later he opened the White Paper Supply Company. He is known to the policy barons, he was one of their associates, he was one of them—he got the business. He has now opened a branch in Detroit (where the policy business is large also) and intends to keep expanding. He sells all kinds of paper to whites, as well as blacks—orders arrive at his office daily from numerous Negro storekeepers and white business enterprises.

That the owners of wheels hire many Negroes both in their policy business and in their other stores and sundry enterprises is one of the major reasons advanced for the support and sufferance of the policy game. Nineteen policy wheel owners have at least twenty-nine different businesses, from small, muckish tailor shops to large, swanky, well-appointed enterprises.

A group of fifty large proprietorships, or partnership establishments, were chosen at random and eleven of them were found to be owned and operated by owners or employees in the policy business.

Another group of eighty-seven advertisers and participants at the famed exposition of Negro business was examined and fourteen of them were found to be businesses backed by policy money. Of the twenty-one full-page advertisements in the program for that affair, five were taken by the businesses owned by policy men; six of the twenty-five half pages were also bought by them.

After the fifty-eight advertisements appearing in a program of the fashionable Style Show sponsored the Junior Service League of Provident Hospital were analyzed, four policy-owned businesses had taken one-fourth page ads, two one-half page ads, and two one-eighth page ads. In addition, two known policy bankers had one-half page ads expressing their compliments. One-half page were the largest ads sold, and of the eight, four were taken by policy men, three by white merchants, and one by Joe Louis.

Mr. S. W., restaurant owner at 4723 South State Street, has this to say:

> Taking everything into consideration, I must give the racketeers credit for having good sound business enterprises. There is Dan Gaines, for instance; he has the only Negro Ford agency handling new and used Fords. This gives employment to a large number of people, and gives the race a rating among the people

of the white business world that we have not enjoyed before. . . .

There are fifteen companies or wheels distributing thirty-six books. Handling the books for these wheels, but for the most part independently owned, are some four hundred eighty-three station or policy shops scattered throughout the entire South Side. They are operated openly and are easily recognized by even the uninitiated or newcomer to the city, often having signs in the windows or tacked on the doors reading "Open," "4-11-44," "Doing business," "All books." People can be seen constantly going in and coming out. Sometimes with their "drawings" (slips on which the results are printed and distributed to the players) in their hands, sometimes muttering and shaking their heads if their "gigs" didn't "fall," chuckling or grinning if they did win. The activity is even more recognizable since there are three drawings a day; at busy stations players form a steady line including those getting the results and those placing new bets.

Policy stations are located in basements, in the rear of barbershops, cigar stores, incense shops, in garages, and in first-floor apartments, groceries, restaurants, small shoe-repair shops, beauty shops—in fact, in almost every conceivable place. Fifty-nine stations located in district ten (31st to 39th Streets, State to South Park) were checked for their location and whether operating alone or in connection with some other business.

Policy stations operating alone, and kinds of businesses fronting (district ten):

Policy stations alone	33
Shoeshine stand and policy station	5
Candy store and policy station	2
Barbershop and policy station	4
Cigar store and policy station	2
Beauty parlor and policy station	2
Delicatessen and policy station	2
Incense store and policy station	1
Moving and expressing and policy station	1
Coal and wood and policy station	1
Cleaning and pressing and policy station	1
Tavern and policy station	1
Lunchroom and policy station	1
Grocery and policy station	1
Laundry and policy station	1
	59

There are fifteen companies (syndicates) in Chicago operating a total of thirty-eight books, and employing either at salary or commission or both about four thousand persons, paying them a total weekly wage of about $65,102.75.

Financial Analysis of Three Wheels for One Week

INTERSTATE COMPANY

Approximate weekly take	$6,000.00
Approximate income of owner	3,085.00
	2,915.00
Weekly salary of checkers	$265.00
Pick-up men	170.00

Syndicate fee	250.00
Hits normally 40% of take	2,400.00
	$3,085.00

EAST AND WEST COMPANY

Approximate weekly take	$7,200.00
	3,425.00
	3,725.00
Manager said to get 10%	372.50
Owner's weekly income	**$3,352.50**
Weekly salary of checkers	$240.00
Pick-up men	135.00
Rent	50.00
Syndicate fee	250.00
Hits normally 40% of take	2,800.00
	$3,475.00

MONTE CARLO COMPANY

Approximate weekly take	$6,000.00
	3,340.00
	$2,660.00
Two owners, each receive	$1,330.00
Weekly salary of checkers	$320.00
Pick-up men	310.00
Rent	60.00
Syndicate fee	250.00
Hits normally 40% of take	2,400.00
	$3,340.00

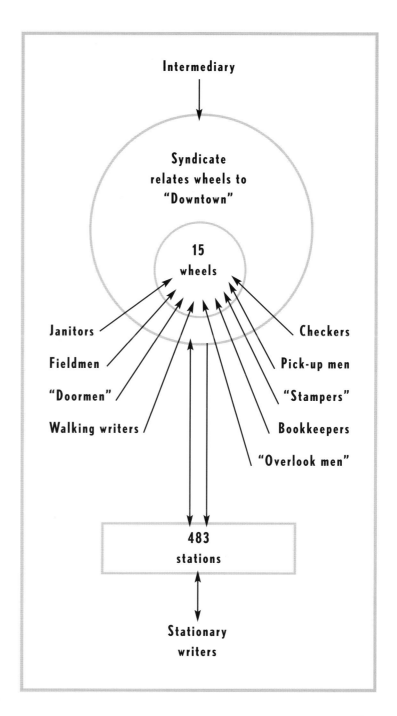

These three companies are neither the largest nor the smallest, but rather represent the average of the fifteen companies.

The Interstate Company is owned by an Italian who has been in various kinds of illegitimate businesses on the South Side for the past thirty years. An approximation of the gross work income was six thousand dollars. After the wages of his employees and approximate amount of hits were deducted, the income for the owner equalled two thousand nine hundred and fifteen dollars ($2,915.00).

The East and West Company is principally owned by Julian Black, who is also manager of Joe Louis, World's heavyweight champion, and a holder of extensive real estate properties. This is one of the largest companies, with a gross weekly "take" of about $7,200, netting the owner in the neighborhood of $3,352.50.

The Monte Carlo Company is in the six-thousand-dollar gross weekly income group. There are two partners in this wheel and they have an average of about $1,330.00 a piece per week.

Using these wheels as examples it would seem that the income of policy men would equal about $1,880,000 per year. On the other hand, when the various estimates of incomes are computed using an average of $150 a day per pick-up man and $6,536.25 a day from walking writers, we get a gross total business for the year of $6,765,875. If we accept forty percent of this as profit we arrive at $2,705,350.00 as the owners' "take" for a year.

There are about 1,691 persons employed in these stations who earn an average of $9.00 a week, making a total weekly income for the group of $15,214.50.

An analysis of a ten percent random sample of the policy stations showed that there were stations that hired as many as fourteen "stationary writers" and some of the writers reserved as high as $20.00 per week.

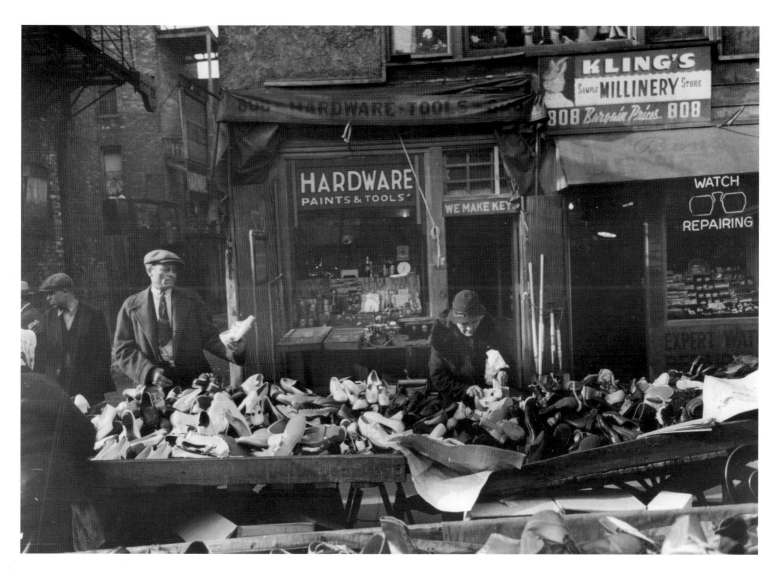

77. People shopping for shoes on Maxwell Street. *Russell Lee, April 1941.*

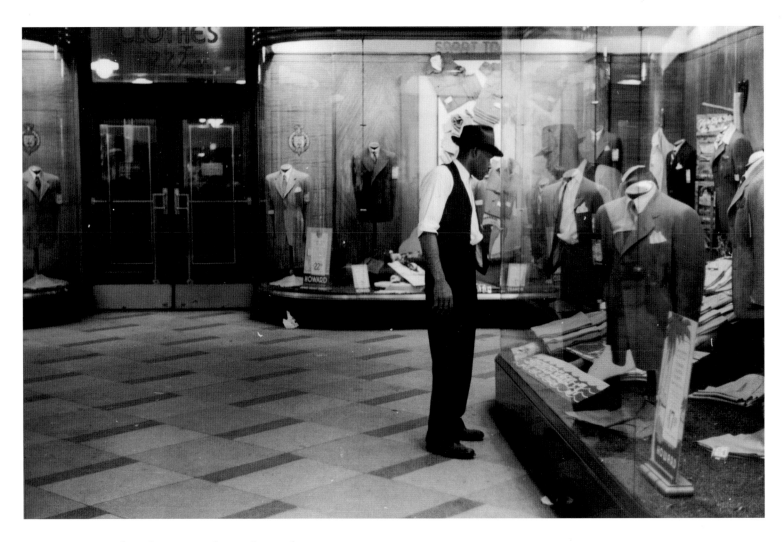

78. Window shopping. *John Vachon, July 1941.*

From Ardis Harris, "Negro Employees in Stores and Offices" [South Center Department Store, 421 East 47th], Federal Writers' Project: Negro Studies Project.

STORE AND OFFICE EMPLOYEES

The South Center Department Store Inc., at 421 East 47th Street, employs more Negroes than any other firm of its kind in the United States. There are approximately four hundred persons employed and 49 percent are women and 51 percent are men. Their ages range from eighteen years to fifty-five years old. After one year's service each employee is eligible for ten days vacation each subsequent year with pay. All work eight hours a day. The minimum salary is $15.00 dollars a week.

This store does not belong to any chain system and it has no branches. It was established March 17, 1928.

The general manager of this firm is a Negro. Every department of the entire store is under his personal supervision. He is responsible only to the board of directors.

Sixty-nine percent of the women employed are Negroes and 31 percent are white women. And 51 percent of the men are Negroes and 49 percent are white men.

The foregoing information was obtained by the writer in a personal interview with Mr. Richard L. Jones, general manager of the South Center Department Store.

From G. R. Wilson, "Interview with Dick Jones, Manager of South Center," "Negro in Illinois" Papers, Harsh Collection.

INTERVIEW WITH DICK JONES, MANAGER OF SOUTH CENTER

Mr. Jones is of average size, dark brown. Born in 1893 in Albany, Georgia, he left Georgia at fifteen, he states. His father was a businessman.

"Father comes to see me now sometimes. He says that the people back home ask about me. They heard I had a store in Chicago.

"In the South, I was not the submissive kind, but I learned respect for authority. Many Negroes have not learned that yet. They come up here and try to run away with the town. I had no

trouble in the South. I avoided trouble. If you see a nail, why sit on it? Much trouble could be avoided by Negroes in the South if they tried to. Get me straight! I am not for conditions down there. They are bad, but could be bettered.

"I was police chief in Louisville, Kentucky. They had a riot there, and I was at camp. I was called and given charge. I had more white under me than colored. We ruled with an iron hand. I was riding down the road with a white man one day and an old Negro spoke and tipped his hat to this white man. The white

man tipped his hat back. That thing weighed on my mind. Finally I asked the white man why he tipped his hat to this colored man and the white man said that he had made it a rule never to let a man be nicer to me than I am to him. So I learned a lesson from that. The colored in the South could make things better. Conditions are not so bad in the South, if they was, colored couldn't live there. But, they do live there and prosper there. Many of them in Georgia own property.

"I guess you think I talk funny. But I got over the color complex. Why stress something that does not exist? There is no such thing as color. I find that people don't care about your color, if you forget it. Now why should I bring that up? They know I'm black. Why tell them what they know already?

"I attended the University of Cincinnati and I went to all the functions. I was given just as good grades as the others. Now why should I bring up the color question?

"I started in law school at the University of Illinois, then the War came on and I was drafted. I was supposed to go to a southern camp, but went to Sherman, Ohio. I had no trouble there. I was not forced into a company, but the captains were asked who would take me. One man from South Carolina said that he would. So, I attended school under the special supervision of this man. I made good, not because of what was in me, but because I was specially tutored. I found no prejudice in the army.

"When the War closed, I organized a bank. I organized an insurance company. I worked for the *Defender*. On the *Defender* I had charge of the ads. I got business for them. So, the color question did not affect me. The *Defender* did not change me any.

"I was attending a theater one night and somebody called me. I looked around and saw my old army captain. We embraced and kissed right there in the lobby. I had to go in with him, his wife, and daughter and sit with them. He was in business on the West Side. So, he invited me out to see him. I went out and he asked me what I had been doing. I told him. This Jew came in and my friend told the Jew that I ought to go along in the new store that the Jew was building. I told them that I did not know anything about a store. My friend said that the trouble with the educated nigger was that he tries to get away from work. The Jew said he would like to talk to me. So we talked a half a day. He just sat and twirled his fingers. I told him all I had done and where I had been. He did not know that there were colored men like me, he said. He had been in business, but had never employed colored. He asked me what salary I expected. I told him I was not expecting anything. He asked if I would go along with him. I told him $150.00 a week. He said that he could not pay that. I told him that I was not asking that. I only said that I would go along with him. If he made I made. He said I was hired.

"I started here for nothing. I had no job. I had to make one. I received no salary. I started from the bottom. Now I know how to work in any department in this store. You can't fool me now. If one of my employees quits I know how to do the work or I can tell the other fellow how to do it. I'm not a big shot. You don't have to make an appointment with me. I meet you on the street and I don't tell you that I am manager of this store. Why? I did not make myself. I make no speeches. I believe in fair play. When the final division comes I must be on the side of the Negro. I know that.

"I'm a businessman, not a speechmaker. In a worthy cause I give. I gave a scholarship to Fisk last year. I attend Pilgrim Baptist Church. I hear them preach against the white man. But, I know that the Negro has no business. Were it not for stores like this, there would be no Negro business. We have a training school here. The people we employ here work at other places.

The Jones boys got their employees from those who had worked here. They consulted me about the business.

"We have 230 employees here. Our scale of wages is like downtown. We employ white and colored. Fifty-three percent colored. We make no difference in treatment. We promote by seniority. Once you are an employee, always one. We have not fired a person in eight years. We don't hire that kind that we have to fire. All make time. That is understood. Seventy-five percent of the white employees are from the South. They do not show their prejudice here. They better not.

"There is no difference between white and colored. The difference is in individuals. Whites are just as lazy as colored, I have found. The only trouble I have found is with these educated sons-of-bitches that think themselves too good to work. You can't expect a person from a poor home, you can't expect that person to be like one from a decent home, can you? That goes for both races. I'd rather give some servant girl a job than some girl who has never helped her mother to work.

"We began here in September 1927; opened up in March 1928. We have nine thousand square feet of floor space. We have a colored store doctor. A colored law firm handles our business. How many colored businesses can you find with colored lawyers and doctors? [Chicago *Defender* publisher Robert] Abbott has a white doctor. His lawyer is white. We have white employees who say that they would rather go to our store doctor. No, we have no insubordination on the part of whites. The whites are used to discipline and fair play. That is what we give. We pay on the salary and percentage basis. Some of our employees belong to unions. But that does not affect us. We can always reach a discussion. If you discuss an issue there is no chance for a fight.

"We need more businesses like this. The Negro is an infant, and don't know it. He gets up every Sunday and cusses the white man. On Monday he asks the white man for bread.

"No, I'm not married now, I had a wife and she thought I was making a big salary. She tried to spend all I made. I want no woman like that. That is the way it is with the Negro. The goddamn educated Negro has led the race wrong. The Negro ought to avoid trouble.

"I gave to the Scottsboro boys. But, those boys had no business on that train. They should have been paying their fare."

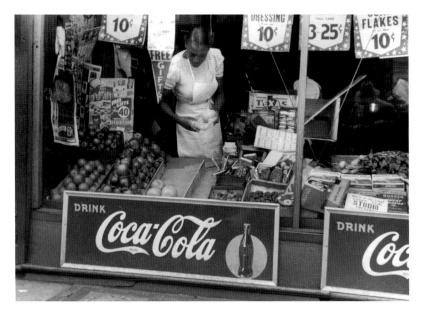

79. Negro grocery store, Black Belt. *Edwin Rosskam, April 1941.*

80. Children in front of grocery store. *Russell Lee, April 1941.*

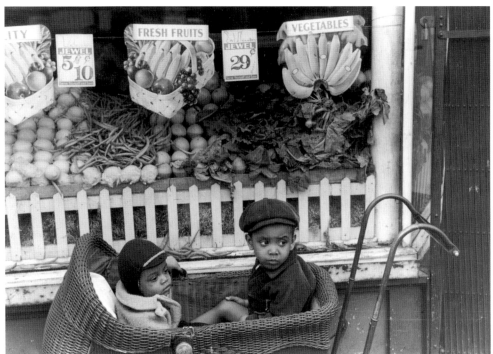

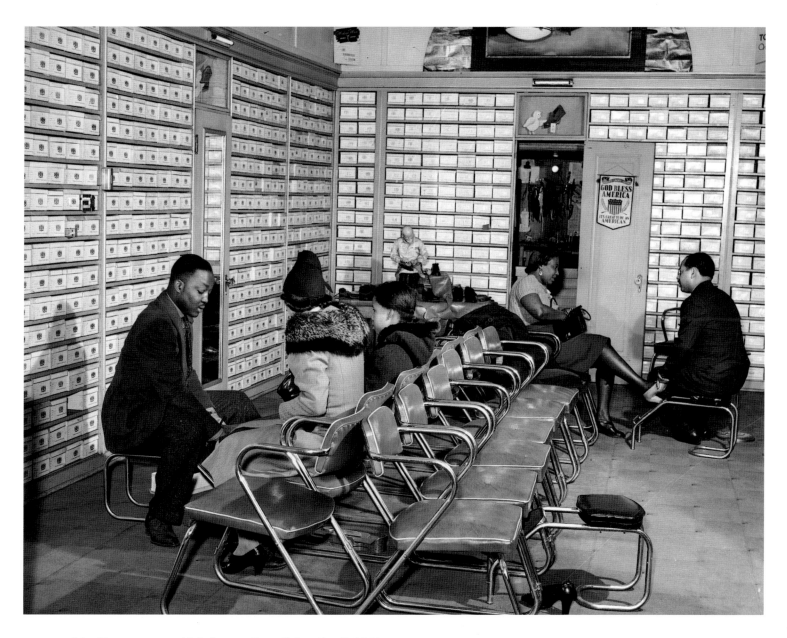

81. Shoe store on 47th Street. *Russell Lee, April 1941.*

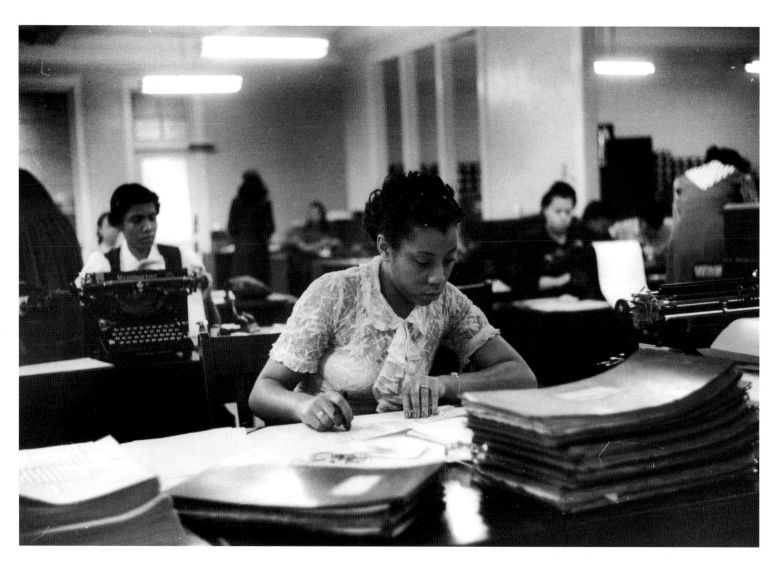

82. Employees of Negro insurance company. *Edwin Rosskam, July 1941.*

83. Brushing off a customer in
a barbershop on the South Side.
Russell Lee, April 1941.

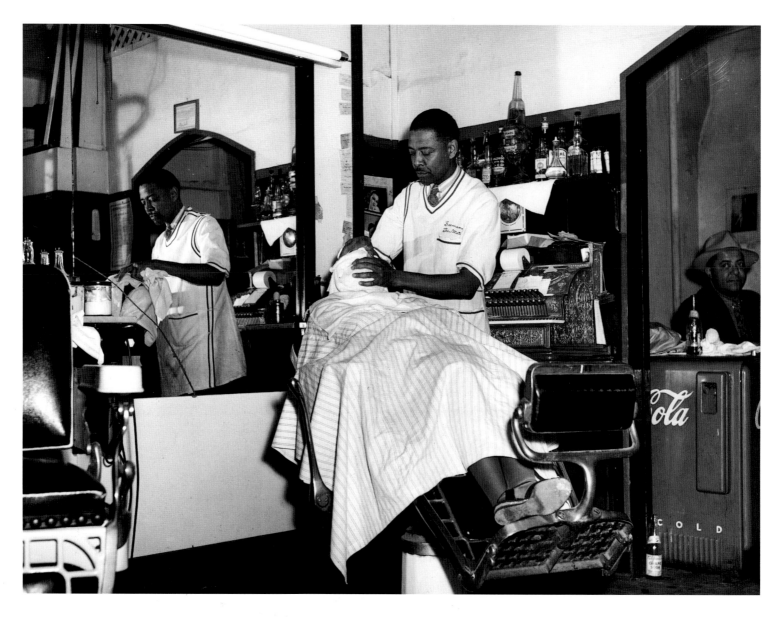

84. Mr. Oscar J. Freeman, barber, owns the Metropolitan barbershop, 4654 South Parkway. Mr. Freeman has been in business for fourteen years. *Jack Delano, April 1942.*

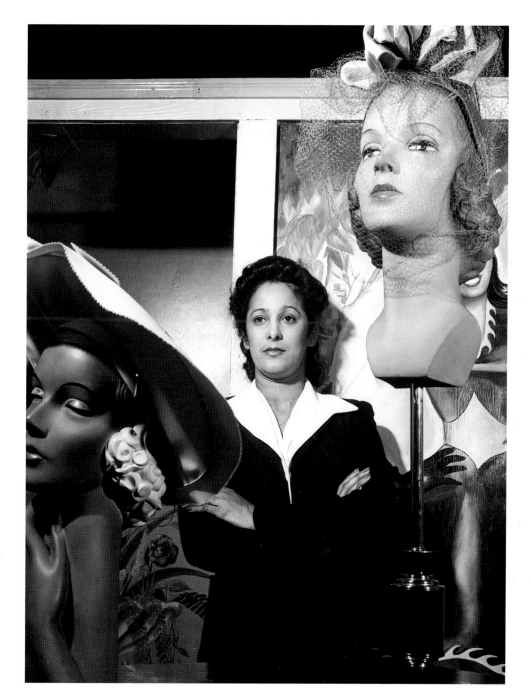

85. Miss Selma Barbour, manager of the Cecilian specialty hat shop, 454 East 47th Street. Miss Barbour has been managing this store for one year and has been in business for four years. She was born in New Orleans and has eight brothers, seven of whom are eligible for the army. *Jack Delano, April 1942.*

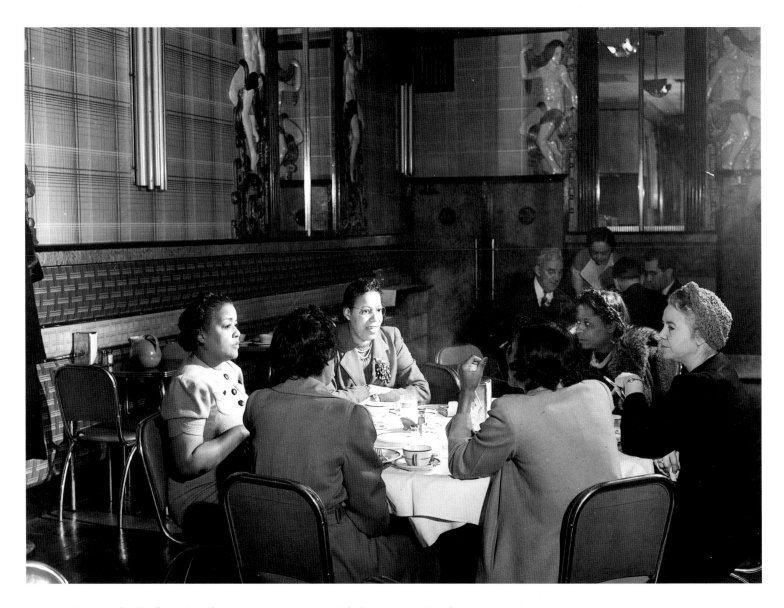

86. In the Perfect Eat Shop, a restaurant on 47th Street near South
Park, owned by Mr. E. Morris. *Jack Delano, April 1942.*

From William Page, "The Ben Franklin Store," Federal Writers'
Project: Negro Studies Project.

THE BEN FRANKLIN STORE
Owned and operated by Edw., Geo., & McKissick Jones
436–444 East 47th Street, Chicago, Illinois

The Ben Franklin Store is situated on the first floor of a building at 436–444 East 47th Street, is a three-story brick structure also owned by the Jones Bros. The storefront is made of beautiful marble of several colors including a base of black and white.

The formal opening of the Ben Franklin Store on Thursday July 22, 1937, was one of the most spectacular and dramatic instances in the commercial history of Chicago's South Side. There were a number of reasons for this jubilant celebration: first, it was a new kind of venture for young men of the Negro race; second, it gave employment to scores of young, intelligent colored women who ordinarily find it most difficult to get any sort of employment commensurate with their fitness and training; third, it served to demonstrate the value of cooperation in the way those three young men worked together, saved together, and planned together all the way; and last, it was a means of inspiration to hundreds of other Negroes both young and old everywhere. It has been well said that the store will stand out as a sentinel in the community, indicating what Negroes may do when they have the inspiration, industry, and spirit of cooperativeness. The opening was witnessed by thousands of people, representing many races. . . .

There were notables at the opening representing many walks of life, especially those who stand out in Negro life, such as businessmen, entertainers, ministers, professional men, and athletes. Among these was Robert S. Abbott, owner and publisher of the Chicago *Defender*, a leading Negro newspaper, and Joe Louis, Negro heavyweight champion of prizefighters. There was entertainment by many leading Negro entertainers from both Chicago and other cities.

The interior of the store is modernly set and equipped. There is the streamline effect in fixtures, and a modern air-conditioning service. A very attractive lunch counter and soda fountain are installed on one side near the front. The store is situated in the heart of the Negro business section near the well-known South Center Department Store and serves to help swell the commercial traffic of this growing South Side metropolitan section.

The stock in the Ben Franklin (Jones Bros. Store) is of the variety type with prices ranging from five cents to one dollar. Though the store is owned by the Jones brothers, it is affiliated with a league which is sponsored by Butler Brothers, of Chicago, which promotes a chain of stores throughout the country known as the Ben Franklin Stores, each of which is privately owned and operated. Butler Bros. gives these stores the advantages of experience and facilitates the stocking of

the stores for the league. There are twenty-six thousand of these stores in the country.

At the present time there are eighty-five persons employed in the services of the store on 47th Street, more than seventy-five of whom are well-trained girls working as sales girls and clerks. There are also a number of girls employed by Marguerita Ward at a cosmetics demonstration counter located in a corner section near the front of the store. Three other stores are housed in the Jones brothers' building, all located on the main floor. There is ample space on the two upper floors for the maintenance of other stores, offices, club rooms, etc., which has not been let out for service as yet. The manager of this store is Mr. Darrow Damon. Mr. James Hill is the director of personnel.

The aim of this business undertaking as expressed by the Jones brothers, Edward, George, and McKissick, in addition to giving employment to many capable colored girls, is to effectively serve the community by placing within their reach many articles of value and service with the greatest amount of consideration and appreciation.

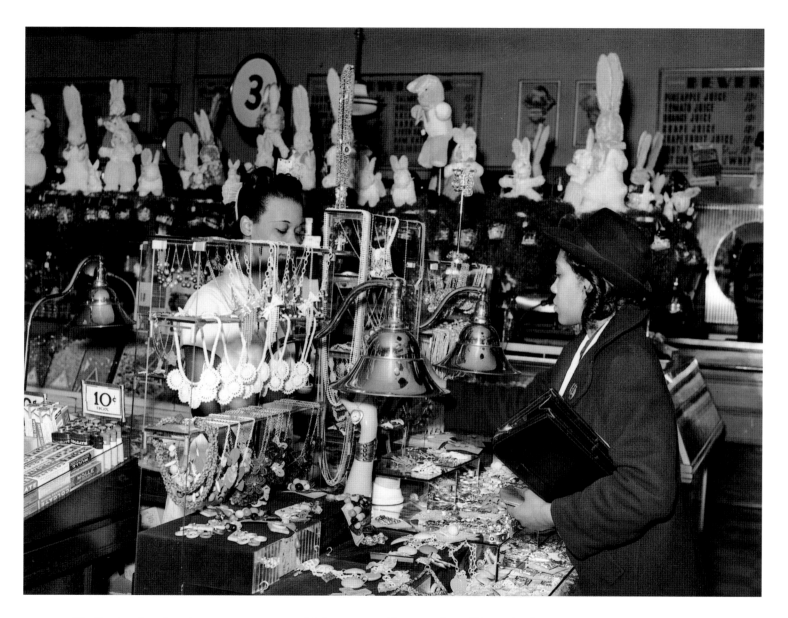

87. Buying jewelery in a ten-cent store which caters to Negroes. *Russell Lee, April 1941.*

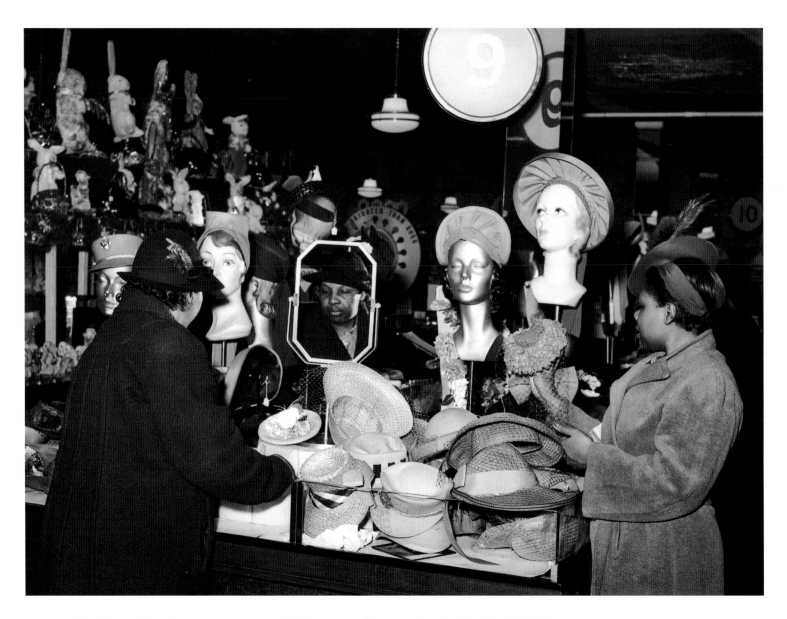

88. Buying hats in a ten-cent store which caters to Negroes. *Russell Lee, April 1941.*

From M. O. Bousfield, "Major Health Problems of the Negro"
[Provident Hospital], "Negro in Illinois" Papers, Harsh Collection.

PROVIDENT HOSPITAL

Provident Hospital and Training School of Chicago has over one hundred Negro physicians on the staff, a white superintendent, and a white supervisor of the social service department. It is affiliated with the University of Chicago as a teaching institution and for such purposes has a white consultation staff and, in some cases for teaching purposes, has a white chief of service. It offers certain clinical clerkships for students, mainly colored, in the University of Chicago Medical School. The house staff is colored, the nurses and their superintendent are colored, and the patient load is predominantly colored. It is called a colored hospital.

Harlem Hospital of New York City has a mixed staff, predominantly white, mainly a Negro patient load, Negro interns, Negro nurses, with white superintendent, and . . . is classified . . . along with other Negro institutions.

In New York City . . . Lincoln Hospital is almost 100 percent white as to patients and completely white as to visiting and house staffs. The nursing school trains only colored nurses, has a white superintendent, and is considered a white hospital.

The so-called unit of Grady Hospital in Atlantic receives only Negro patients, has colored nurses under white supervision, white interns and a white visiting staff. There is not a Negro doctor anywhere. It is called a Negro hospital. Dixie Hospital at Hampton is almost completely a biracial institution—a white side and a colored side—yet called colored.

There are in the South also at least two hospitals in which Negro physicians and nurses attend Negro patients, one a municipal institution, which are designated as white.

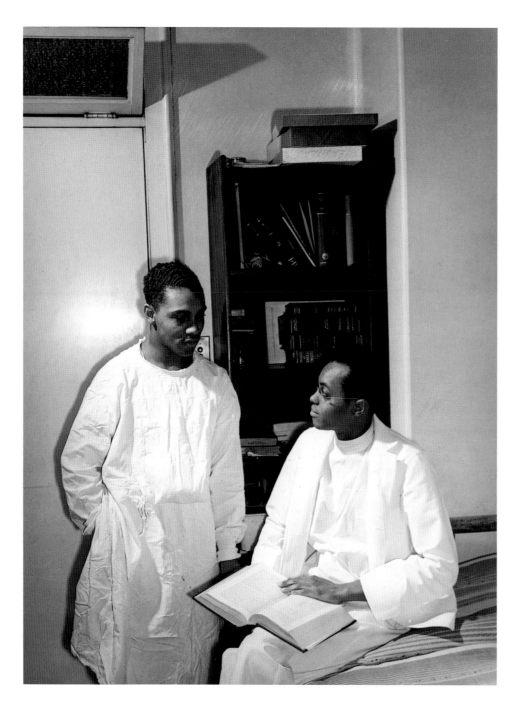

89. Provident Hospital. Dr. S. J. Jackson, left, and Dr. E. V. Williams, interns. Dr. Jackson was born in Texas and studied at Meharry Medical School in Nashville, Tennessee. Dr. Williams comes from Kansas and was a Phi Beta Kappa at Kansas University.
Jack Delano, March 1942.

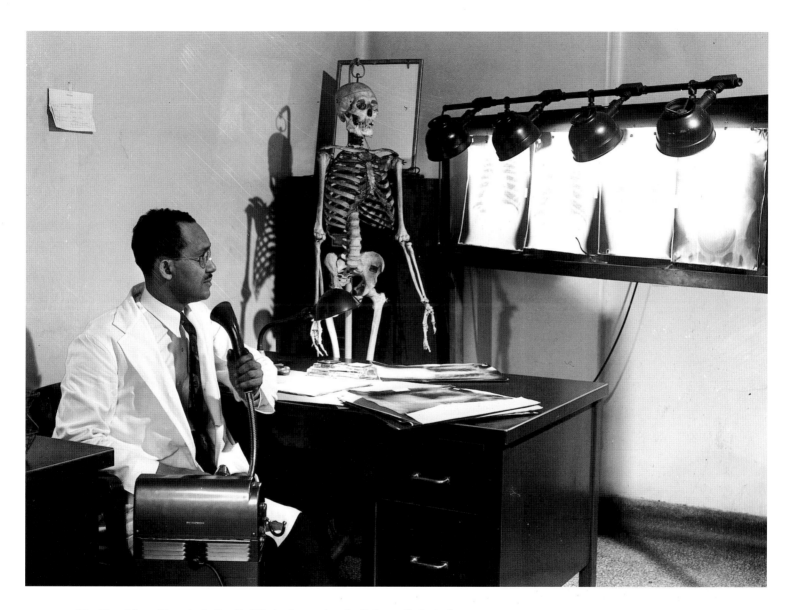

90. Provident Hospital. Dr. B. W. Anthony, head of the radiology department,
dictating a report on X rays. *Jack Delano, March 1942.*

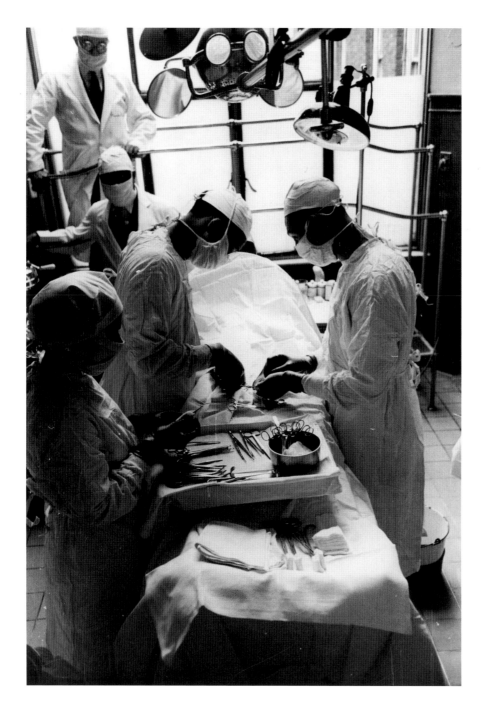

91. Operation at Provident Hospital.
Russell Lee, April 1941.

From Dorothy Jones, "The Martha Washington Guild, Provident Hospital,"
"Negro in Illinois" Papers, Harsh Collection.

THE MARTHA WASHINGTON GUILD, PROVIDENT HOSPITAL

I found the door of the sewing room at Provident locked. I couldn't imagine what had happened. Had the ladies come and gone? That couldn't be true because several of them always find it more convenient to come around 1:30 or 2:00 in the afternoon. What had happened to the Guild? Then I saw the ladies in the women's room. Mesdames Chenault, Rhinehart, Claybourne, and Goins were sewing when I went in. They returned my greeting and Mrs. Rhinehart, who has accepted me completely, asked how school was going. I decided to fold masks for her to stitch on the machine.

I believe I mentioned in my last write-up on the Guild that several ladies had been suggested for the sick committee, but that it had finally ended with my being the whole flower committee because of my never being absent, and that Mrs. Claybourne had been responsible for sending cards, etc. to the sick.

Chenault: This (indicating me) is your new assistant, Mrs.
　Claybourne.
Claybourne: Oh, I see.

I couldn't help but feel that there had been some discussion about the flower committee, and that Mrs. Chenault (who objected to Mrs. Johnson's buying a gift for Lillian Holly Jones's baby, because Lillian was a new member in the Guild) had implied that the ladies had taken Mrs. Claybourne's responsibility from her and given it to me. Then in order to leave me without a doubt as to my position Mrs. Chenault had said: "This is your new assistant." I was glad, so glad for once that I was of the female sex, for I'm afraid the average man would have missed the implications here. There's the matter of referring to subordinate individuals as "she" or "he" rather than using their names; or when one individual speaks of another to a third, the first often uses this as a means of expressing anger. To refer to the individual by using his name would, at the moment, be showing deference.

I had on my swell poker face. Gee, but I was enjoying it though! I fumbled around in my purse awhile and brought forth fifteen cents left from the flower fund contributions I had collected at the last meeting after I'd sent cards to members who had been ill and delinquent, four penny postals I hadn't used, and a list of the ladies who had contributed and those to whom I'd sent cards. I handed them to Mrs. Claybourne, saying, "Yes, here's what I collected and a list of the ladies to whom I sent cards."

Claybourne: You keep them.
Int: I kept them.

Rhinehart: (to me) Did you read about those four boys they caught who'd been robbing filling stations, stealing cars, and holding up people?

Int: No, where did they operate?

Rhinehart: Well, they caught them hiding money in a woodpile over around 46th and Dearborn. They had a lot of stuff hidden in the house there and some young woman living there was in with them and let them hide the things they stole there. Isn't that a shame? I knew one of the boys too, he lives out in Woodlawn, comes from a good family. Why, he's even been to West Point. Can you imagine? I remember I saw him three times in succession last summer driving different cars, all in about two weeks time or less. The last time I saw him, I hadn't the least notion he was stealing cars. I asked him, "Boy, where are you getting all these cars?" And he told me, when I told him I'd seen him in three different cars: "Well, the first one was my uncle's, and the second was my father's, this is mine." Do you know these were stolen cars! You should know him—let's see, his name is Kirkpatrick.

The other ladies had entered into a discussion on tuberculosis. Mrs. Adams had come in; she is well liked by the members of the Guild. For future use, I decided to see what success I could have at directing the conversation.

Int: Do you believe it weakens the human race as a whole to attempt to effect a cure on such cases and then allow those people to procreate?

Adams: What would you suggest?

Int: What about natural selection? Look at all the care given to syphilitic children. Is or isn't it likely that their children will be syphilitic too, having inherited a tendency or lack of resistance? Or what about the countless effects, mental and physical, shown in the children of syphilitics and tubercular folk for which there is no cure?

Adams: Oh, so you believe in natural selection?

Int: I merely gave an alternative. What about sterilization?

Adams: We might lose a genius that way; furthermore, any number of cases are curable, completely if apprehended in the early stages.

There followed a recital of cases the different ladies knew that had been completely cured. Some had better health after than ever before.

I tried further:

Int: Are you going to see the life of young Pushkin on the opening night at the Sonotone and help the ambulance fund Thyra Edwards is sponsoring?

Adams: Thyra Edwards—do you know, I believe she's a Communist, don't you? We'd better get an ambulance for these Negroes in Chicago before we send one to Spain.

Chenault: She's just attracting a lot of attention to herself.

Claybourne: I'd do that too if it meant I could travel around abroad all the time as she does. I wonder if I'm folding this thing right?

Adams: When do we get our coffee? Ordinarily I wouldn't care whether we had it or not, but I didn't have any lunch today.

Mrs. Franklin and Mrs. Foster had come in.

Franklin: Has Mrs. Johnson gone?

Rhinehart: She's in with a bad cold and so is Mrs. Ashe and
Mrs. Slusser.

Franklin: Oh, that's too bad. Have you any more pins?

Mrs. Jones Anderson came in. She (I believe) is head of the
sewing department at Provident.

Anderson: I hope you ladies don't mind our moving up here;
it's just for today. The auditors are here and they didn't
get finished yesterday; they are using your room, so we
felt you wouldn't mind being here for just a day. Would
you like to come to the dining room to be served? It's
rather crowded in here.

Goins: Oh, there are so few of us today, we could get along
all right in here.

Anderson: Well, I guess we'd have to put the table down the
hall in front of the sewing room; there's really no room
up here.

Claybourne: That would be all right, we could serve ourselves.

Anderson: Well, I'll see about it right away.

Franklin: And send us some pins, will you?

Anderson: Yes, yes, of course.

I could see everybody was anxious for the coffee. Mrs.
Adams went out several times to look down the hall and see if it
were there. Finally, after about fifteen minutes it arrived. Three
or four of us went down the corridor and brought the coffee and
cookies to the other ladies.

As she left, Mrs. Claybourne invited me to come to a card
party given by a group of medical men at the Old Tymers Club
on South Park near 47th Street, the following Friday.

Two of the ladies made their contribution to the flower fund
and left. Mrs. Adams cut out enough strips of tape to enable
Mrs. Foster and me to finish the masks that had been folded,
and then went visiting in the hospital.

Mrs. Franklin, Mrs. Foster, and I were left. We finished the
masks and took our leave.

If I can win Mrs. Chenault and Mrs. Adams over, I feel I
shall have won the whole Guild.

92. Provident Hospital. Women's sewing group mending the hospital linen. *Jack Delano, March 1942.*

From Janie Lee Smith, "The Chicago Defender *Plant," Federal Writers'
Project: Negro Studies Project.*

THE CHICAGO DEFENDER PLANT
Material obtained from tour and from pamphlet,
"Some Interesting Facts about a Great Newspaper"

The Chicago *Defender*, one of the most powerful Negro news weeklies in America, is published by the Robert S. Abbott Publishing Company located at 3431–3437 Indiana Avenue. The plant is easily accessible [by car line or bus]. Here there are two buildings, the main building at 3435–37 Indiana, and the annex at 3431 Indiana Avenue. In the main building on the first floor there are the offices of the information clerk, the room where newsboys receive their papers, and a reception room; in the rear is the linotype room. The offices of the managing editor; children's page editor; and foreign, sports, and society editors are on the second floor of the main building. The annex houses the offices of the circulation manager and his staff and the photography department. The huge, straightline sextuple press purchased in 1926 and the old quadruple press are located in the basement of the main building; the stereotype room is also in the main building on the first floor.

The Chicago *Defender* was founded in 1905 by Robert S. Abbott and was first published on May 5, 1905. The first edition was a small four-page sheet, sixteen by twenty inches, of which only three hundred copies were printed. At present the Chicago *Defender* has a circulation of more than 110,000 copies weekly, which exceeds the combined circulation of its three nearest competitors. It has grown from a four-page sheet to a paper of standard dimensions ranging from twenty to thirty-two pages. Among the features are a sports page, theatrical news, society and club news, a page devoted to religious news, dramatics and music. In 1905 the equipment of the plant consisted of a card table, a small press, and a kitchen chair; today this company owns a plant and equipment valued at $475,000. The home office alone employs seventy-two people, there are 563 newsboys handling the *Defender* in Chicago, and over 2,300 agents throughout the United States. Two editions are published weekly, the national edition on Tuesday, and the metropolitan edition on Friday. The paper is a member of the Associated Negro Press.

Since its inception, the Chicago *Defender* has advocated the abolition of race prejudice. The *Defender* costs ten cents weekly, and subscription rates are $3.00 a year.

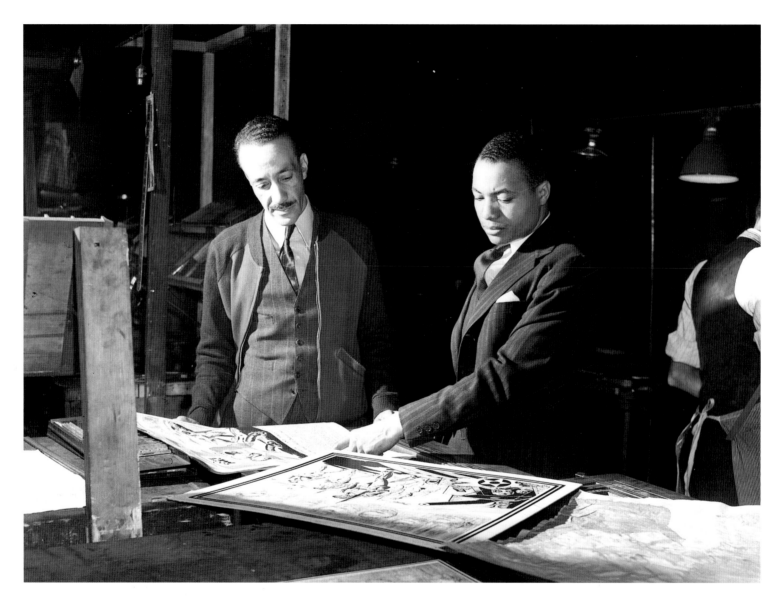

93. Mr. John Sengstacke [right], part owner and general manager of the Chicago *Defender*, one of the leading Negro newspapers. *Jack Delano, March 1942.*

94. Frank Young, better known as FAY, sports editor of the Chicago *Defender,* one of the leading Negro newspapers. *Jack Delano, March 1942.*

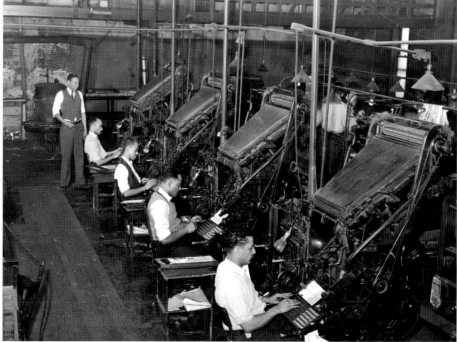

95. Linotype operators of the Chicago *Defender,* Negro newspaper. *Russell Lee, April 1941.*

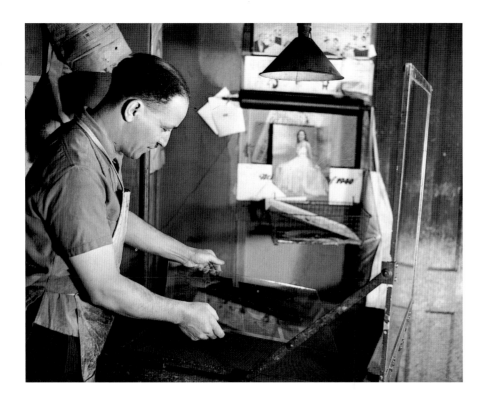

96. Photo engraver at the Chicago *Defender*. *Russell Lee, April 1941.*

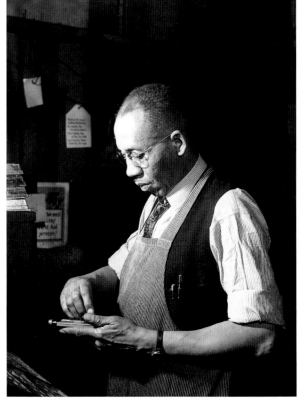

97. Typesetter at the Chicago *Defender*, one of the leading Negro newspapers. *Jack Delano, March 1942.*

From [author unknown], "Newspapers" [draft chapter summarizing IWP research on African American newspapers and magazines in Illinois], "Negro in Illinois" Papers, Harsh Collection.

PRINTERS AND THE UNIONS

In general, Negro printers do not belong to the printers' union. Unorganized, they have been at a disadvantage in bargaining collectively for elevation of the pay scale and rectification of evils in working conditions. Moreover, the absence of an effective bargaining body has practically shut off apprenticeships and discouraged young Negroes from entering the printing trades in Chicago. Negro printers have not been paid in accordance with any standard scale. The wages have ranged from $12 to $50, depending upon the prosperity of the individual plants. The length of the working day has extended from eight to fifteen hours, with most of the printers idle on Fridays and Saturdays. Since in many of the Bronzeville newspaper plants the weekly income was uncertain, the printers were only too glad to get the regular wages without quibbling about overtime.

Visitors to the Chicago *Defender*'s plant before 1935 viewed with disfavor the employment of white printers and mailing crews, something of an oddity in a Negro-owned establishment. The management explained that this was necessary to getting out the paper efficiently. Competent Negro printers in Chicago were then scarce. To cope with the shortage, the closed-shop agreement with the American Federation of Labor union, which had jurisdiction in the *Defender* plant, provided that Negroes would be brought in and trained. As fast as the colored apprentices qualified they were to be admitted to the union and given jobs at the *Defender*. The union allegedly defaulted on its pledge, and the management thereafter sought ways and means to supplant the white printers with young Negro craftsmen being turned out at Hampton, Tuskegee, and other schools. In 1935, application of the rigid restrictions of the National Recovery Act precipitated a dispute between the *Defender* and the white union printers over working hours. The code authority ordered the company to cease working the men beyond the regulation eight hours unless time-and-a-half were paid for the excess hours. In the altercation, the white printers were discharged and replaced by Negro mechanics. The union filed a complaint with the National Recovery Board, which, after sifting the evidence, ruled that the publisher should rehire the union men and pay them more than $30,000 in back wages. The *Defender* was faced with imminent disaster. But before the staggering sum was released, the United States Supreme Court declared the NRB unconstitutional. Under this opinion the *Defender* retained the undisputed right to hire Negro printers without interference. Since 1938, negotiations with the management have been carried on by the colored printers through their own independent union, the Brotherhood of Printers and Allied Craftsmen.

Most of the periodicals in Bronzeville have suffered from the heavy expense of outside printing. Some, notably the *Conservator, Broad Ax, Whip, Illinois Idea, Metropolitan Post,* and *News-Ledger,* had composing rooms where the news was set up and thrown in forms, but then was sent out for the press work. The *Daily Bulletin, Review,* and *Metropolitan News* owned millions of pieces of type, linotype machines, and modern presses for producing a complete newspaper, as do the current *Defender* and *Bee.* The *Defender* plant is the best equipped, up-to-date Negro newspaper layout in the United States. This gives it an advantage over competitors in that a superior product is possible at lower costs. Since 1919, the *Defender* has carried several pages of hometown news, most of which is now printed in the national edition for the consumption of readers in the South and other sections where there is no important Negro newspaper. An expansion of this idea is the establishment during the last few years of local editions of the *Defender* in Louisville, Cleveland, New York, Toledo, and Detroit. The copy for the Chicago *Pittsburgh Courier* is rushed to Pittsburgh to be printed in the main plant there. The *World* has its own composing room, but sends out the forms to be printed elsewhere.

The four Chicago papers that have survived are well equipped, it is apparent, to maintain themselves and to gain new readers from among the 80 percent of Negroes in Chicago, who, study discloses, are not yet regular readers of the race press, and also from among the unknown number in the rest of the state who still are not subscribers. This quartet of journals would seem adequate to serve the Chicago community at least. Doubtless there will be further attempts to publish race dailies, and as surely one will some day be established that will better the records of the Chicago *Daily Bulletin* and the *Cairo Gazette.* Until that day, the *Defender, World, Bee,* and Chicago Edition of the *Pittsburgh Courier,* tried in good times and bad, give promise of valiantly carrying on the struggle for the full civil rights of the Negro, the initial inspiration in establishment of the race press.

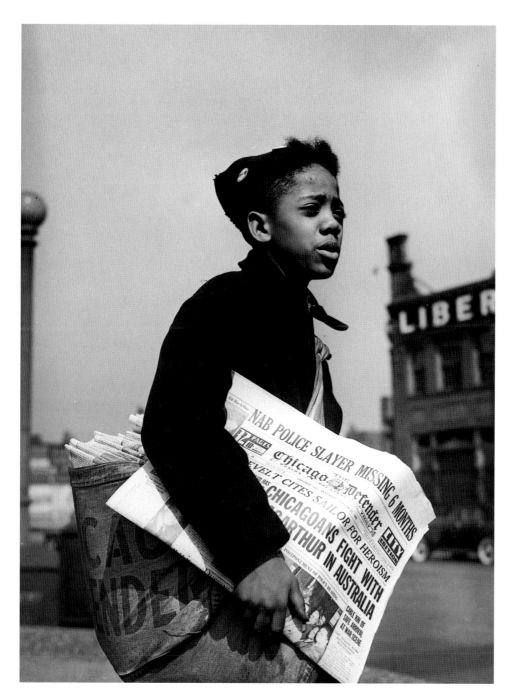

98. Newsboy selling the Chicago
Defender, a leading Negro newspaper.
Jack Delano, April 1942.

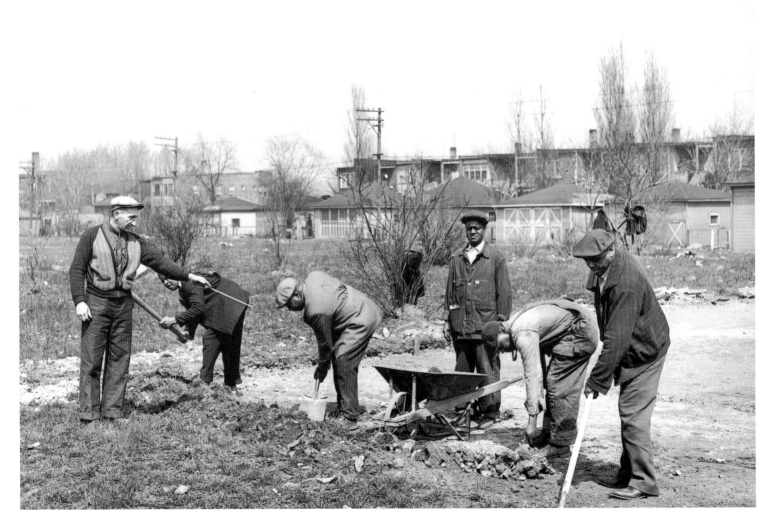

99. Works Progress Administration (WPA) work on playground on South Side of Chicago. *Russell Lee, April 1941.*

From Fenton Johnson, "The WPA Shovel Man," Heritage Press Collection, Harsh Collection.

THE WPA SHOVEL MAN

The foreman said:
"Don't raise your shovel until I say so!
We have to stretch this work to last awhile,
so you fellows will get an extra fifty-five per."
It's cold, leaning on this shovel.
I'd rather be the flagman: he can wave his arms
and keep the blood stirred up a little—
but if I lose this job it's back to the station
with scarcely enough to buy food and seldom
enough to pay rent on a broken-down tenement flat.
Nobody gets anything out of this relief business but the
case workers;
they act as if they're doing something when they let you
have a WPA job.
Back in the days when Hoover was boss
I was a master plumber and was doing fine,
but business went on the rocks, my wife left me
and to support my mother and the kids I went on relief.
This man got up WPA and jobs seemed to fall from the sky—
but nobody got up a project for plumbers. I was put on the
 shovel,
digging six and seven hours a day for fifty-five a month.
It wouldn't be so bad if the job lasted all the year,
but just as things begin to break 403 comes
and you're back again to the handout at the relief station.

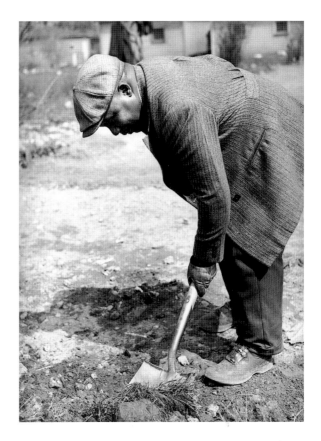

100. Works Progress Administration worker.
Russell Lee, April 1941.

Of course, shoveling isn't my line:
I'm a master plumber,
but I'll never be one again.
I'm getting too old and I've almost forgotten
all I knew when I had my own business.
Now I'm merely a shovel man
and nobody ever gets rich shoveling.
It isn't a trade—it's a government job.

101. Alfred MacMillan, Pullman porter, aboard the *Capitol Limited* bound for Chicago, checking the list of hours when he is to wake people in the morning. *Jack Delano, March 1942.*

From Robert Davis, "The Negro in Organized Labor, Chicago Area, Interview with I. Wilbur Winchester, International Secretary of Brotherhood of Red Caps. History of Local 11, Chicago, Illinois," Federal Writers' Project: Negro Studies Project.

THE NEGRO IN ORGANIZED LABOR, CHICAGO AREA

"We joined the A. F. of L. as a Red Cap local, having in mind the procuring of an international charter. We were refused an international charter on the grounds that we were under the jurisdiction of the Railway Clerks Union and that we were not yet capable of handling our own affairs. The Railway Clerks did grant us a charter but we discovered that their constitution had a color bar. [A. Philip] Randolph knew about this color clause and maintained that the Brotherhood of Sleeping Car Porters should have jurisdiction over the Red Caps. He began negotiating to get jurisdiction over us. We put up a squawk. We felt that we needn't participate in a fight over jurisdictional rights, so the Independent Brotherhood of Red Caps was formed.

"Five of our union officials went to the officials of the LaSalle Street Station to negotiate for us. They couldn't see anyone in authority there. Finally when we pinned them down, the railroad company officials told us that we were under the jurisdiction of the Railway Clerks and that they would deal with them. The Railway Clerks refused to negotiate for members who did not receive a minimum salary of $30 per month. Red Caps do not receive any salary at all, so you can appreciate the paradoxical situation in which we found ourselves. We formed an independent union, June 15, 1937. We meet at the Fort Dearborn Hotel. About one-third of our membership attends regularly."

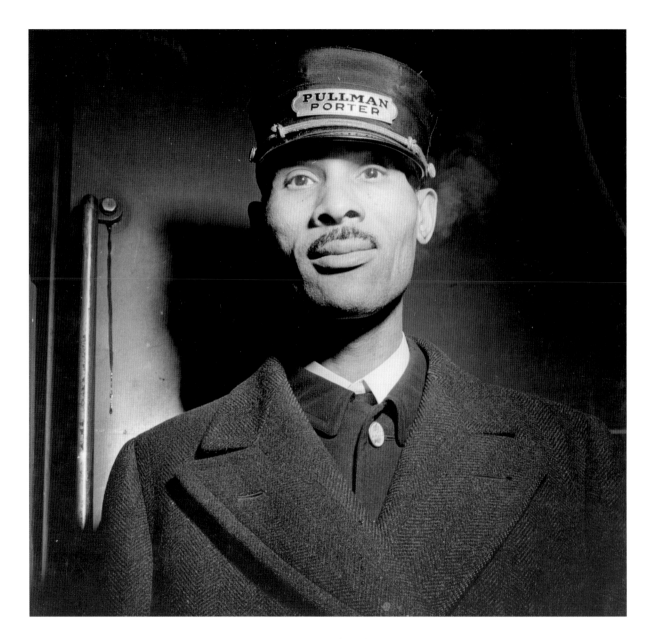

102. Pullman porter at the Union Station. *Jack Delano, January 1943.*

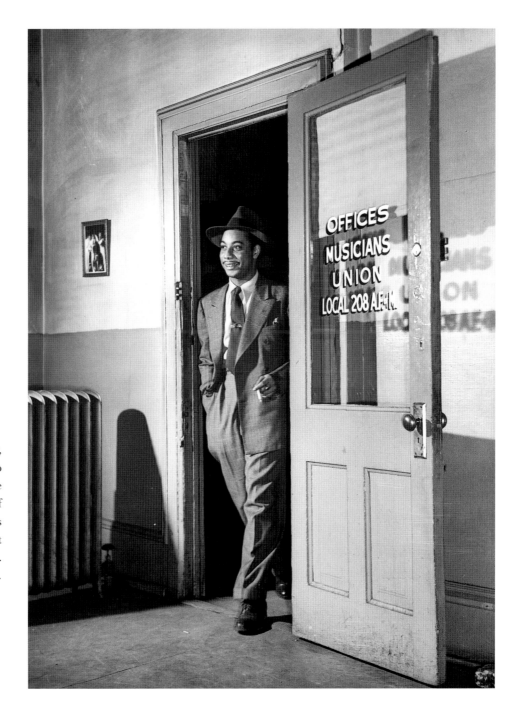

103. Oliver Coleman, drummer, making one of his biweekly visits to his union hall, Local 208 of the Musicians Union. He is proud of his union and of the Musicians hall. His local is one of the largest in the country and are all Negroes. *Jack Delano, April 1942.*

From Louise Henry, "A History of Negro Music and Negro
Musicians in Chicago, A History of Local 208, American
Federation of Musicians [interview with George E. Dulf]," "Negro
in Illinois" Papers, Harsh Collection.

A HISTORY OF LOCAL 208
AMERICAN FEDERATION OF MUSICIANS

In the spring of 1899, the Eighth Illinois Band, consisting of
thirty-four musicians, were made a National Guard Regimental
Band. Formerly, the K. of P. Band was enlisted in the Regiment,
with Alexander Armant as band master and George E. Dulf as
principal musician. This band, one of the finest in the middle
west, specializing in concerts, dances, and parades, made sever-
al excursions, playing Milwaukee, Wisconsin; Indianapolis,
Indiana; Columbus, Ohio; Detroit, Michigan; Lexington,
Kentucky (Colored Fair); St. Louis, Missouri; Peoria, Illinois;
Springfield, Illinois; and many other cities.

"Armant's band played all dances of any consequence, both
colored and white. As a matter of fact, they played so many
white engagements that President Thomas Kennedy of Local
10, A. F. of M., came to one of the rehearsals in the fall of 1901
and asked the band to join his union.

"Mr. Armant and I met with the Chicago Federation of
Musicians at their headquarters, 175 West Washington Street,
at which time several hundred members were present. After
discussions for and against admitting us as members, I asked
for permission to secure a charter from the American
Federation of Musicians, in order that we could have our own
union. Mr. Armant, however, was not in accord with me, as he
was firm in his belief that there should be but one union in
Chicago. I shared his opinion, for I have always been of the
opinion that music should know no creed or color. On the
other hand, I readily observed that a factional dispute existed
within Local 10. Naturally one faction was stronger than the
other, and the stronger faction would have taken us in to gain
the upper hand, later finding some plausible excuse to eradi-
cate us. In other words, I had every reason to doubt their sin-
cerity. After a stormy session, we were granted permission to
secure a charter from the A. F. of M. This charter was issued
July 4, 1902, under the name of Musicians' Protective Union,
Local 208, A. F. of M.

"Our charter was kept open for one year, during which time
the special joining fee was only $1.00 and dues $1.25 per quar-
ter. Our first headquarters were located at 3031 South State
Street, and it was quite a problem to pay the rent, which was
only $15.00 per month. The first set of officers were as follows:
Alexander Armant, president; George E. Dulf, vice president; J.
Edward Smith, secretary; Wiley G. Alexander, financial secre-
tary; John W. Corbin, treasurer. Board of directors were William

A. Sherrill, Ben Cooper, Richard Springs, Charles Washington, and J. H. S. Jackson. During the first year Local 208 had not more than fifty members.

"Today I can well appreciate the progress that Local 208 has made. We are different in every respect from our impoverished beginning way back in 1902, when officers worked without pay, and it was a problem to pay our meager expenses such as rent, telephone, and other bills. It makes me proud to realize that our headquarters are paid for, that we are able to pay our officers a fair salary, that we have a strong organization that is respected in our constantly growing community. I am proud to know that today we have not only the largest local in the Federation, but one of the best-conducted middle-sized locals therein.

"Our officials are cooperative and do everything possible to uphold and preserve the integrity of the American Federation of Musicians, to create employment opportunities and better relations with other labor organizations."

Today Local 208 is able to boast of a membership of one thousand, two hundred musicians. It has grown to be one of the strongest aggregations in the country. Free of financial encumbrances, the members have been able to remodel their homesite with the latest equipment conducive to both comfort and utility.

There are three stories to this musical "Mecca." The ground floor acts as the "open sesame" for those who seek information, make appointments, and desire auditions. One may meet here musicians of national and international prominence and from such contact can receive inspiration not otherwise so easily available. One's presence here is to live in a world of music, and spur is given to the ambition of anyone musically inclined from the sight of the pictures of the many artists adorning the walls. To the right of the room are the offices of Mr. Musco C. Buckner, financial secretary-treasurer, and Mr. Herbert H. Byron, secretary. Adjoining the foyer is a large and spacious room used for auditions.

The second floor houses the offices of the president and various members of the staff.

No comment can here be made about the third floor because of the apparent strict privacy with which it appeared to be invested.

The present officers for 1939 are as follows: Harry W. Gray, president; Zinkey Cohn, assistant to the president; Charles A. Elgar, vice president; Herbert H. Byron, secretary; Musco C. Buckner, financial secretary-treasurer. The board of directors are: Charles Allen, Clarence D. Byron, Preston Jackson, William Everett Samuels, and George A. Smith.

A Trial Board for dealing with infractions of rules and regulations is part of the government of the local. The personnel consists of: Gerald Casey, chairman, Buddy Gross, William Bill Johnson, Ernest F. Smith, Andrew Stewart, Lucius Wilson, Walter J. Wright.

To maintain a proper standard in music, an examining board functions to test prospective members who are required to satisfy it with respect to their ability to read music at sight, and to qualify in every manner with regard to what is required of musical competence. Its examiners are: George Dixon, William Logan, and John L. Thomas.

The list of officers is completed with the sergeant at arms in the person of Richard E. Curry.

From Edwin Rosskam, "Railroad Worker's Family," FSA/OWI General Caption. RA/FSA/OWI Written Records.

RAILROAD WORKER'S FAMILY

[One] worker, a fireman in the New York Central engine house, was born in Tuckerman, Arkansas, in 1903. His father was a tenant farmer and gin worker. He himself worked in cotton before coming to Chicago in 1923.

His wife, from New Orleans, came to Chicago in 1933. She is a former voice student and stenographer. The couple has three children, two girls, two and three years old, and a six-month-old boy. Both are active in church work where the husband is a preacher and the wife a worker in the "progressive circle," a young people's church club (Baptist). The husband is also an official of his union local of which his wife does the correspondence.

They live in a two-room apartment on the second floor of a former one-family house. Their rent is $24.00 a month. They have their own cooking facilities but share the bathroom with twelve adults and ten children. As the wife is entirely occupied with her volunteer work for church and union, her housekeeping and the raising of her children, the family depends entirely on the husband's wage of $52.00 every two weeks. At the present time, living with them in the same quarters and on the same income is the wife's sister who came to Chicago four months ago and is therefore not eligible for relief. As a domestic worker, she can only find an occasional day's work, and is unemployed almost all the time.

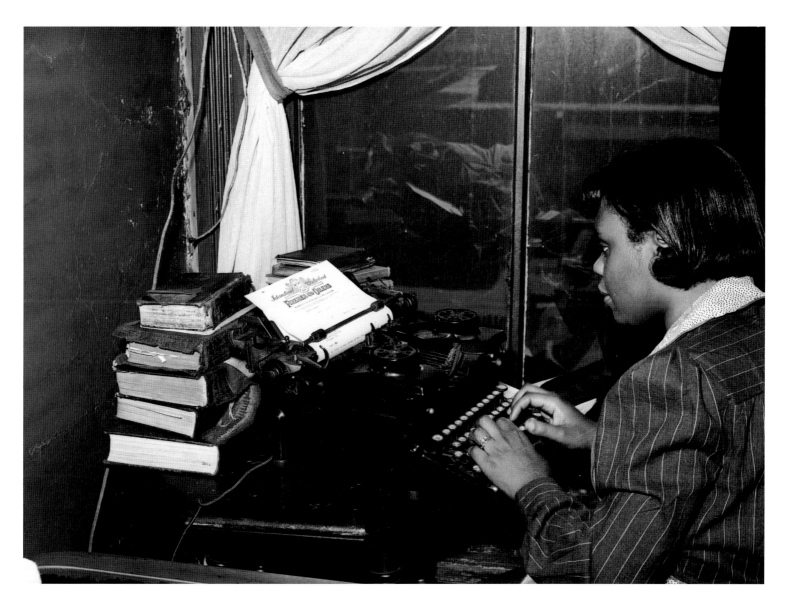

104. Wife of a railroad worker typing a letter. *Russell Lee, April 1941.*

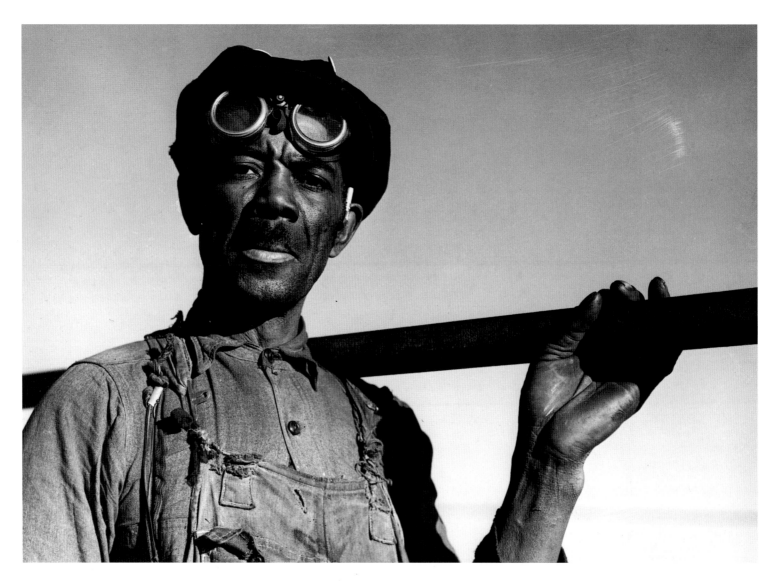

105. Frank Williams, working on the car repair tracks at an Illinois Central railroad yard.
Mr. Williams came to Chicago from Pocahontas, Mississippi. He has eight children, two
of whom are in the U.S. Army. *Jack Delano, November 1942.*

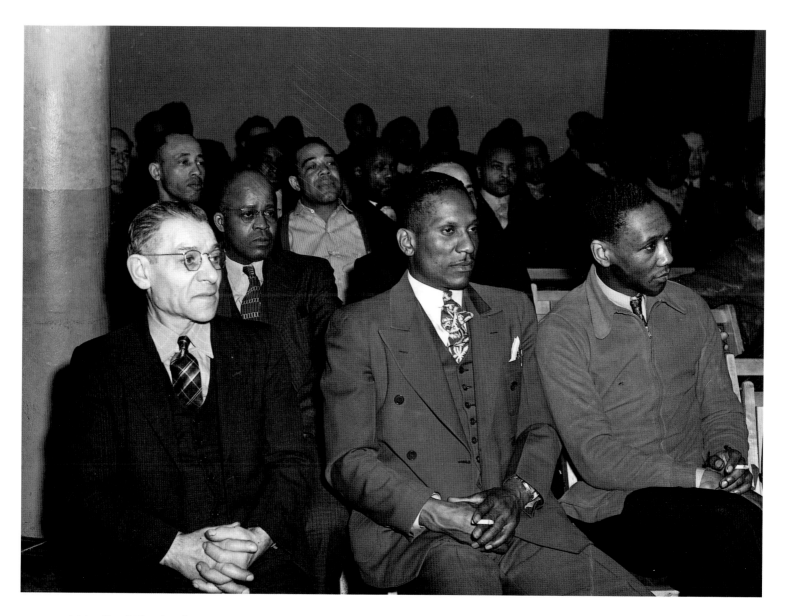

106. Good Shepherd Community Center. Steelworkers at a union meeting. *Jack Delano, March 1942.*

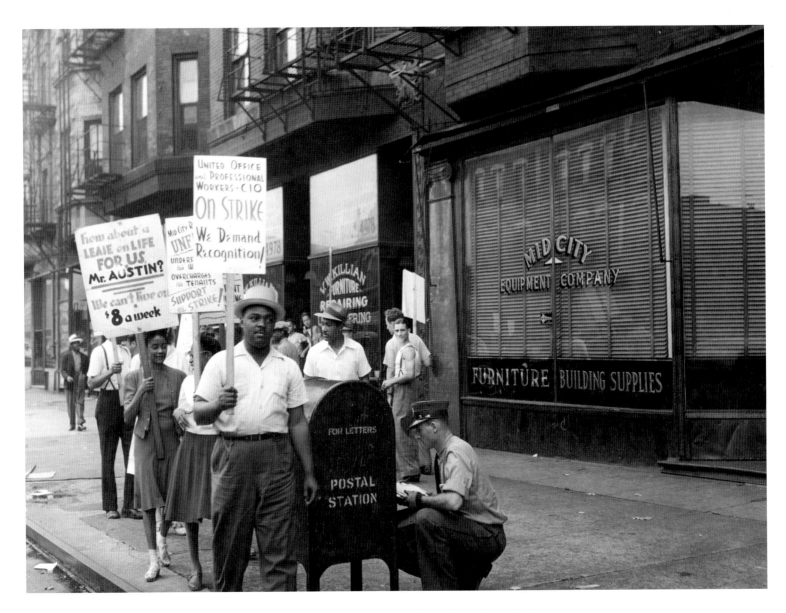

107. Picket line in front of the Mid-City Realty Company. *John Vachon, July 1941.*

From Robert Davis, "The Negro in Organized Labor, Chicago Area, Interview with Wife of CIO Organizer," Federal Writers' Project: Negro Studies Project.

INTERVIEW WITH WIFE OF CIO ORGANIZER

"Time was when the man of the house carried on his struggles with the boss to earn a wage sufficient to take care of the 'little woman' and the kids, and the 'little woman' remained at home in the kitchen and tended her pots and knitting. The harsh realities of the workingman's battles were not for her, but to be carefully hidden from her. At least that was the ideal of every good husband. But what could be more real than an empty pot, crying, hungry children, and a harassed man?

"Of necessity women have had to take their place beside men in the struggles of labor against capital, so that they can have something in the pot and something to knit. The bitter competition for jobs, the recent 'depression' and the meager wages have forced the housewife not only to take part in the struggles of her husband, but also, as a job-seeker and a job-holder, she has struggles of her own.

"Women have come forward in the present strike in Republic Steel, Inland Steel, and Youngstown Sheet and Tube Steel Mills. Women were on the first picket line around the Republic plant in Chicago. One was arrested, not tenderly. Her woman's refuge of tears was of no avail. She went to jail and stayed until she was bailed out. And she went back to the picket line.

"A group of women from the South Chicago Women's Auxiliary picketed city hall after the first pickets' battle with the police. Hoodlums tore their signs from them and the women fought back bravely.

"There were women in the historic Memorial Day massacre of pickets at Republic Steel Company's South Chicago plant, and they brought their children with them. Many were beaten and shot; and they saw their children beaten and shot by Chicago's finest, and many more were gassed. As they lay in the first-aid room retching and bleeding, they would say, 'Go get the men. They may be dying. We'll live.' And one brave little fellow, shot in the leg, said, 'Look after this man first. He's shot in the head. I'm only shot in the leg.'

"Behind the lines, the women conduct kitchens, furnishing hot food for the pickets, day and night. And ALL the women are participating—Negro, white, Mexican, all the various nationalities that work in the mills. The women work side by side in complete harmony. Here is no gossip club but a group of determined women, with one object in view—victory for the strikers.

"Once it was the women who broke strikes. They tried to prevent their men from joining the union, and when they knew

that the man had joined they argued that they couldn't afford to pay union dues. And when a strike was called, they urged their husbands to go back to work. But the Steel Workers Organizing Committee has realized that women are a factor to be reckoned with and have organized women's bands. They show their solidarity with the men by going on the picket line themselves and sending their children.

"Saturday is Children's Day and Sunday is Women's Day on the picket lines. These pickets are particularly annoying to the police 'protecting the plants.' Then the children sing, 'The cop stands on the corner, his shoes are full of feet,' and 'Hang Tom Girdler to the sour apple tree': the cops threaten to break up the picket line if they don't 'take those d——n kids off.' And they shout at the women that they belong at home in the kitchen.

"But the women remain on the picket line, and they continue to work in the strikers' kitchen. They say that they will participate in the strike until it is won."

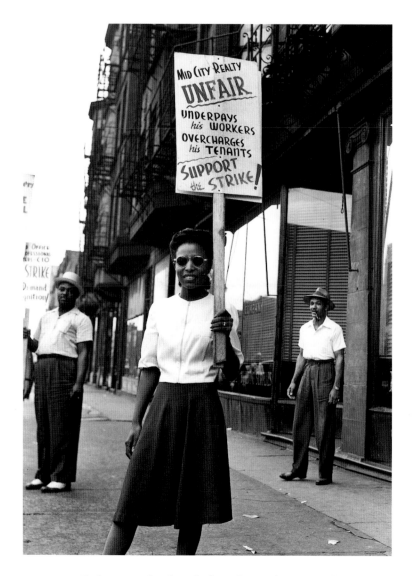

108. Girl in a picket line before the Mid-City Realty Company in south Chicago. *John Vachon, July 1941.*

109. Entrance to an apartment house.
John Vachon, July 1941.

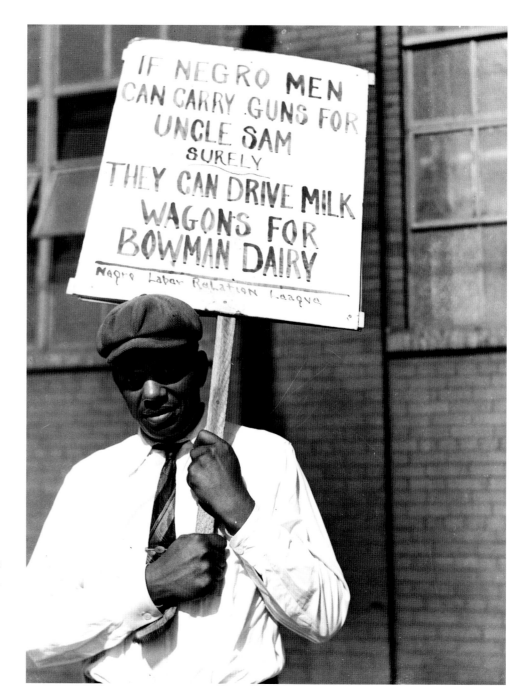

110. Carrying a sign in front of a milk company. *John Vachon, July 1941.*

Part Three

CHURCH

From Edwin Rosskam, "Negro Church," FSA/OWI General Caption. RA/FSA/OWI Written Records.

NEGRO CHURCH

The preacher tells of days long ago and of a people whose sufferings were like ours. He preaches of the Hebrew children and the fiery furnace, of Daniel, of Moses, of Solomon, and of Christ. What we have not dared feel in the presence of the Lords of the Land, we now feel in Church . . . we begin to sway in our seats until we have lost all notion of time and have begun to float on a tide of passion . . . we are lifted far beyond the boundaries of our daily lives, upward and outward, until, drunk with our enchanted world, our senses lifted to the burning skies, we do not know who we are, what we are, or where we are.

—Richard Wright, *Twelve Million Black Voices*

There are hundreds of Negro churches in Chicago. The great majority are "storefront" churches, places of worship located in the only space available to congregations of such limited means—former grocery, drug, or notion stores vacated by their original tenants when the white population relinquished the neighborhood. Most of these churches are occupied by the fundamentalist sects transported intact from the Southern land— Hardshell Baptist, Pentecostal, Seventh Day Adventist, Holiness, and the like. Their congregations are composed chiefly of comparatively recent "immigrants" from the South, who have brought their religion with them as they tried to bring their gardens. In these humble churches worship retains the ecstatic character and native poetry of the revivalist prayer meeting. On Sunday it is easy to hear fervent crescendoes issuing from three or four places within the same block—from across the street, from a narrow window in a basement, from a small shop between a hamburger joint and a tavern, and from a three-story brick house that has "kitchenettes for rent" on the upper floors.

The physical "plant" of the church is an almost certain index to the comparative wealth of the congregation. There are quite a few churches with imposing buildings and preachers who are men of the world. With money—no matter how little—comes sophistication, at least in the second generation. High school graduates want a different environment, a more literate approach to their faith, than their transplanted sharecropper parents. In one case at least such a second-generation congregation has taken over a former synagogue, and the resultant conflict of the stone-hewn Hebrew inscription and the recent sign "Pilgrim Baptist Church" is a monument to outward growth of the Black Belt. In such churches as these the service is much

more decorous and formal and less inspirational than in the old shops and stores. Negro society frequently belongs to churches which, in their service, have given up all specifically Negro character, such as the Episcopal church photographed in this coverage during Easter Sunday procession. Not only the service and the church, but the congregation, the minister (preacher no longer), the choir in its vestments are all exact duplicates of a fashionable white church.

The social influence of the urban Negro church, though less than that of the rural Negro church, is greater by far than its equivalent among whites. Though the preacher has had to share his position with leaders in Negro business, education, and the professions, he has not yielded his importance. He is still, ex officio, one of the chief nuclei around which the community revolves. His distinction and influence rise in inverse ratio to the social and income scale of his parishioners.

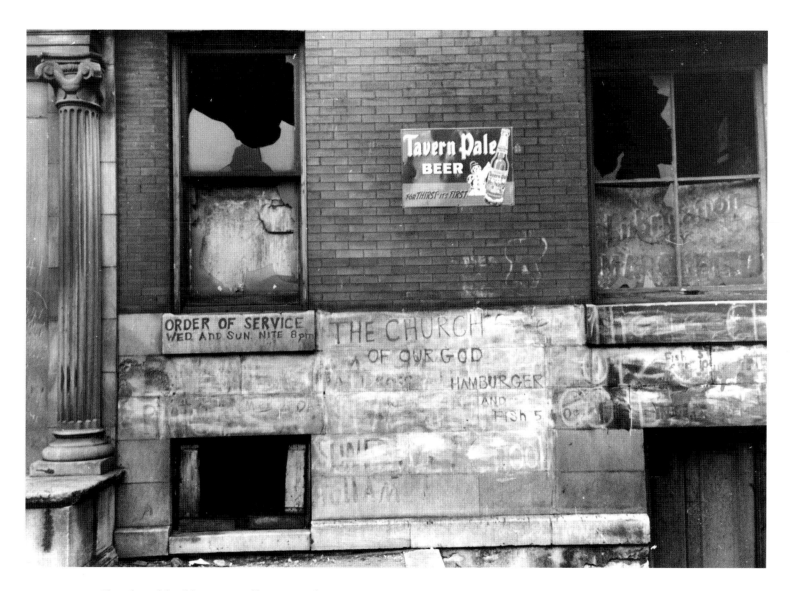

111. Abandoned building. *Russell Lee, April 1941.*

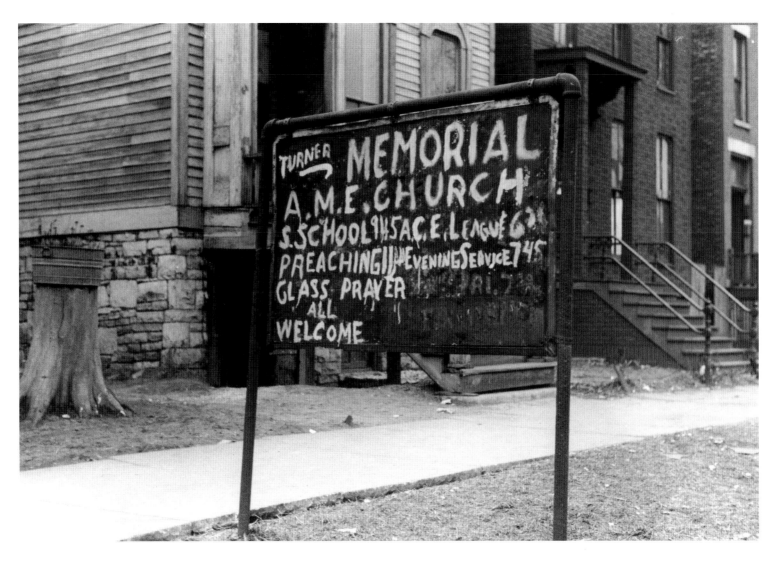

112. Sign outside of a church. *Russell Lee, April 1941.*

From [author unknown], "And Churches" [draft chapter summarizing IWP research on churches established by twentieth-century African American migrants to Illinois, and on storefront and other nontraditional black churches], "Negro in Illinois" Papers, Harsh Collection.

INDEPENDENT CHURCHES

The [independent] movement was crystallized definitely with the revolt of Dr. D. W. Cook from the African Methodist Episcopal Church to found a community church. On the first Sunday of its existence, the new church attracted a hundred persons. Now at 41st Street and South Parkway, Dr. Cook's organization boasts one of the best-known choirs in the world, called the "radio and prize-winning choir," under the direction of Wesley Jones. Officers of the church are a group of intelligent, vigorous men; and the Sunday night forum is outstanding.

Today there are about a dozen independent churches in the colored district of Chicago, the leading ones pastored by Dr. J. C. Winters and by Dr. J. Russel Harvey. This independent movement is a terror to stabilized churches, according to Harold M. Kingsley, head of Good Shepherd Church, a notable member of the group. The leading churches of the new movement, states Kingsley, are St. Thomas P. E., St. Edmunds P. E., Grace Presbyterian and Hope Presbyterian, Lincoln Memorial Congregational, and Michigan Avenue Congregational.

The Good Shepherd Church and its pastor are good examples of the modern independent trend. A practical, positive, and aggressive churchman, Kingsley's emphasis is on the virtue and value of labor and character. "He is not a religious genius," says Herbert Morrisson Smith; "instead he strikes one as a social engineer. His sermons do not discuss the golden streets of the New Jerusalem. He is more concerned with the challenge of the slums and dives of Chicago. The fact that men of this type and temper are so few and far apart in the religious history of black America makes them all the more valuable and significant when they do appear." Kingsley serves mainly a congregation of professional and upper-strata people. Good Shepherd Church has been criticized by Negroes who assert the color line is drawn within the organization, because the great majority of the members are fair skinned, as is the pastor, and they control and direct the activities of the church.

An interesting classification of Negro churches has been outlined by Reverend Kingsley; although the groupings are arbitrary, they are clear cut. Each of the types mentioned has played a role in the life of the colored community.

1. The old-line churches: the established Methodist and Baptist churches of the traditional type, all of which have permanent church buildings.

2. The storefront and house-front churches, of which there are 178 out of 278 churches in Chicago. These

churches are usually transitory and without deep root in the community, a case of the blind leading the blind.

3. Liturgical churches: the Roman Catholic, the Lutheran, and the Protestant Episcopal.

4. The fringe churches: holiness, spiritualist, and various eastern cults such as the Mohammedan Temple, Moorish cult, and others. Most of this group are thinly camouflaged with religion for exploitation purposes.

5. So-called "intellectual" churches: those which have a rationally expressed application of Christianity, of which the Congregational and Presbyterian are types.

The standard churches of the Negro community have engaged in numerous activities besides ministering to the spiritual needs of the race in Chicago. They have played a leading part in forwarding social and political movements. Two of the many projects sponsored by them are the Young Men's and Young Women's Christian Associations, which furnished healthful recreation and residence to thousands of young Negro men and women arriving in Chicago from the South during the Great Migration and later.

Numerous churches interested themselves in politics and candidates especially during the early twenties, when the Negro's political power was increasing rapidly. Certain ministers in return for services rendered received appointments to state and local offices paying handsome salaries, or dictated appointments of loyal followers. Many churches frankly used their pulpits as forums for rival candidates to plead their causes. The minister frequently played one candidate against the other and endorsed the one making the best bargain. Negroes followed the judgment of their pastors in such matters without question. In several notable instances whole blocks of votes were directly controlled by ministers. In certain mayoralty elections these votes determined the victor. . . .

The Depression which began in 1929 found great numbers of the race turning to other agencies for aid, however. . . . The church was largely unprepared for the unprecedented catastrophe that followed the market crash and stood helplessly by while other organizations lured away a sizable portion of its membership.

Although economic conditions have propelled masses of Negroes toward civic organizations, political groupings, social service agencies, and labor organizations, the colored community yet maintains approximately five hundred churches, half of them storefronts. About seventy-five thousand Negroes attend one or another of the vast variety of religious institutions. The Baptists lead the field, with the Methodists second, and Holiness churches embrace the third largest number of communicants.

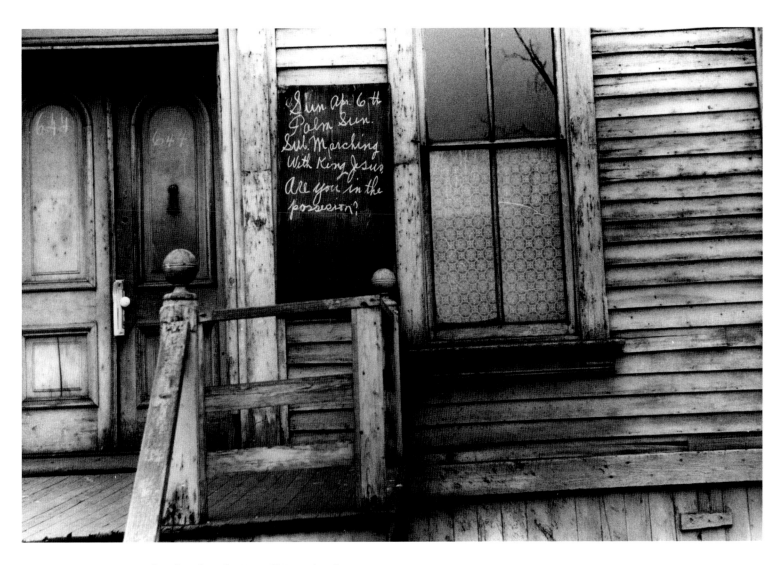

113. Sign outside of a church. *Russell Lee, April 1941.*

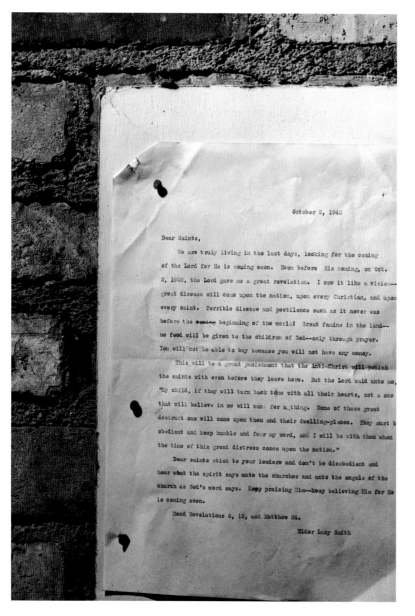

114. Letter to the congregation of the Pentecostal church.
Russell Lee, April 1941.

*From [author unknown], "And Churches" [draft
chapter summarizing IWP research on churches
established by twentieth-century African American
migrants to Illinois, and on storefront and other
nontraditional black churches], "Negro in Illinois"
Papers, Harsh Collection.*

ELDER LUCY SMITH

One more major group of churches, considered another form of
cult, is the Pentecostal denomination. Perhaps the most
famous preacher of the order is Elder Lucy Smith, a huge black
woman who boasts of being the only member of her sex in
Chicago ever to have built a church from the ground up; unlike
most other church edifices of the race in the district, hers was
not purchased from whites. Human sympathies of preachers
were typified by Elder Smith in 1932 when she set up a soup
kitchen to feed hundreds of unemployed workers. For six
months, over ninety persons daily were fed in her kitchen. Both
races were seated at table, the beneficent elder insisting that
no difference be made because of color. Described as a simple,
ignorant, untrained, but deeply sympathetic woman who
believes absolutely in her power to help and heal others, her
congregation consists largely of new arrivals from the South
and those Negroes who have not and probably never will
become urbanized. They are persons of little or no formal edu-
cation, mostly day laborers, domestic servants, WPA workers,
and relief clients.

From H. Bratton, "All Nations Pentecostal Church,"
Federal Writers' Project Records, Manuscripts Division,
Illinois State Historical Library.

ALL NATIONS PENTECOSTAL CHURCH

All Nations Pentecostal Church, 3716 Langley Avenue. Lucy Smith is known to a vast radio audience as Sister Lucy Smith. She has an ardent following of about three thousand, and is noted for her ability to arouse religious emotion. She is a Bible preacher, that is, she preaches straight from Biblical texts instead of improvising or orating her sermons. The choir contains about one hundred voices which are accompanied by drums, saxophones, and a piano.

The church is known all over the city for its singing and manifestations of primitive emotionalism. White and Negro visitors are welcomed and the most representative services are held on Sunday nights at 8 PM. On Thursday nights before the first Sunday in each month, there is a foot-washing ceremony, the significance of which is allegedly spiritual. An elaborate ritual is maintained at all times; the members are referred to as saints, and as each enters the church for worship a hand is raised skyward with palm facing forward. This indicates that the saint is saved. The walls of the basement are lined with canes and crutches, left behind by those healed.

Every Wednesday, Friday, and Sunday nights at 11 PM the choir broadcasts over station WIND.

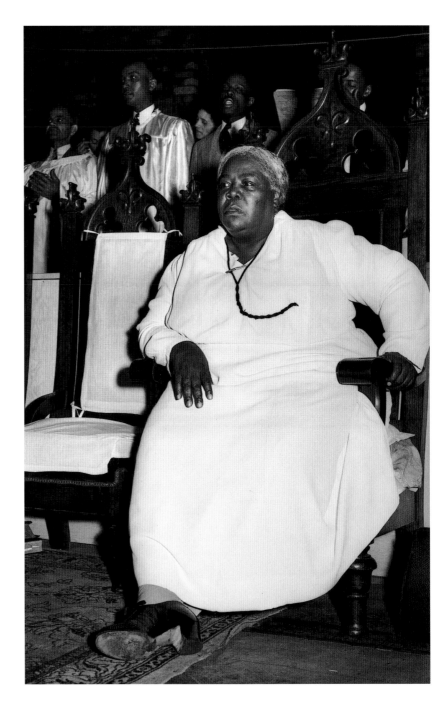

115. [Elder Lucy Smith,] pastor of the
Pentecostal church on Easter Sunday.
Russell Lee, April 1941.

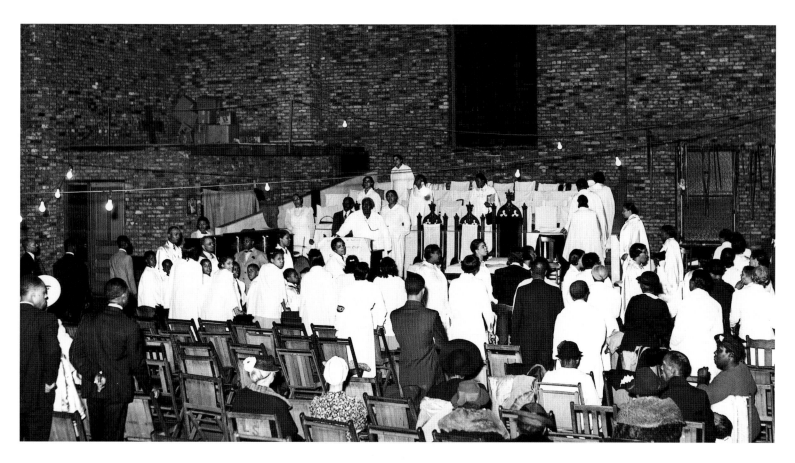

116. Opening of services at the Pentecostal church on Easter Sunday. *Russell Lee, April 1941.*

From Roscoe Johnson, "Some Folk Song Customs [divine heal-ing]," Federal Writers' Project: Negro Studies Project.

DIVINE HEALING
Some Folk Song Customs

An outstanding feature of the activities of this group is the program which aims to carry out its belief in "Divine Healing." In short, Divine Healing is one among several of the phases of the group's activities.

[The following is based on] an interview with one of the members (consultant secretary) of the Langley Avenue All Nations Pentecostal Church, and also a direct observation of a large part of the "Healing Service."

The Healing Service is held every Wednesday beginning at 1:30 PM and lasting about two hours. As the name indicates the Divine Healing theory holds to the belief that concrete physical ailments can and will be, after performing elaborate details participated in by a number of persons, completely cured. The music (piano, drum, singing, humming, and similar phenonena as instruments) is involved in bringing about the objective. . . .

I am submitting herewith an authentic pamphlet issued by the group, indicating some cases of patients and the result that is the "cure." The belief is very deep rooted. The belief enables the persons as observed at the particular meeting in question to exhibit remarkable (at least remarkable to the observer) stamina, for there didn't appear to be even a modicum of "letup" in the physical movements (which lasted for about one hour) of the participants, particularly of the administrators of the cure.

As a form of social relations there seems to exist complete rapport, so to speak, between the group of participants, from the head of the organization down (a kind of hierarchy), for as indicated the head has aids in carrying out the program, and as indicated the belief seems so deep that the regard for the efficacy of their leader will persist. There seems no doubt of the soulful earnestness of all, disregarding any comment on the concrete results of the objective. Moreover, it appears that one must consider it a privilege to be ministered to. It was observed that the secretary records the names and addresses of all who seek the service.

The healings are free; that is, no money is charged. A "free-will offering," however, is accepted. So much, then, for this interesting belief and custom.

Next there is the "Foot Washing Practice," held each Thursday night "before the first Sunday," this is, each Thursday night preceding the first Sunday of each month. Another feature is the "Spirituals" rendered by the Gospel Choir. It may be added here that there are three distinct choirs: (1) the Senior Choir, (2) the Junior Choir, and (3) the strictly Radio Choir.

The Gospel Choir is also called the Radio Choir, because it broadcasts. Held in the main auditorium of the church, these broadcasts are witnessed directly by a crowded house. The main programs are spirituals, interspersed by brief statements from Elder Smith plus a song number or two from a child of ten years. Elder Smith's daughter makes necessary announcements. These broadcasts may be witnessed directly free of charge (free-will offerings are accepted). According to Elder Smith the demand for the broadcasts requires an additional hour.

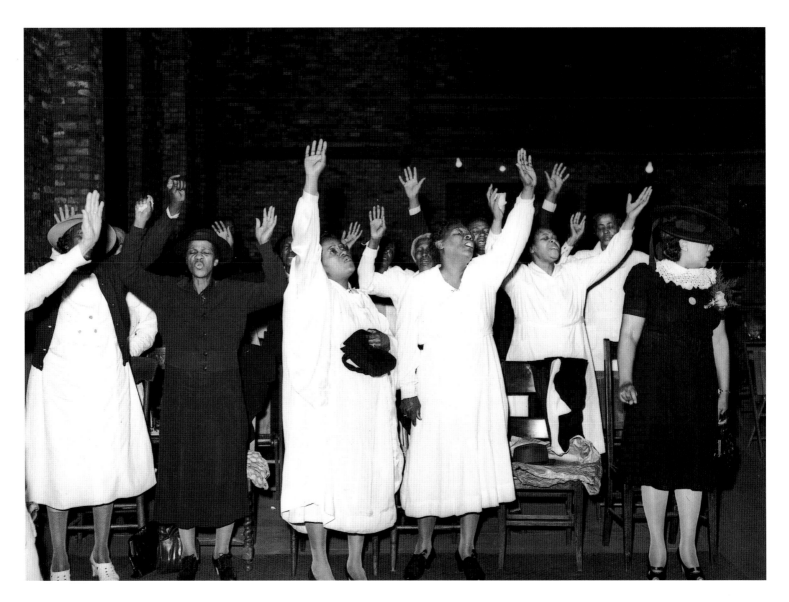

117. Members of the Pentecostal church on Easter Sunday praising the Lord. *Russell Lee, April 1941.*

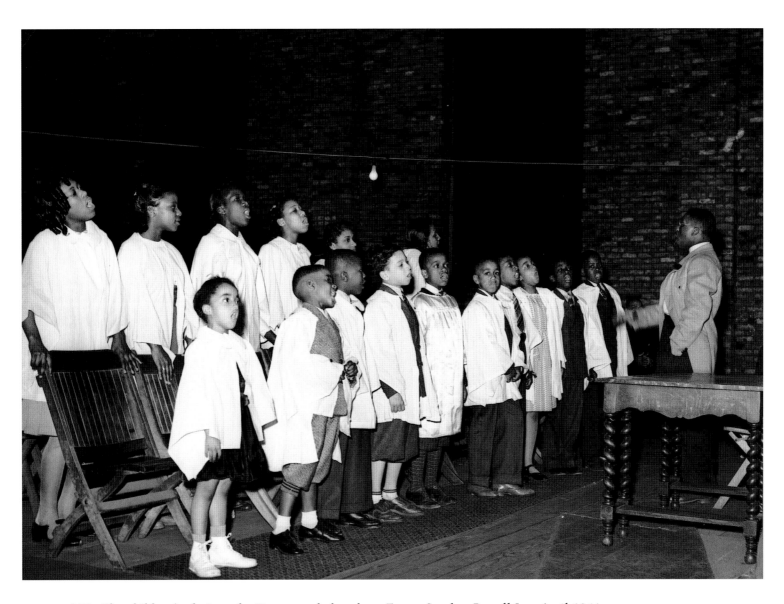

118. The children's choir at the Pentecostal church on Easter Sunday. *Russell Lee, April 1941.*

From Louise Henry, "History of Negro Music and Musicians, Churches," Federal Writers' Project Records, Manuscripts Division, Illinois State Historical Library.

HISTORY OF NEGRO MUSIC AND MUSICIANS

Purple Rose Mystical Temple: Storefront. Congregation does not exceed fifty. Meetings of some kind almost every night in the week. Choir consists of ten people. Sing anthems and religious sanctified as the choir leader informed me. Original song: "The Lord Is Watching Over Me, Oh Yes." A Mr. Alruthius Taylor is the composer.

Walters A. M. E. Zion: F. W. Fisher is conducting a revival. He is an evangelist of national note. Carries with him a five-piece band which he terms his gospel band. Specializes in gospel songs. Travels throughout the country conducting revivals of seven- and ten-day durations. The minister recites a parody on "Precious Lord" and "Breathe on Me."

Mt. Nebo: Storefront. Small congregation. No special choir. Entire audience sings. Songs syncopated and consist of spirituals and gospel songs of all sorts. Two years old.

Hebrew Church: Songs different. Conduct service in Hebrew. Chants seem to be a specialty. Arrangement on "Ali, Ali." Congregation small.

Church of God in Christ: Small churches built on gospel songs. Entire congregation takes part—the larger churches of this denomination have regular choirs.

Crossroads to Happiness (foot washing) Church: The church is very small but has a choir of twenty. The songs are all gospel ones. Choir director Mr. Mose McReynolds composed a song which they sing called: "Wait Until Jesus Comes." It is unpublished.

Watering Station for Souls: Sanctified church. Meetings conducted in songs and testimonies. Mr. Jones leader of singers. Original songs: "I've Been to That Watering Station," "When I Saw the Writing on the Wall," and "He Told Me So"—all unpublished.

Brother Beal's Church: The minister's wife, a former cabaret singer, is the leader of the choir. It is a Holy Roller's church and the songs are typical. There is a Miss Lewis, who, upon hearing the testimonies of the members, has made up a melody which we might say is a cross between everyday swing and the classics. The members merely chant as an accompaniment "Yes, Lord." She has also written, or rather composed, "When That Great Day Comes," "I Was Wrong but I Ain't No Mo," and "Redemption of Souls."

Peter's Rock: Very small church. Songs are not unusual—anthems and gospel plus a few spirituals are sung. No original songs.

St. John's A. M. E. Church: A large church in Englewood district. Sing regular church songs—say they do not sing spirituals and believe we as Negroes should get away from them.

Shiloh Baptist Church: Another church in Englewood district: congregation of about three hundred fifty. Choir of about twenty-five. Sing spirituals and gospel songs. Do a special arrangement of "Precious Lord." Have a choir of about thirty children ranging from four to eight. Have gone all over the city giving concerts and have appeared on station WCFL.

New Thought Baptist Church: Small church. Choir of about fifteen people. Leader Mrs. Janie Wright. Mr. Ray Johnson wrote "He Left Me and I Went Astray." Miss Rosie Sampson wrote "When We Meet We Shall Rejoice." Singing very good.

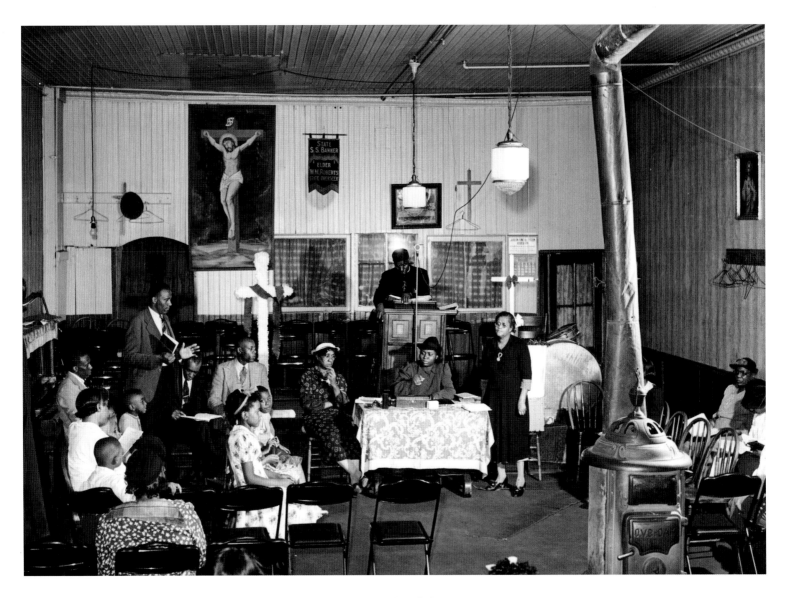

119. "Storefront" Baptist church [or Church of God in Christ] during services on Easter morning. *Russell Lee, April 1941.*

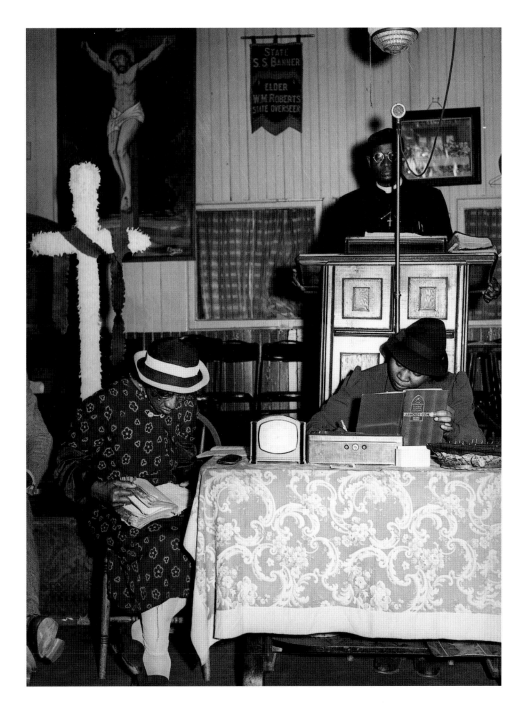

120. During the services at a "storefront" Baptist church [or Church of God in Christ] on Easter Sunday. *Russell Lee, April 1941.*

From Edwin Rosskam, "Holiday," FSA/OWI General Caption. RA/FSA/OWI Written Records.

HOLIDAY

These pictures were taken on Easter Sunday. Their subject matter varies from the Easter Parade outside a Congregational Church to the crowd outside a Negro moving-picture theater at matinee time. What the pictures cannot convey is the rainbow of color in both men's and women's clothing.

On days such as Easter Sunday, Negro "society" parades as white "society." The photographers of the Negro press "shoot" the prettiest and the most socially prominent for the Chicago *Defender* or the Pittsburgh *Courier.* Negro "society" is an exact replica of white "society" on a lower income level. Imitative of its white example, Negro "society" is, if anything, more restrictive and more proper. Its activities include teas, dances, coming-out parties, etc.

The children in front of the motion-picture house in the majority of cases come from "kitchenette homes." It is continually astonishing to see the high standard of appearance and clothing among people living in the worst slum conditions.

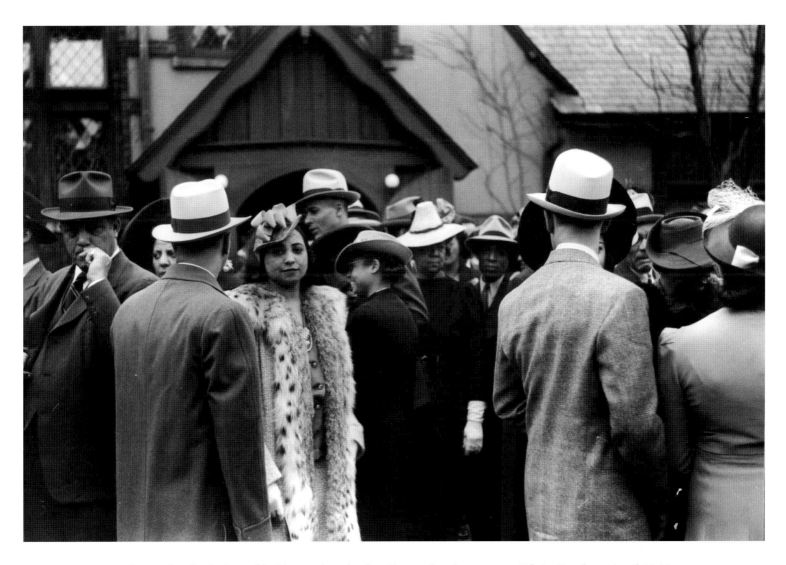

121. Crowd outside of a fashionable Negro church after Easter Sunday service. *Edwin Rosskam, April 1941.*

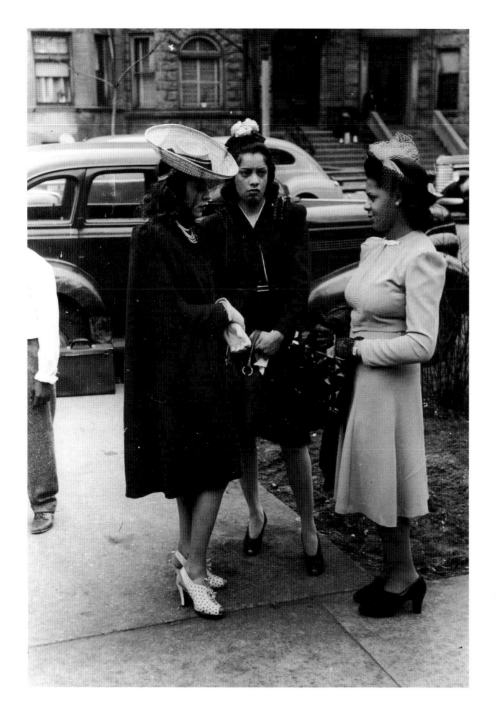

122. Part of the Easter parade on the South Side. *Russell Lee, April 1941.*

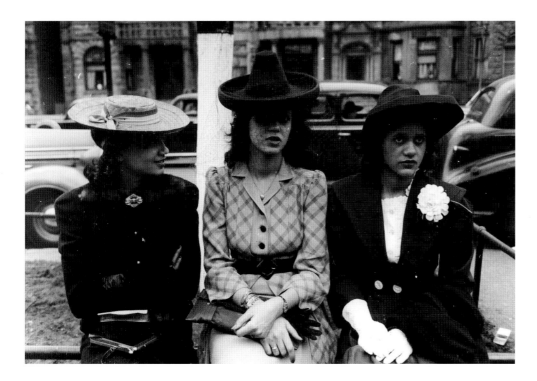

123. Girls waiting for Episcopal church to end so they can see the processional. *Russell Lee, April 1941.*

124. Untitled. *Photographer unknown [either Lee or Rosskam], [April 1941].*

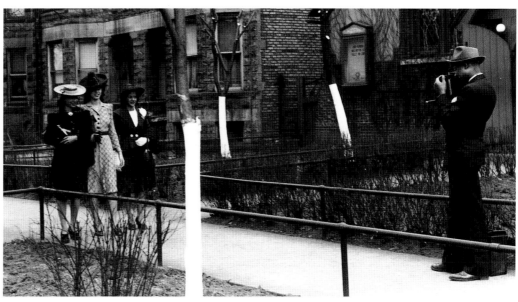

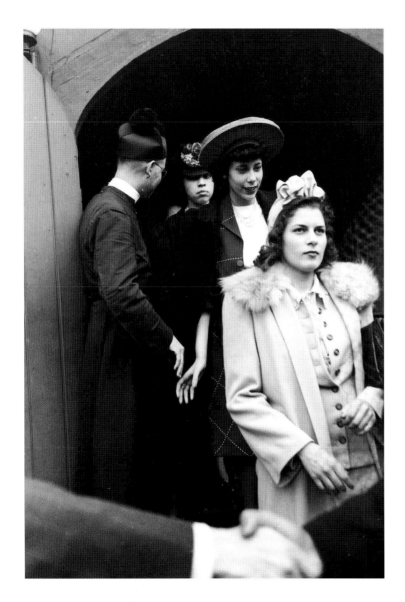

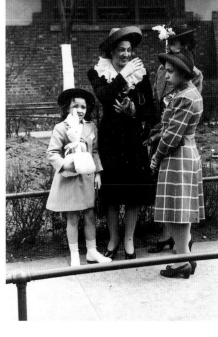

125. Shaking hands with members of the congregation after Easter services at an Episcopal church. *Russell Lee, April 1941.*

126. Group of people talking in front of church. *Russell Lee, April 1941.*

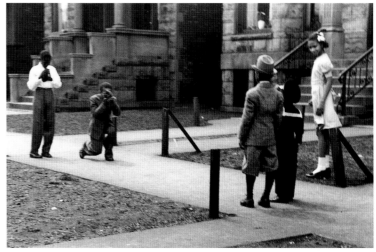

127. Untitled. *Photographer unknown [either Lee or Rosskam], between 1935 and 1942 [April 1941].*

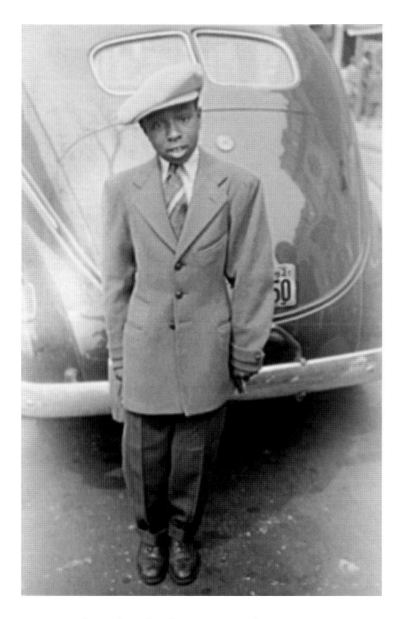

128. Boy dressed up for the Easter parade.
Edwin Rosskam, April 1941.

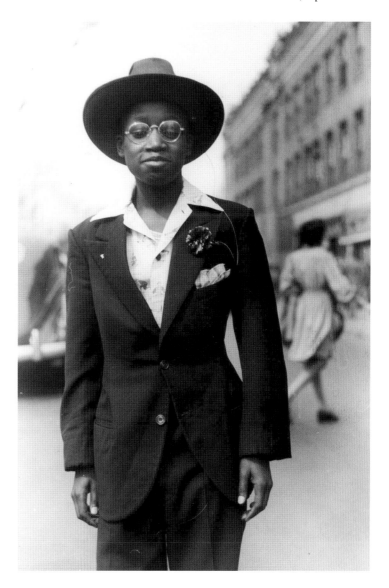

129. Young boy dressed up for the Easter parade.
Edwin Rosskam, April 1941.

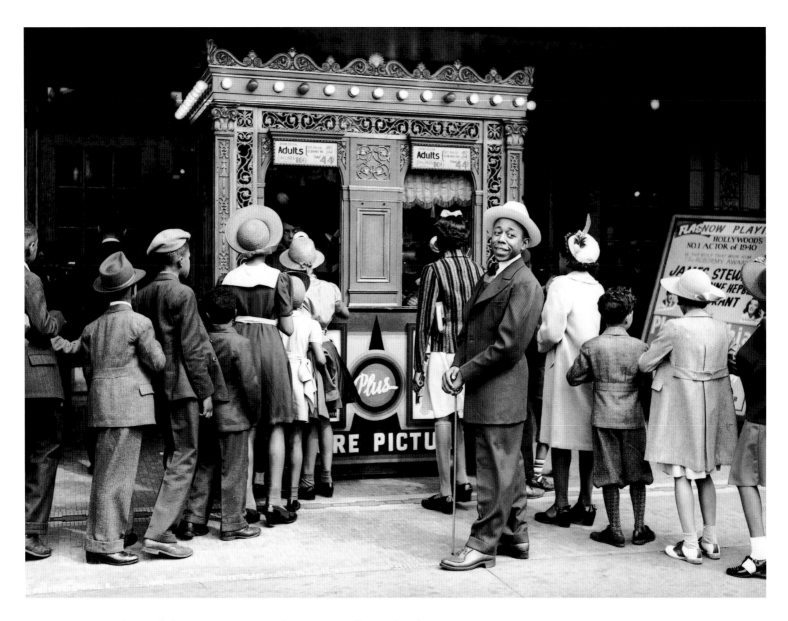

130. In front of the moving-picture theater. *Russell Lee, April 1941.*

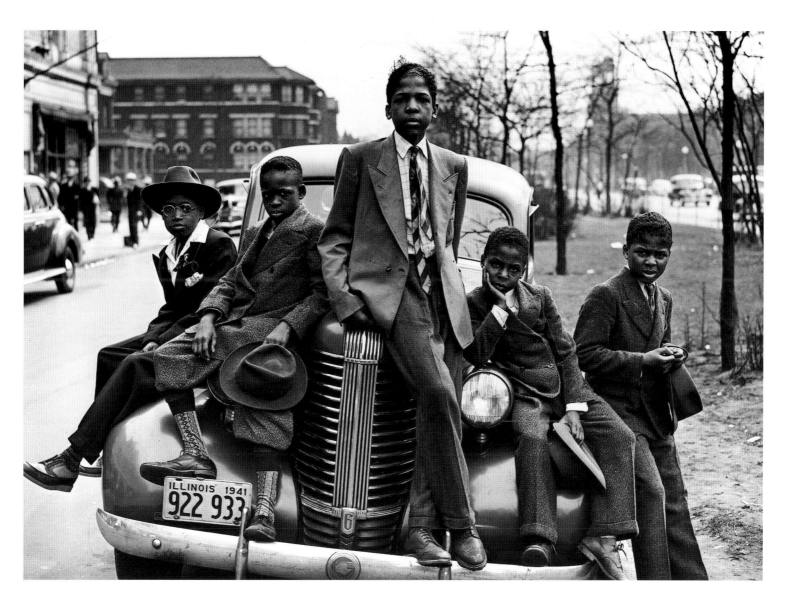

131. Negro boys on Easter morning. *Russell Lee, April 1941.*

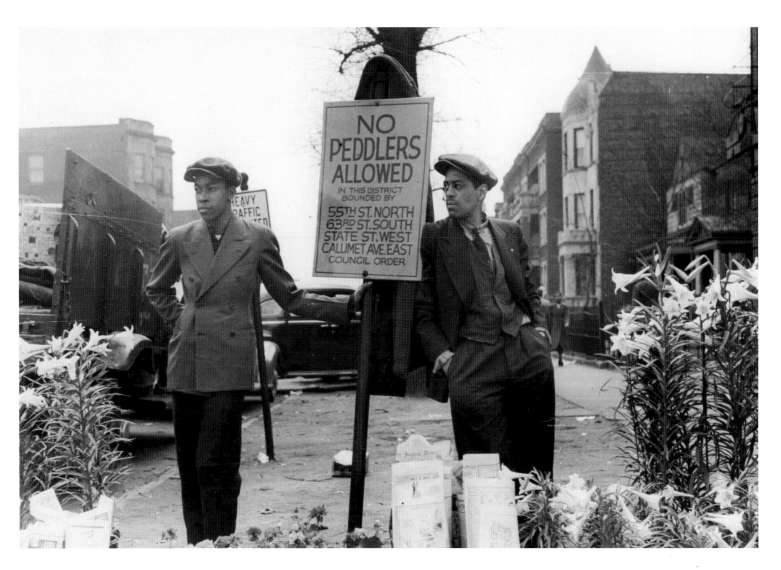

132. Peddlers on Easter morning on Garfield Boulevard. *Russell Lee, April 1941.*

From L. Jackson, "Music [Pilgrim Baptist]," Federal Writers' Project: Negro Studies Project.

THE CHOIRS AT PILGRIM BAPTIST

There are no particular types of music peculiar to this district. Jazz is the only folk dance.

There are only two composers that live or did live in this district and they are Earl Hines, who used to live at 3628 Calumet Avenue and Louis Armstrong, who lives at 3533 South Parkway.

Pilgrim Baptist Church has four choirs and each has its own organist. They are: The Regular Senior Choir, with Mrs. Ion Trice, organist, and Prof. G. A. Gillet, director, J. C. Austin, pastor. The Gospel Chorus, with Mrs. Mabel Hamilton, organist, and Prof. Thomas A. Dorsey, director. The Sunday School Chorus, with Mrs. Charlene Willet, organist, Miss Ethel Knox, organist, and Mrs. Fuqa, directress. Pilgrim Church is located at 3301 Indiana Avenue. These choirs may be heard at various times during any of the regular services. The Gospel Chorus, under the direction of Prof. Dorsey, has been broadcasting each Sunday night at 9:30 over station WCFL. . . .

From H. Clayton, "Survey of Negro Music [gospel song]," "Negro in Illinois" Papers, Harsh Collection.

THOMAS A. DORSEY AND GOSPEL SONG

Still another type of music to come out of Chicago and gain popularity in recent years is the so-called "gospel song." In less than twelve years, these "swing spirituals" have pushed all other sacred music into the background in many Negro churches. According to Thomas A. Dorsey, the leading writer and purveyor of the new religious songs, they are "gospel sermons preached in music." Though this type of music made its appearance in 1905, it was in the thirties that it gained wide popularity, its rise being due mainly to Dorsey, formerly a composer of blues. When he started writing these "new spirituals" in 1928, he found no market. For a number of years he and his associates traveled the country over singing them to the people. Many churches closed their doors to him. But despite opposition he established a reputation, and before his travels ended, many of the same churches were clamoring for his and other gospel composers' works. The Gospel Choral Union of America, a national organization promoting this music, was formed in 1932 by Dorsey, with headquarters in Chicago and branches throughout the country. Although of Negro origin, "gospel songs" appealed to others as well, as revealed by Dorsey's statement that 30 to 40 percent of his customers were white. Most popular of these compositions were two by Dorsey. "How About You?" and "Precious Lord Take My Hand," and one by Roberta Martin, "Didn't It Rain?" . . .

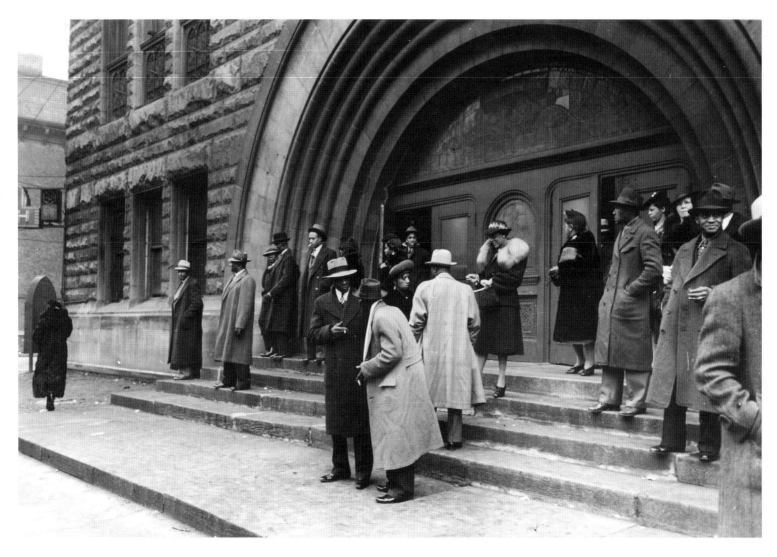

133. In front of the Pilgrim Baptist church on Easter Sunday. *Russell Lee, April 1941.*

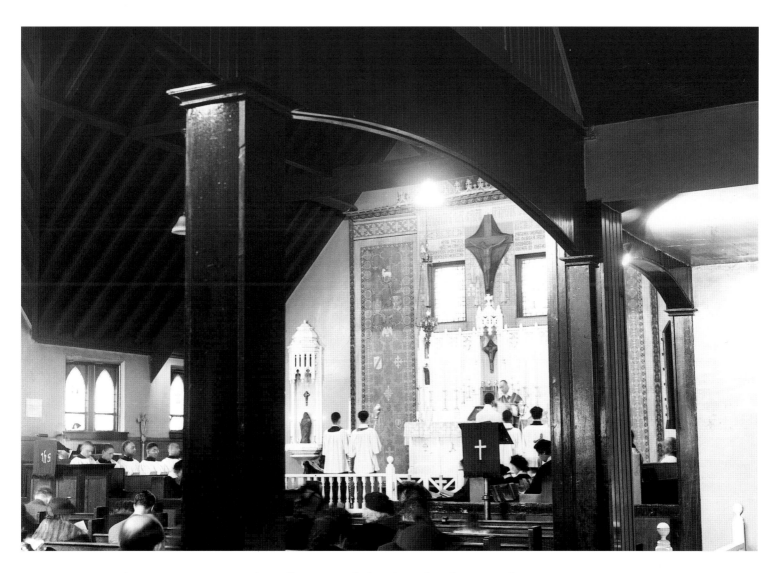

134. Sunday morning at Saint Edmund's Episcopal church. *Jack Delano, March 1942.*

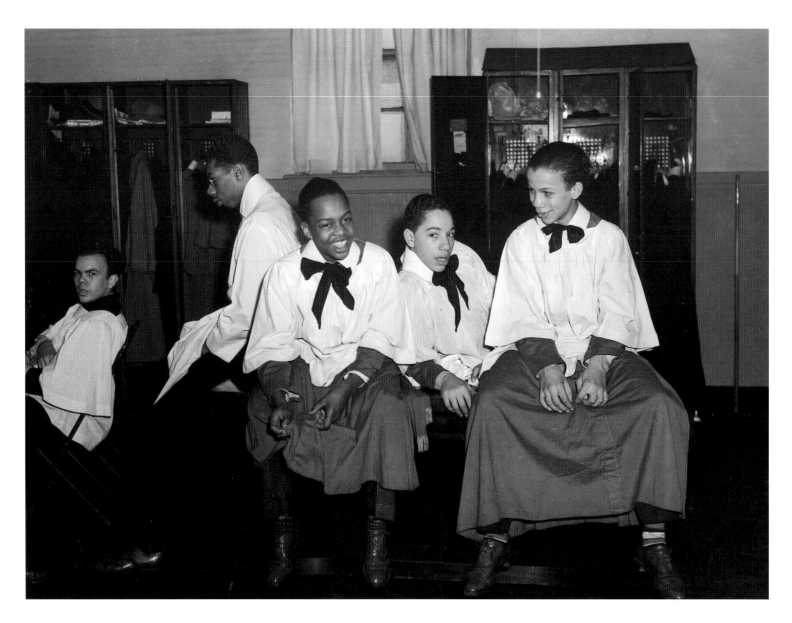

135. Sunday morning at Saint Edmund's Episcopal church. *Jack Delano, March 1942.*

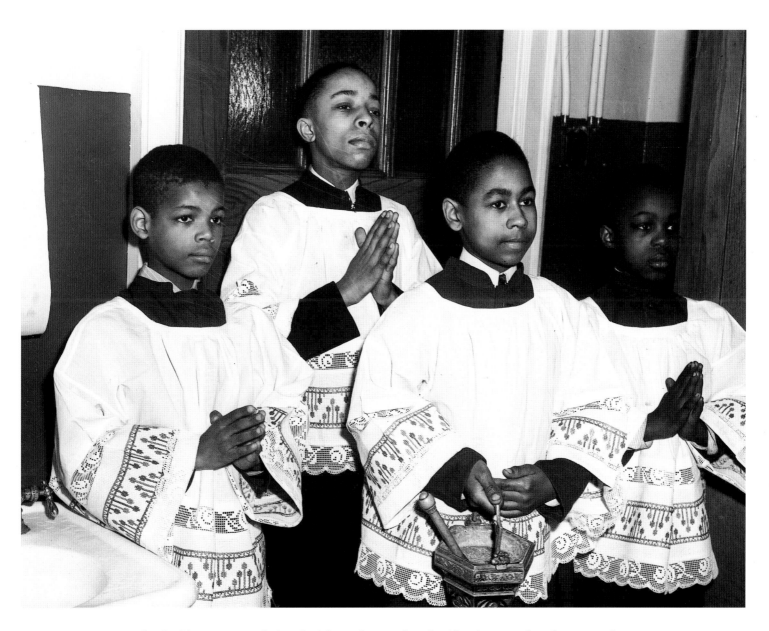

136. Saint Elizabeth's Roman Catholic church on the South Side. Altar boys. *Jack Delano, March 1942.*

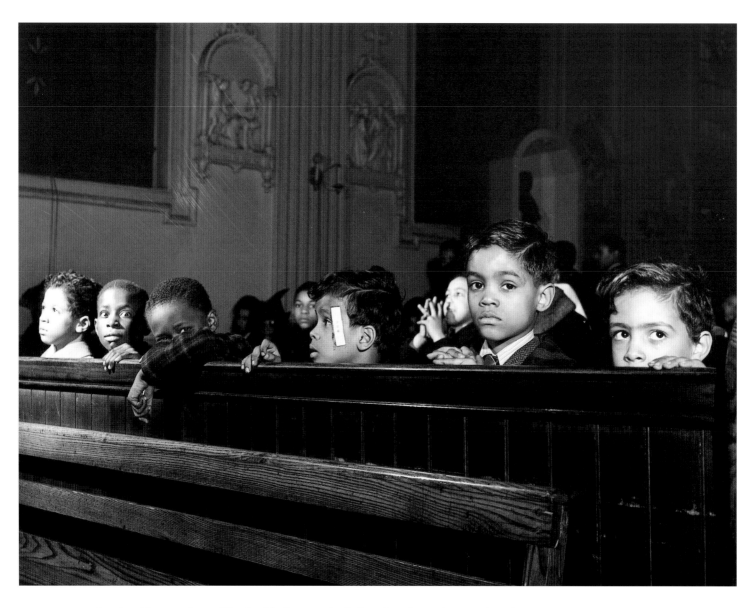

137. Sunday Mass at Saint Elizabeth's Roman Catholic church on the South Side.
All the pastors here are white with the exception of Father Smith. The congregation
is made up entirely of Negroes. *Jack Delano, March 1942.*

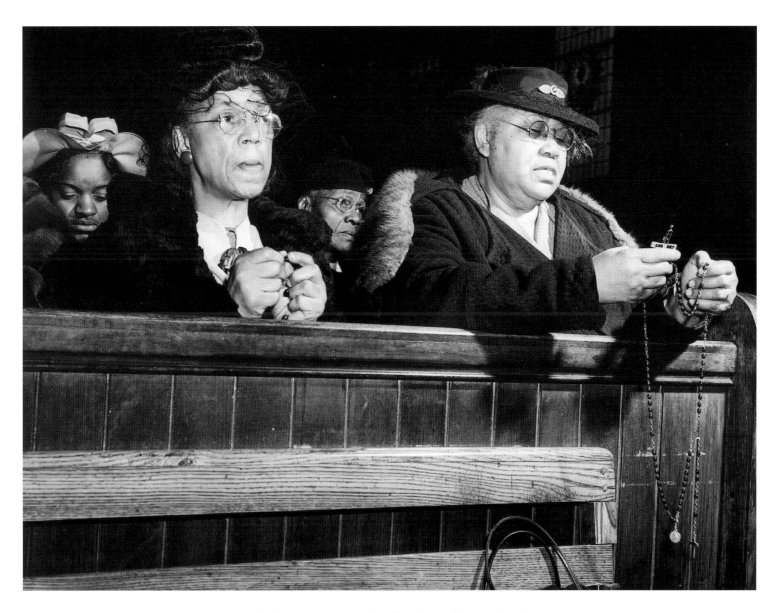

138. Sunday Mass at Saint Elizabeth's Roman Catholic church on the South Side.
Jack Delano, March 1942.

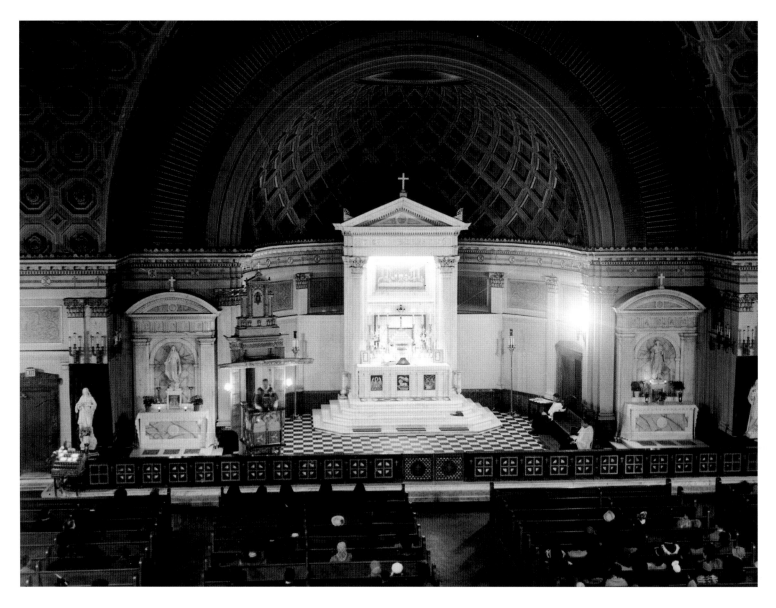

139. Church services at Corpus Christi Roman Catholic church on the South Side.
The pastor, Father Refinus, is white, and 98 percent of the congregation are Negroes.
The total church membership is over two thousand. *Jack Delano, March 1942.*

Part Four

GOING OUT

From Margaret Brennan, "Recreation Facilities in Chicago's Negro District," Federal Writers' Project: Negro Studies Project.

RECREATION FACILITIES IN CHICAGO'S NEGRO DISTRICT

During the postwar period the growth of the Negro sections of the large cities of America has become of intense interest to the public. We hear much of New York's Harlem and of the Beale Street district in Memphis, the former through the works of left-wing literati and the latter through the syncopations of "Tin Pan Alley" Mozarts.

But bronze Chicago is neglected, despite her Ivory Coast and her boast of representation in the national House of Representatives, the Illinois Senate and the Illinois Assembly, and the Chicago City Council. The neglect is not justifiable, if what one should see on a cruise of the district between 43rd and 63rd Streets and between Wentworth Avenue and South Parkway is evidence.

We have referred to the Ivory Coast. The Ivory Coast is a soubriquet the daily newspapers of Chicago have applied to 47th Street and South Parkway, the present Chicago Negro Rialto. It is a popular stroll for colored people and on holidays and evenings it is crowded with the pleasure lovers of the Negro race, usually well dressed and many of them in high-powered automobiles. When the lights blink at night the wayfarer might, so far as the spirit of the matter is concerned, compare it favorably with New York's Times Square. For at 4719–24 South Parkway is the Regal Theatre, the largest motion-picture house for Negroes in Chicago. . . . The Regal Theatre, in addition to first-run pictures outside of the Loop, presents Negro stage shows. Many of the outstanding Negro theatrical stars have appeared on its boards, among them Miller and Lyles, Sisa and Blake, Duke Ellington, Ethel Waters, Louise Beavers, and Stepin Fetchit.

Next door to the Regal Theatre is the Savoy Ballroom. It is the largest dance hall for Negroes, perhaps, in America. . . . The other dance hall for Negroes is not exactly on the Ivory Coast, but is located at 4859 Wabash Avenue. It is Bacon's Casino and is purely a Negro investment. The remaining dance hall is the Roseland Ballroom, 4711–17 South Parkway. . . .

Though this district needs a YMCA, sadly there is none. The Wabash Avenue YMCA at 38th Street and Wabash Avenue is overcrowded and, apparently, would not be injured if in a city so heavily populated by Negroes another Negro YMCA came into existence and especially to serve this district. . . .

The park necessities of the people are served by the South Park, 51st to 55th Streets, and Washington Park, 55th Street to 61st Street. During recent years the Washington Park lagoon has been idle so far as boating is concerned and park athletics

revived only through the advent of WPA. The old Washington Park Refectory is now the fieldhouse. Occasionally there are open-air performances near the fieldhouse; but the band concerts, so prevalent as late as the Coolidge administration, are now merely memories.

As for bathing beaches there are none. Children joyfully wade in the duck pond in South Park for both wading and diving. How the Negro in this district can enjoy, so far as pleasure bathing is concerned, what other Americans and even aliens can enjoy is a problem for the sociologists.

The spirit prompting this district can be preserved only through heeding the silent prayer of the Negro home builder against the riotous invasion of his garden districts by the tavern and the nightclub and such cheap contrivances as barbecue stands and hot dog wagons and the pernicious, greedy scheming of real estate brokers, regardless of race, that results in the lowering of residence standards.

It must be remembered that what injures one group of people injures all.

From Edwin Rosskam, "Night," FSA/OWI General Caption. RA/FSA/OWI Written Records, Federal Writers' Project: Negro Studies Project.

NIGHT

The music of the Negro, his sense of rhythm and his talent for the dance, sprung from an age-old folk tradition, have given him a chance at employment in an industry where he is generally accepted—entertainment. Negro musicians, dancers, waiters, etc., make their living mostly at night. In Chicago there are several nightclubs in the Black Belt which cater to a white clientele. But Negroes themselves love nightlife and have many places where—at lower prices and in less elaborate surroundings—they enjoy the same entertainment with greater verve.

In addition to Negro nightclubs, there is the whole range of tavern life, from the "classic" establishments where a scotch and soda costs 40¢ to the workers' taverns where a large beer, two slices of bread, and a hot dog cost a dime. A Negro sociologist points out that the complete lack of privacy, home life, and a decent place to spend an evening leads even low-income Negroes to patronize taverns to a degree out of all proportion to their financial abilities.

Bowling is a favorite pastime among Negroes as among whites. Roller skating is a favorite in the younger set. A well-known Negro orchestra such as that of Count Basie will draw a packed, standing audience of thousands, who weave ecstatically to the hot tunes—in unison: there is no room to dance. And of course there are the movies.

Social clubs with wild names such as "the Hellions" give large dances by invitation. And occasionally there is a low-priced pay-dance where the poorer class can go.

Negro nightlife is as overcrowded as Negro day life. Few facilities are available. And yet out of this complex network of fetid dives, taverns, and nightclubs continues to spring music to which all America listens on the radio.

140. Night club, beauty shop, public baths, and entrance to an apartment building in the Black Belt. *Edwin Rosskam, April 1941.*

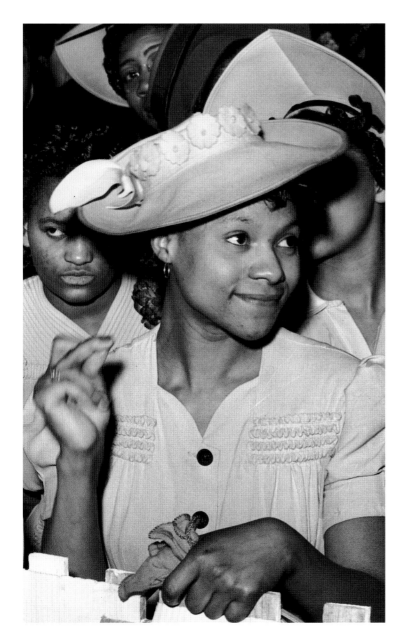

141. Girl listening to music at a dance.
Russell Lee, April 1941.

From Richard Wright, "Amusements in Districts 38 and 40," Federal Writers' Project: Negro Studies Project.

AMUSEMENTS IN DISTRICTS 38 AND 40

After leaving 35th Street on South Parkway, the most attractive place of entertainment is the Grand Terrace Dine and Dance Cafe at 3955. It caters to a high-class clientele and is visited by those seeking good food and good music. This establishment is one of the most popular and best known of all Black Belt night-clubs. It was opened in 1929 at a cost of $100,000. Structurally it is a very pleasing place. It is about fifty feet wide and reaches in length back to the alley. A huge red electric sign covers its facade.

It possesses a splendid dance floor, accommodating about two hundred. Its seating capacity is five hundred and fifty. The interior is excellently arranged. The orchestra is far to the rear, fronting the café and dance floor. The tables are in front, facing the door. The lighting is very diverting. It is next door to the 40th Street "L" station and enjoys remarkable parking facilities for automobile tourists. There is no cover charge at any time, and good food is served at medium prices. There is courteous usher advice.

The most distinctive feature of the Grand Terrace is Earl Hines's NBC orchestra which is known the nation over. Hines is known in music circles as the "peer of modern jazz." Four floor shows are given nightly; it is an all-Negro revue. The place opens at 10 PM and runs till 5 AM.

Further south, at 4418 South Parkway, is the Poro Tea Room. It is housed in an old brownstone mansion. The furnishings, even to the woodwork and lighting, are the same as when the original owners occupied it. This tearoom serves the best food to be found on the South Side at very reasonable prices. The tearoom itself consists of two large rooms, in one of which is a very entrancing water fountain. The place is quiet, clean, and is frequented by those seeking seclusion and privacy.

After leaving 43rd Street on South Parkway we enter what is popularly known on the South Side as the "promenade." This name comes from the fact that this section, reaching from 43rd to 51st along South Parkway, houses the most fashionable shops and stores. On holidays, such as Easter and Christmas, Negroes parade up and down here, dressed in their best finery.

At 4544 South Parkway is the Metropolitan Movie Theatre, the second most popular movie palace in the Black Belt. The front is of white stone, a large part of which is covered with bright electric signs. It specializes in first-run pictures, like *G-Men*, *Top Hat*, and *Imitation of Life*. The interior is spacious and comfortable. The usher system is polite and efficient. The parking facilities for tourists are good. The price of admission is 25¢ for adults and 15¢ for children. In summer there is a "cooling system."

Diagonally across the street from the Metropolitan Theatre is the Regal Theatre, at 4723 South Parkway. This is the largest and finest of the movie palaces to be found in the Black Belt area. It was erected in 1929 at a cost of $1,000,000. It, like the Metropolitan, specializes in first-run pictures. They also carry occasional stage shows, starring such stage, dance, and music celebrities as Ethel Waters, Cab Calloway, the Mills Brothers, Bill Robinson, Duke Ellington, and others. The parking facilities are excellent and there is an efficient usher service. In front, covering the entire facade, is a gigantic electric sign, shedding a red haze for blocks around.

The interior is actually beautiful and is agreeably lighted. The whole architectural structure of the interior is Far Eastern in design, producing an enchanting Moorish atmospheric effect. The dome, huge and high, is tentlike in character and gives the spectator the sensation of being seated out of doors under a clear sky.

The admission is 40¢ and the hours are from 2 PM to midnight. The theater is surrounded by candyshops and lunch counters. There is an excellent "cooling system" in summer.

(There is in the inner lobby of the Regal Theatre a bronze statue. It was made by an Italian artist named Rondoni in the year 1873. It bears the inscription *Sirma*. This statue was imported by the management when the theater opened. No one, however, seems to know whether the statue has any artistic significance or not.)

A few doors south of the Regal Theatre is the Savoy Ballroom. In the late twenties this was the most popular dance hall on the South Side. Louis Armstrong used to play here to huge crowds. There are no regular dances at the Savoy; the floor is rented out to various clubs, societies, etc. On holidays it is open for business.

Next door to the Savoy Ballroom is the Savoy Outdoor Boxing Arena, seating about five thousand. Here on Tuesday nights are given boxing bouts, mostly amateur. The admission runs to about 40¢, plus tax. This amateur boxing is followed by the athletic-minded on the South Side. The usual "card" consists of ten boxing bouts and two wrestling matches. Adjoining the arena is a training headquarters. Joe Louis, contender for the World's Heavyweight Championship, trained here for his

bout with King Levinsky. It is also used by Joe Louis for training purposes when he is in the city.

Walking southward along South Parkway we pass the homes of wealthy Negro publishers, doctors, bankers, lawyers, and businessmen. Turning westward at 49th Street and walking to Wabash Avenue we find Bacon's Casino Dance Hall at 4859 South Wabash Avenue. This hall, though not as ornate as the Terrace Garden, is very popular among the so-called "social set" of the South Side. No regular dances are arranged by the management. Clubs, societies, etc., rent the hall for various affairs. The place is busy almost every night. The parking facilities are good. The price of admission varies from time to time.

Returning again to South Parkway and continuing to 51st Street we find the Grand Hotel which houses a very popular beer tavern, the Grand Hotel Tavern at 5044 South Parkway. Its clientele is mostly of a sporting, theatrical, and traveling character. On 51st Street there are many taverns of a mediocre sort.

It is not until we reach Garfield Boulevard that we see the heart of the Negro Rialto district. Along Garfield Boulevard, from South Parkway to State Street, are dozens of beer gardens, restaurants, shops, policy stations, "chicken shacks," horse racing, bookies, pool rooms, and small hotels. Here is the center of gambling, prostitution, and "high life."

Perhaps the most popular of all nightclubs in this area is Dave's Cafe at 243 East Garfield Boulevard. The exterior is rather unattractive, but within it vies the Grand Terrace in ornateness. There is a large dance floor, and a very novel lighting system. The parking facilities for automobile tourists are excellent, and its location is but a block from the intersection of State and Federal highways. Unlike a great many nightclubs, it maintains an open lunch counter at all hours. There are three floor shows on Saturday nights. The admission is 50¢ for weekday nights. On Saturday nights it is $1.00. There is food at medium prices.

The most distinctive feature of Dave's Cafe is the nine-piece orchestra of François. It broadcasts twice a week over WIND. Of all the nightclubs on the South Side carrying the old-time atmosphere, Dave's Dine and Dance Cafe is the most typical. There is no cover charge.

Vying for second place in popularity is the Panama Cafe just a few steps west of Dave's Cafe at 307 Garfield Boulevard. There is no admission and no cover charge. The clientele here is a "rougher" caliber than that at Dave's Cafe. It is quite lively.

Still further west on Garfield Boulevard, at 317, is Ciro's Cocktail Lounge. This bar specializes in drinks, and has quite a reputation in this area. Floor entertainment is also featured. Each Sunday afternoon, between the hours of 5 PM and 7:30 PM, is known as "cocktail hour." Drinks can be had as cheap as 20¢. The clientele is predominately Negro.

Walking still further west on Garfield Boulevard till we reach State Street, we find a nightclub of the old 1920s variety—the Club DeLisa at 5516 South State Street. There is an average bar, and a huge dance floor. The place is Italian owned, and caters, it is rumored, to "gangster trade." It is very popular with the more daring "nighters-out." The exterior is very attractive, being a design of white and green coloring. The bar is open all day; the dance floor opens around 10 PM.

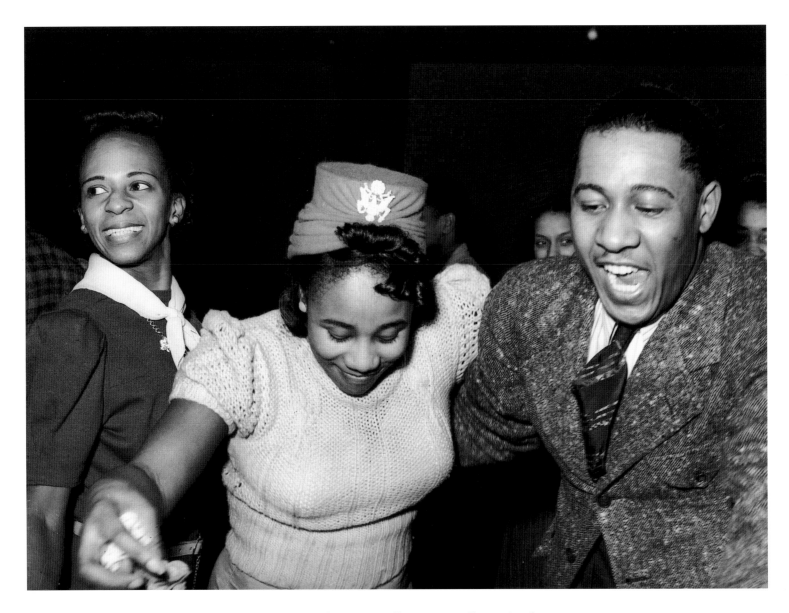

142. Having fun at a roller-skating party at the Savoy Ballroom. *Russell Lee, April 1941.*

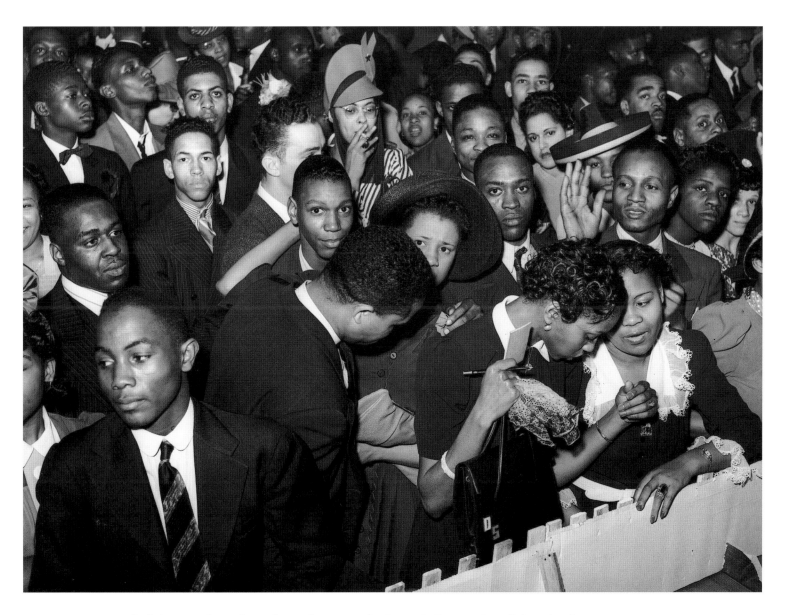

143. Detail of the crowd watching the orchestra at the Savoy Ballroom. *Russell Lee, April 1941.*

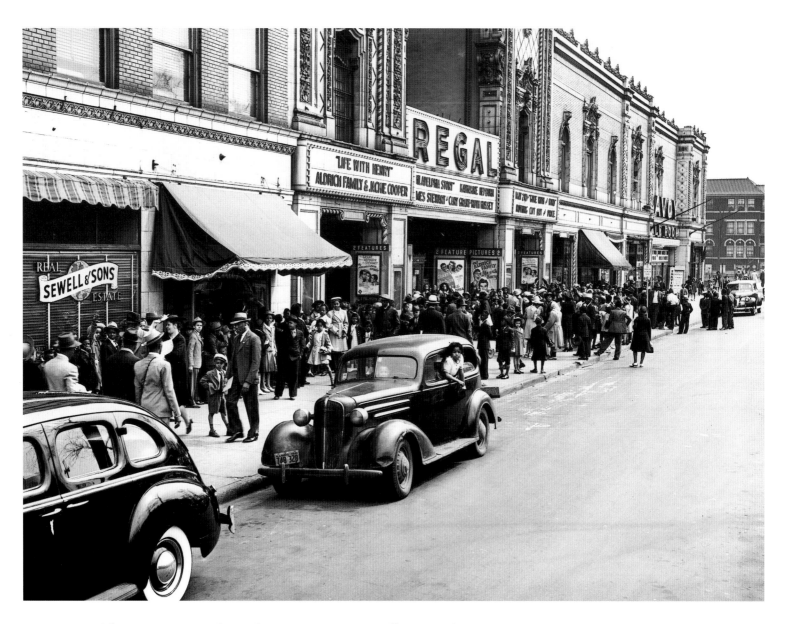

144. The movies are popular in the Negro section. *Russell Lee, April 1941.*

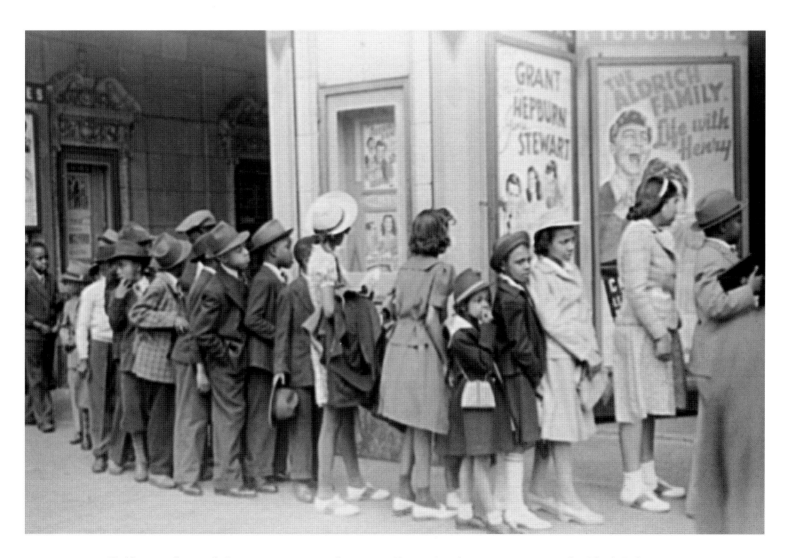

145. Children in front of the moving-picture theater on Easter Sunday at a matinee in the Black Belt.
Edwin Rosskam, April 1941.

From M. Bunton, "Taverns," "Negro in Illinois" Papers, Harsh Collection.

TAVERNS

Saloon keeping for Negroes is an ancient occupation. As early as 1769 an emancipated slave named Emanuel left an estate valued at five hundred and thirty-nine pounds which he had accumulated operating the first oyster and ale house in Providence, Rhode Island. He was the forerunner of the large number of black saloon keepers, restaurants, and caterers who followed in the next century. . . .

In 1933, the Eighteenth Amendment was repealed. First 3.2 beer appeared, sold at street stands, but gradually, liquor was housed and the old-time saloon became, instead, a tavern.

In 1937, the number of retail liquor establishments in Chicago exceeded the number of licensed ones in any other year including those of the pre-Prohibition era. The pre-Prohibition peak was reached in 1905 when 8,097 saloon licenses were issued. In 1934, 8,052 licenses were issued; in 1935, 8,682; in 1936, 9,173; and in 1937, 9,331.

An indication that these taverns are doing good business is that 91.6 percent of the 1936 licenses were renewed in 1937.

In the area bounded by 31st, 71st, Cottage Grove, and State Streets, there were 269 licenses issued to dealers in retail liquors. They were distributed in the following manner:

Taverns	70 percent
Restaurants	15 percent
Drugstores	5 percent
Retail liquor stores	3 percent
Grocery stores	2 percent
Cabarets and nightclubs	1 percent

In all sections there are two kinds of taverns, one patronized by a "sporting" class and the other by the "working" class. The two are distinctly different in atmosphere, appearance, attendance, type of drinks served, the manner of consumption, the

conversation of the patrons, hours open, and the attitude and behavior of the respective owners and bartenders to the clients. Even persons who frequent both places alter their behavior accordingly.

A working-class tavern might be described as one which is quiet, light, and in which profanity is rarely heard. A number of workers are often seen in parties slowly consuming their beer and talking earnestly over the day's policy drawing or clearing house results.

Equally characteristic of the sporting-class taverns where "business" seems to be paramount and the drinking or fraternizing more casual, are quick straight drinks, women on the "make," and discussion of the day's horse races.

In one are husbands and wives who have been trying to "catch" policy in order to buy clothes or place a downpayment on furniture; in the other are the racehorse touts, pimps, prostitutes, and bar flies. In one, quiet is the order, in the other a nickel vendor never stops.

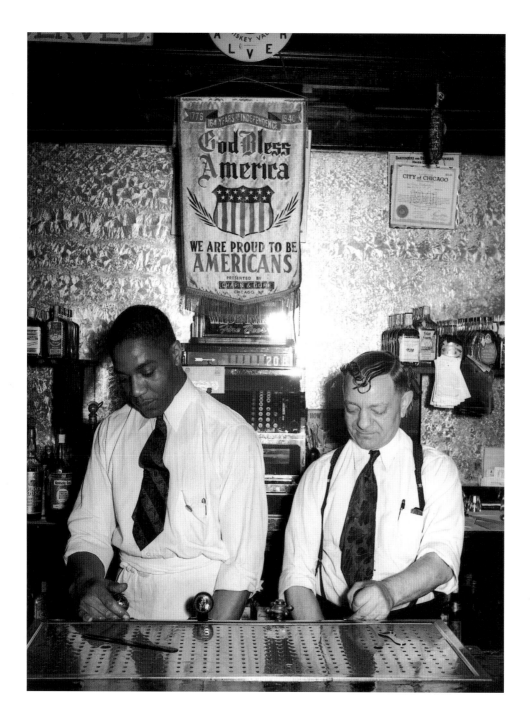

146. Bartender and owner of a
tavern on the South Side.
Russell Lee, April 1941.

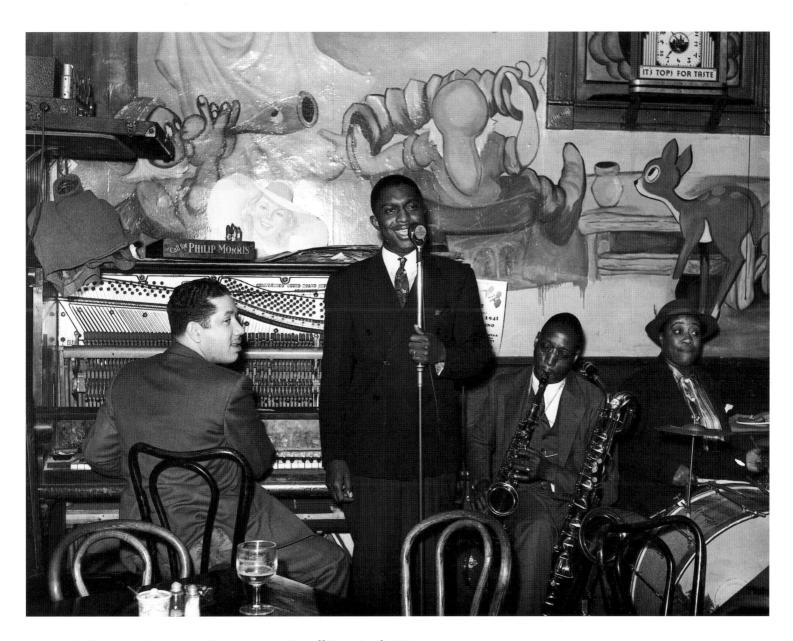

147. Entertainers at a Negro tavern. *Russell Lee, April 1941.*

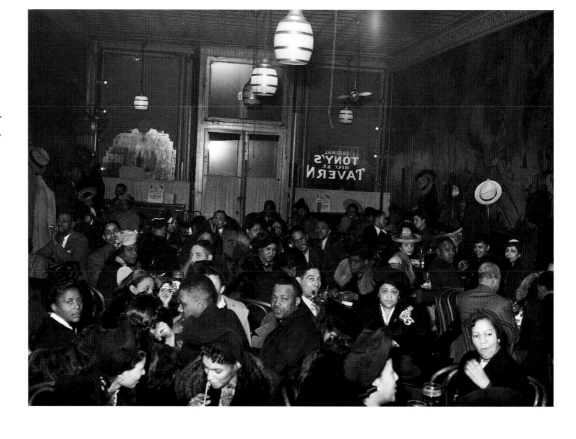

148. Tavern on the South Side.
Russell Lee, April 1941.

From Onah Spencer, "Negro Music and Musicians [Tony's Tavern]," Federal Writers' Project Records, Manuscripts Division, Illinois State Historical Library.

TONY'S TAVERN

But for strictly shirt-sleeved slumming, *Tony's Tavern*, Federal and 31st Street, is tops, decorated in the Snow-White motif with Walt Disney's gnomes and princesses of a fairyland smiling down on Gilbert Stewart's Three Piece Swing Set.

Professor Holmes, a tuxedoed baritone with a first-rate voice, does vocal, while an old Uncle Ned type who looks as though he just laid down his shovel and his hoe has picked up—of all things—a bazooka. Old, brassy, and soldered, yet when the ancient musician blows in, weird noises still come out. Here a sandwich or a few shrimps are served with every beer. For polyglot contrasts, slumming parties should add this one to their *musts*.

Summing up all South Side joy spots, I should like to add that in addition to first-rate food, drink, and entertainment, one is likely to find in this section more visiting celebrities than you can shake a stick at. Slim, of Flat Foot Floogie fame, Stuff Smith's guitarist, and Count Basie and band members were volunteer performers at the various spots last week.

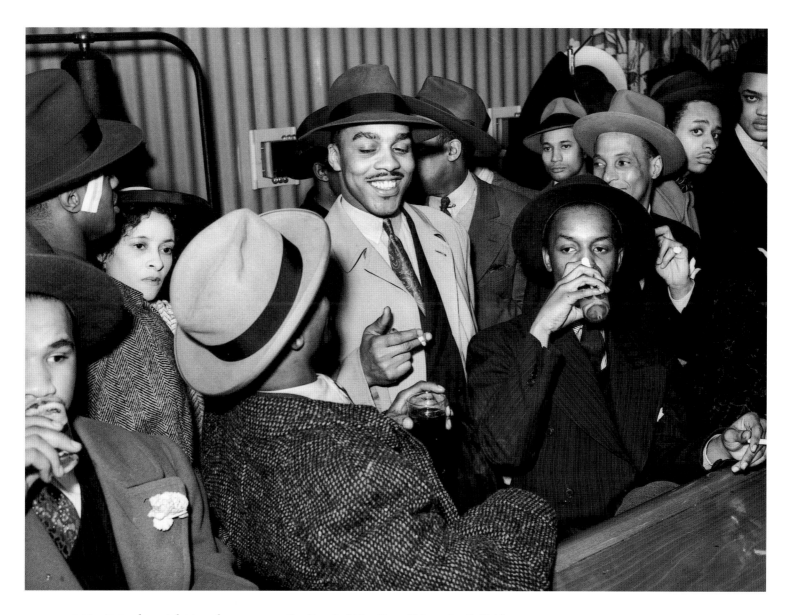

149. Saturday night in a barroom on the South Side. *Russell Lee, April 1941.*

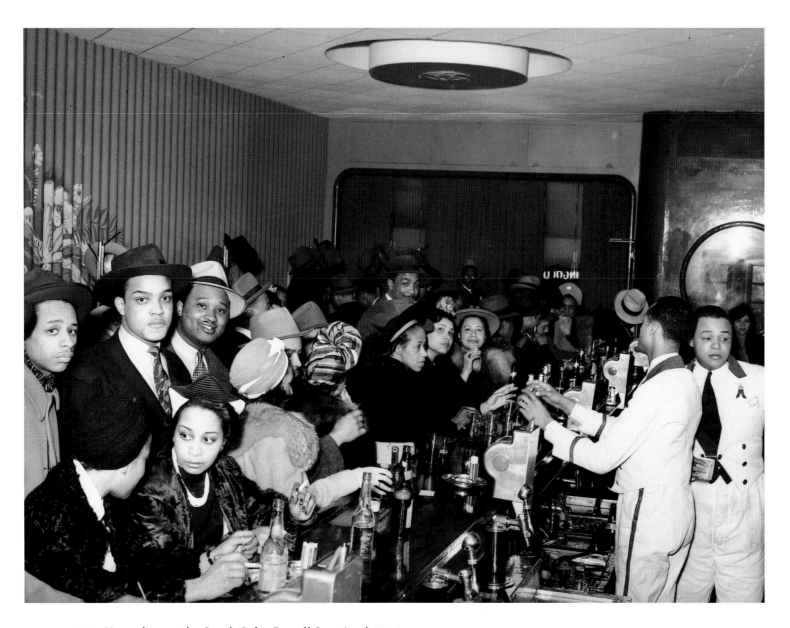

150. Negro bar on the South Side. *Russell Lee, April 1941.*

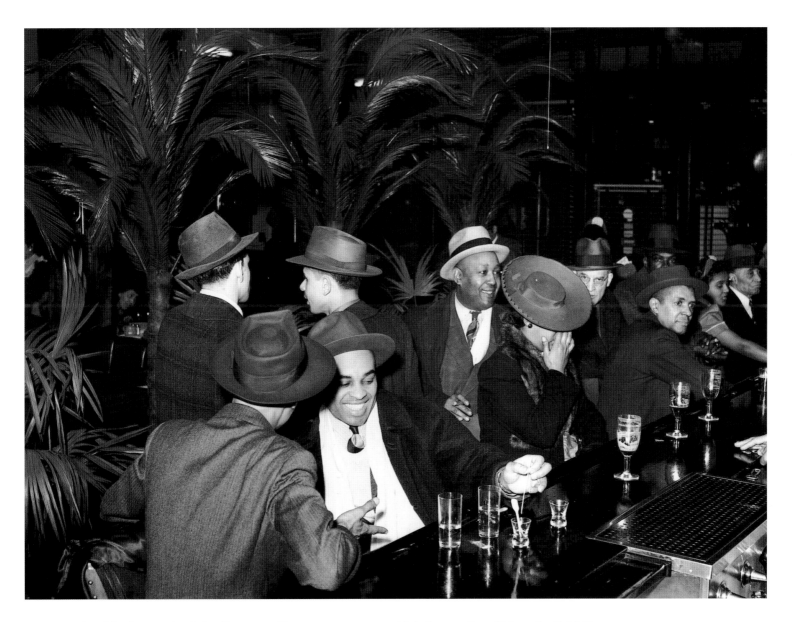

151. The bar at the Palm Tavern, a Negro restaurant on 47th Street. *Russell Lee, April 1941.*

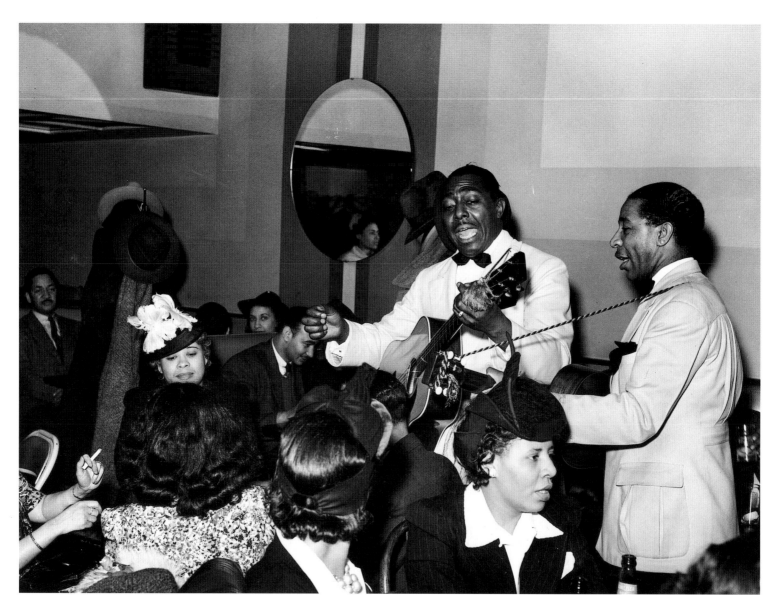

152. Tavern on the South Side. Musician at the right is Lonnie Johnson, famous blues singer. *Russell Lee, April 1941.*

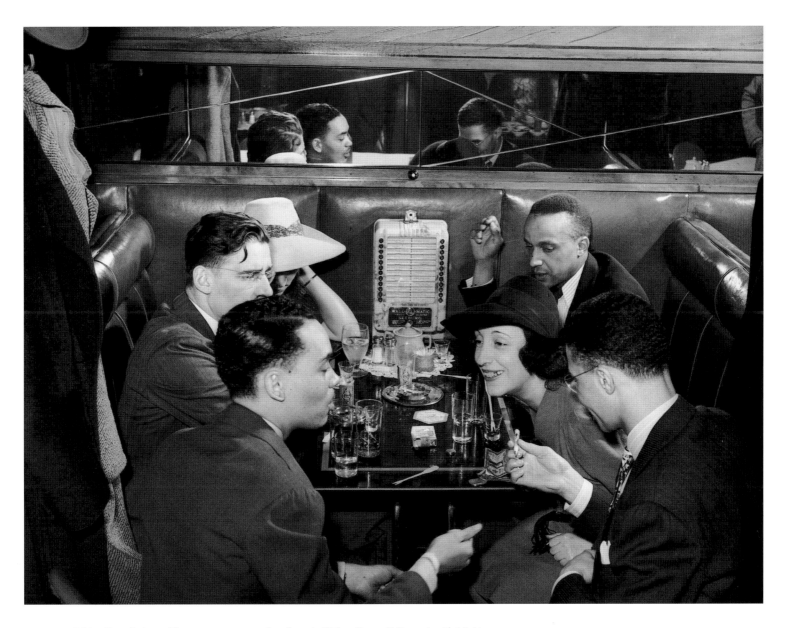

153. Booth in a Negro tavern on the South Side. *Russell Lee, April 1941.*

From Richard Wright, "A Survey of the Amusement Facilities of District 35," Federal Writers' Project: Negro Studies Project.

A SURVEY OF THE AMUSEMENT FACILITIES OF DISTRICT #35

State Street, from 2600 South to 3600 South, is almost solidly lumpen-proletariat. The places of amusement are many, but of a single character. Numerically, the beer taverns predominate, there being about twenty-five. Dingy cafés and restaurants are a close second, there being about twenty. There are eight pool rooms, seven drugstores, four smoke shops, and two movies.

This section was once the high spot of the Negro Rialto district. That, however, was in the prosperous twenties. Since then the more well-to-do workers, gamblers, pimps, prostitutes, sports, and businessmen have moved southward to the vicinities of 47th and 55th Streets. What this section once was can be seen from the numerous "for rent" and "for sale" signs hanging in store windows. Many of the establishments are now completely abandoned. Official notices of "this building is condemned" are posted in many places. Crumbling walls and peeling paint are everywhere. Lurid advertisement posters are plastered on the sides and walls of buildings.

Most of the beer taverns are dark, dank places where the neighborhood drunks hang out night and day. The beer sells for 5¢ and 10¢ a stein. The whiskey for 25¢ a drink. Usually a bowl of soup, crackers and shrimps, a hot dog, or an egg is given with a purchase of beer. Electric pianos are an added attraction. The larger places are owned by Jews, Greeks, and Italians. The smaller ones by Negroes. Each place employs from three to five people, paying them from $5 to $8 per week.

The "day" business of these taverns is small. But they are crowded to capacity at night. The more pretentious taverns have small orchestras which play for customers. In the more ornate establishments a floor show is arranged. There are costumed cigarette girls and waitresses. Dancing is permitted. Usually there is no cover charge, for competition is keen. The cost of the entertainment is recovered through the sale of high-priced drinks. The talent of the entertainers is nil. Most of them are amateurs, and are secured from nearby neighborhoods.

The ideological import of the entertainment is largely sexual. Blues and popular songs are sung. Dances, such as the "Continental" and "Snake-hips," are performed. Fights are many and frequent.

All of these taverns, no matter how small or mean, strive to maintain a homelike atmosphere for their patrons. The names of the taverns run something like this: Jim's Place, Babe's Tavern, Bob's Beer Shop, etc. The customers know the proprietor and the proprietor knows the first names of many of his customers.

As strange as it may seem, a great many "bootleg" joints are still doing a rushing business in this area. The reason for this is not far to seek. The price of legal whiskey is still much too high for many of the poorer drinkers.

However, the old-time "beer flats" have completely vanished. With the legalization of whiskey, the alcoholics have transferred their patronage to the tavern. The hangers-on are for the most part habitual drunkards, unemployed workers, petty thieves, prostitutes, and a few young men still in high school.

Perhaps the most affluent of the State Street taverns is the Cabin Inn at 3353. The floor show is reputed to be the best on the South Side. It is what is known as a "black-and-tan" tavern, that is, it caters to Negro as well as white trade. Many of the jokes, songs, and dances of the entertainers find their way into the daily speech and actions of the people.

The next in popularity is the South Side Cotton Club at 3445 State Street. Its entertainment generally resembles that of the Cabin Inn. . . .

If the taverns are dingy, the restaurants are dingier. Some of them are huge places, reaching back to the alleys. Others are but shacks held together by rusty pieces of tin and old boards. Some handle a well-rounded menu while others specialize in unique dishes, mostly of southern origin.

Perhaps the largest and most typical of these restaurants is Footes' Restaurant at 3032 State Street. Because of the low-priced food, this place is almost always crowded. Like the others it is dingy and unclean. A bowl of hot soup can be had for 5¢. Rice and gravy for 5¢. Coffee and doughnuts for 5¢. Corn beef hash for 10¢. Etc., etc.

The next in esteem is Bud's Eat Shop at 3406 State Street. This place specializes in fish, tripe, and short orders.

The Lincoln Doughnut House at 3033 State Street is among the best in the neighborhood, serving food at medium prices. There are many chili parlors, selling chili at 10¢ per bowl.

There are numerous lunch wagons, shoeshine and soft-drink parlors, red-hot stands, hamburger stands, and barbecue pits. Most of the ice-cream parlors are closed because of winter.

Vying for third place among the amusement spots is the pool room. If it can be imagined, these sink in general character even below the tavern and restaurant.

The proprietors of most of them are Negroes. Each pool room carries its own unique following. Some of these places are indeed vicious. Unsuspecting strangers are lured in and filched of their money through various schemes and rackets. Nothing is done to make these places physically attractive. The walls and ceilings are usually bare and full of cobwebs. The floor is bare and littered with cigar and cigarette butts. The plumbing is bad. Many of them are heated with stoves. A typical description of a pool room in this vicinity would run something like this: A store about thirty feet wide and from sixty to ninety feet long. Two, three, four, or five sagging billiard tables. A few rickety chairs lined along the walls. Stale air. One or two rusty spittoons. A short cigar counter behind which stands the owner and his cash register. That is all.

The smoke shops have the air and character of smoke shops everywhere. A straggling crowd files in and out of them. It is here that the neighborhood wiseacres congregate to dispute the merits of political and religious isms.

Only incidentally are the drugstores places of amusement. They carry many "chance games" which attract crowds. Slot machines, punch boards, and various other gambling devices lure many.

There are two main theaters on this section of State Street. At the lower end of the district is the State Street Theatre which is widely patronized. It specializes in sex, murder, gang-

ster, adventure, and western films. It is an ill-smelling and dank house, seating about a thousand. It keeps the sidewalk littered with lurid posters. The other theater is the Grand at 3110 State Street, and is of like calibre.

These two theaters employ bold means to lure their customers. When there is a red-hot murder mystery film, they hire "sound trucks" to patrol the streets of the neighborhood. Handbills and throw-aways are given to passersby. They also operate weekly and nightly contests to keep the interest of their customers. Cheap glassware, cheap cigarette cases, and other bits of tinsel are given to the holders of lucky numbers.

The influence of these two theaters reaches deeply into the everyday life of the community. The gestures and idioms of the movie stars are aped by the schoolchildren and adults.

Wabash Avenue presents a sharp contrast to State Street. From 26th Street to 36th Street there are no places of amusement worth mentioning. . . .

It is not until we reach Cottage Grove Avenue that taverns and pool rooms again become prevalent. And it is well to remember that this street is the so-called "dividing line" between the white and black neighborhoods. Naturally, some of the places are *understood* to be for white and others for Negro. The street is mainly commercial. Tinsmiths, tailors, realtors, doctors, notion stores, etc., form the bulk of the business establishments. Most of the stores are owned by Jews and Greeks.

There are about ten taverns in the ten-block area. On the whole they are of a better character than those found on State Street.

Thirty-first and 35th Streets are the two main business thoroughfares running east and west through the district. The places of amusement have the same general tone of those on State Street and Cottage Grove Avenue. . . .

Generally, this about covers the amusement, entertainment, and recreational facilities to be found in this district. There are, however, other places of amusement of a peculiar nature—that is, sponsored by various churches. But these are so mixed in character that I think it advisable to report on them separately.

154. Good Shepherd Community Center. Two of the actors with Mr. Langston Hughes discussing the script of a new play during rehearsal. *Jack Delano, April 1942.*

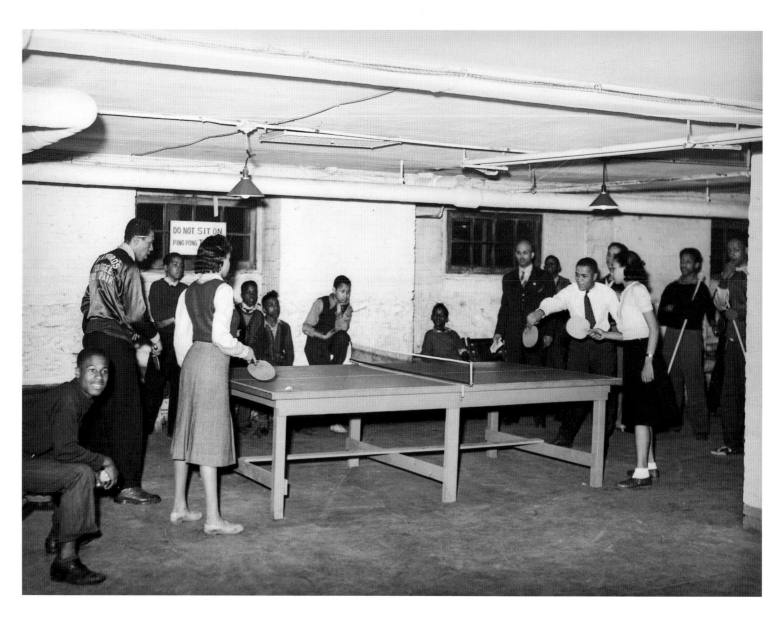

155. The basement of the Good Shepherd Community Center is largely used for recreational purposes. *Russell Lee, April 1941.*

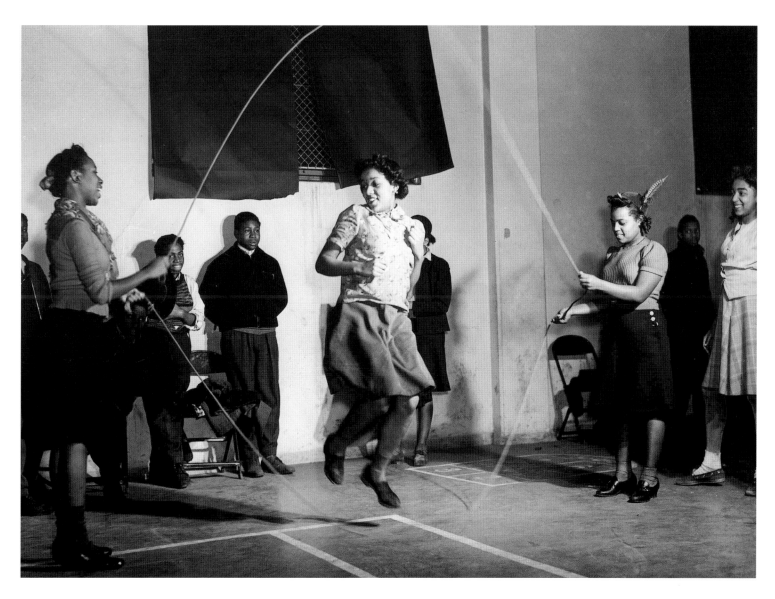

156. Ida B. Wells housing project. Skipping rope in the recreation hall at the community center.
Jack Delano, March 1942.

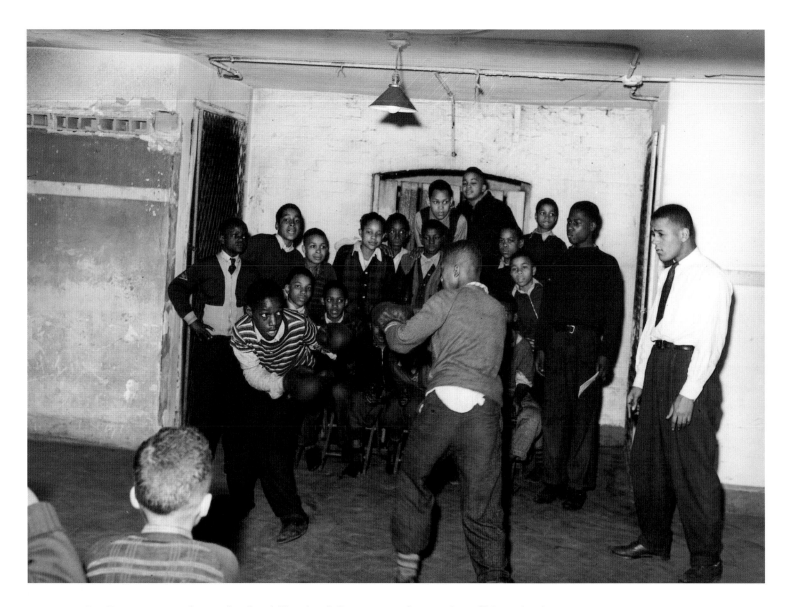

157. Boxing is popular at the Good Shepherd Community Center. *Russell Lee, April 1941.*

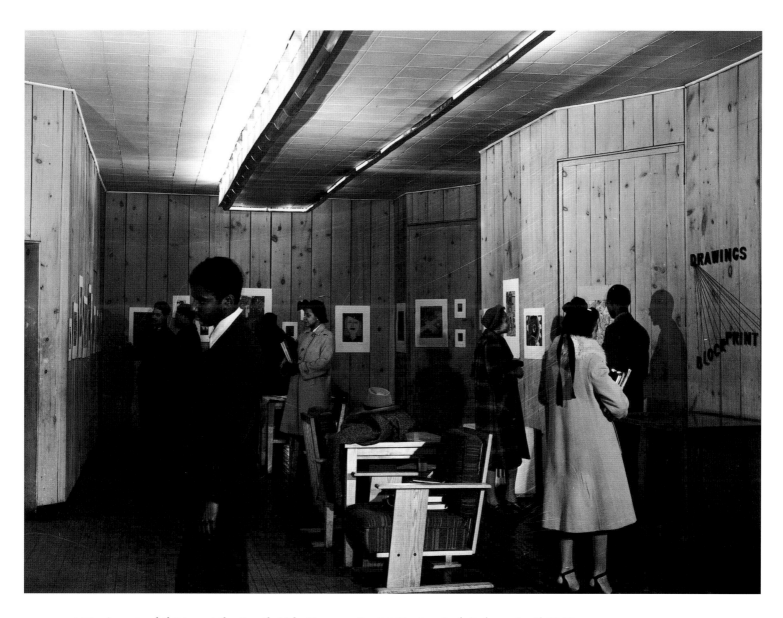

158. An art exhibition at the South Side Community Art Center. *Jack Delano, April 1942.*

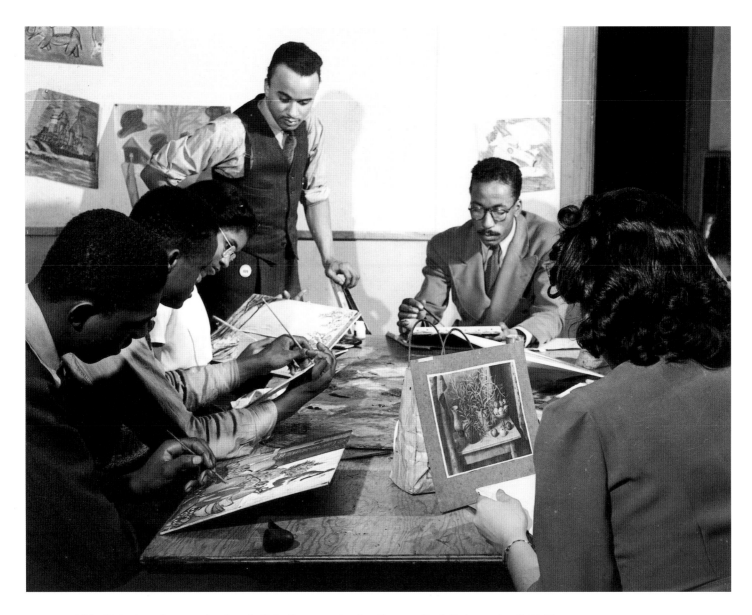

159. Painting class at the South Side Community Art Center. *Jack Delano, April 1942.*

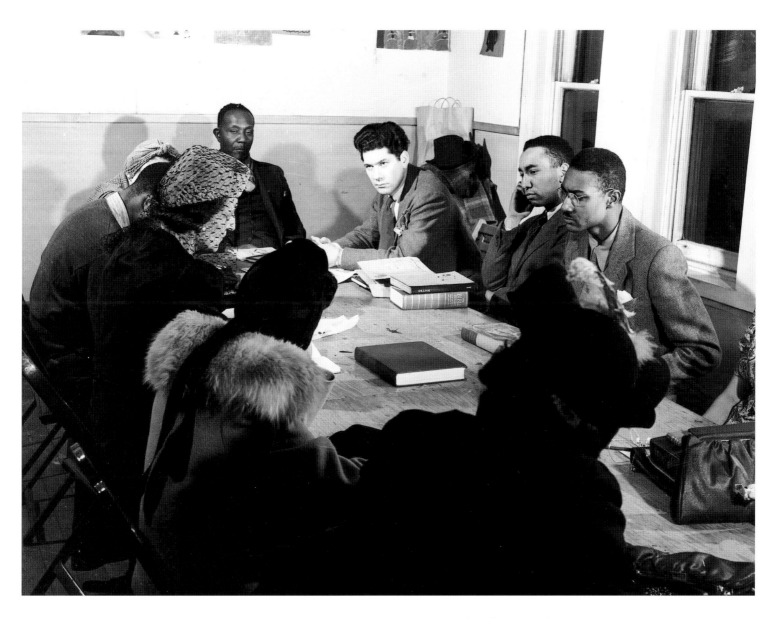

160. Poetry study circle at the South Side Community Art Center. *Jack Delano, April 1942.*

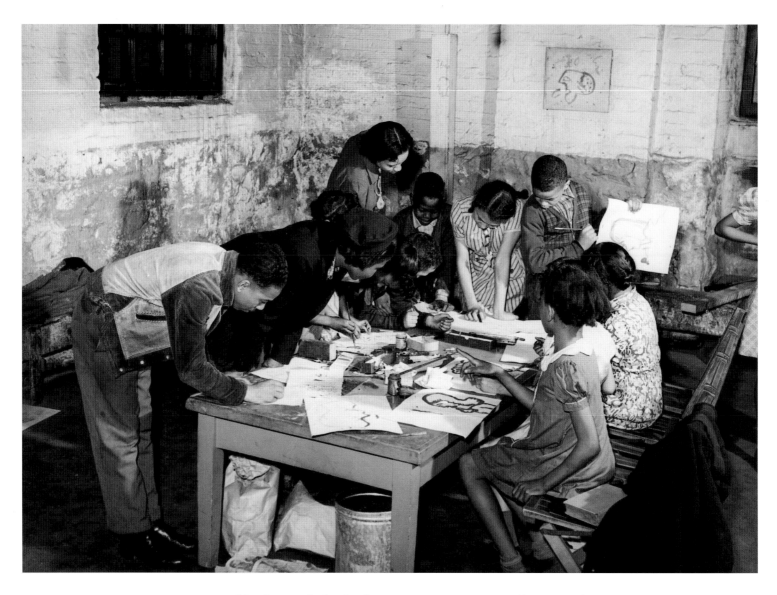

161. Art training is sponsored by the Good Shepherd Community Center. *Russell Lee, April 1941.*

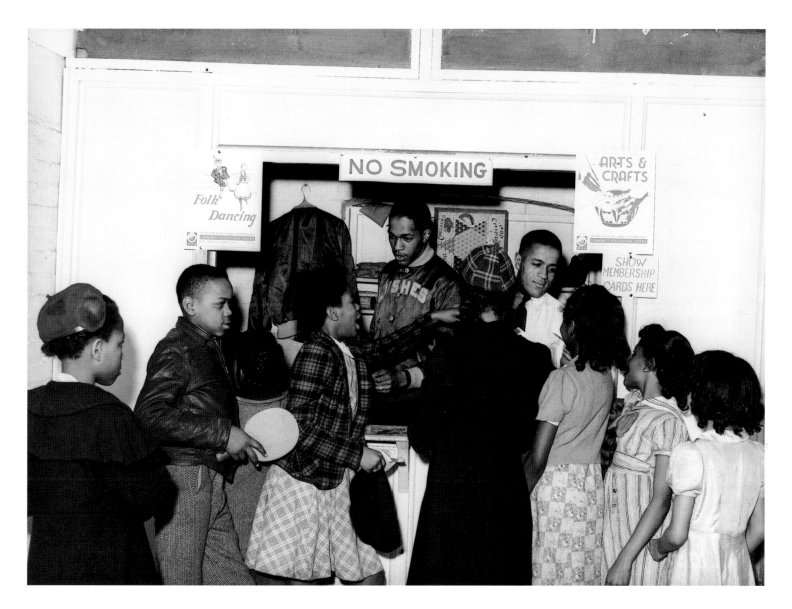

162. Boys and girls presenting membership cards at recreational booth in basement of the Good Shepherd Community Center. *Russell Lee, April 1941.*

From Grace Outlaw, "Folk-lore [flat foot floogie]," Federal Writers' Project: Folklore Project, 1936–39.

FLAT FOOT FLOOGIE

A group of colored boys between the ages of ten and fifteen were playing on a vacant lot in Chicago. After having played leap-frog, baseball, and several other games, one began to sing lustily, "Flat foot floogie wid the floy floy." Others took up the refrain, humming, whistling, or singing. Suddenly one boy started kidding the other in the song, making up verses as he sang and after a while the others answered in kind. The verses ran something like this:

> I can tell by the shape a yoh head
> You been eating that cha'ity bread.
> Flat foot floogie wid the floy, floy etc.

> I can tell by the shape a yoh feet
> You been eatin that cha'it can meat.

> Boy, jist look at that guy's knees,
> Yuh know he been eatin that cha'ity cheese.

> Everywhere yoh mama goes
> She's all dressed up in cha'ity clothes.

A hush fell over the crowd as the boy singing the last verse looked directly at another boy. The latter stopped his play and in a sullen manner said, "I ain't play no dozens . . . 'n if you don't take it back I'm gonna beat you up." The other boys crowded around, urging them to fight.

The boys were squaring off to go into battle when the squad car came along and, seeing the situation, dispersed the crowd.

The "dozens" among colored people means talking about one's relatives, especially one's mother. These references are also termed "slipping one in." There is no quicker way to start a fight, even among adults, than to "talk about one's mother."

Another slang popular especially among the younger groups is, "Layin' my racket."

Example:

Ted: Hi there! Saw you at the Savoy . . . and was you goin' to town . . . cute little chick you had with you. Who is she?
Red: Ain't she a killer-diller! . . . And can she jitter! . . . Met her at a dance the other night. Kinda hinkty at first, but boy, *I layed my racket* . . . I told her 'bout my dad bein' a big shot and got Ben to let me use his car . . . boy, she fell like a ton a bricks.

Ted: But what you gonna do when she finds out you was lying?

Red: So what! . . . Done layed my racket then. Don't matter what she thinks. . . . She can take it or leave it.

During a recent political campaign in Chicago there were many witty expressions that came from the speakers. One zealous young Negro was a favorite with the people. Here are some of the expressions which brought thunderous applause and laughter:

You better get down on yoh knees and pray that none a these isms gets started here in this good ole USA and thank the Lawd for *Uncle Sam and Ant Cha'ity.*

Republicans always knocking the WPA, saying we poke along. . . . I ain't seen none of 'em refusing to poke 'long with us and payday they ain't long poking they hands out for democrat money.

Millions a folks got to eat and sleep;
Millions of us settin' on the anxious seat.
Yo'all better vote right on 'lection day
And keep this good ole WPA.
Ain't no ifs and ands about it
How you gonna get 'long widdout it?
Now you can take a little Republican jelly,
But I ain't messin' wid my belly.
You got relief, ole age pensions and WPA,
But not if the Republicans coulda had they way.

The word "jelly" is slang among some Negroes, meaning getting by or taking advantage of an opportunity. The inference in the verses is that some of the Negroes may accept Republican money and either split their ticket or take the Republican money and vote for the Democrats all the way.

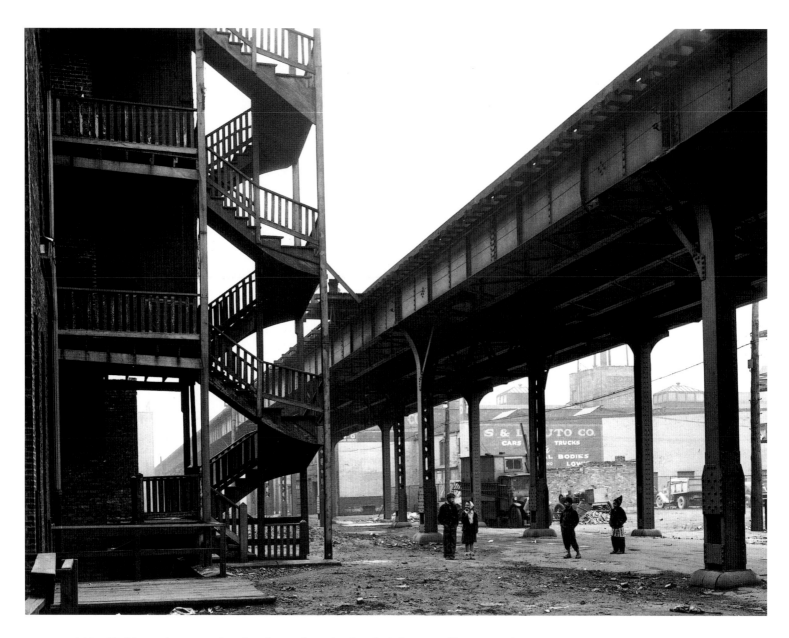

163. Children playing under the elevated on the South Side. *Russell Lee, April 1941.*

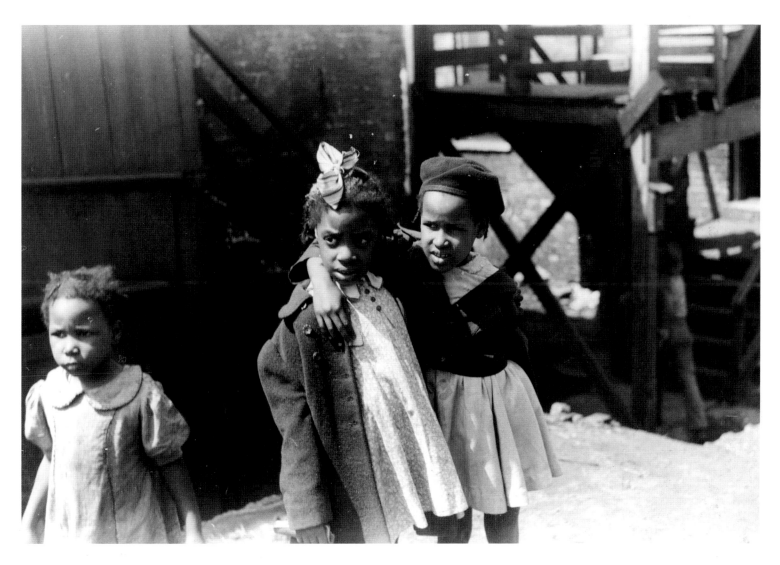

164. Children playing on the street in the Black Belt. *Edwin Rosskam, April 1941.*

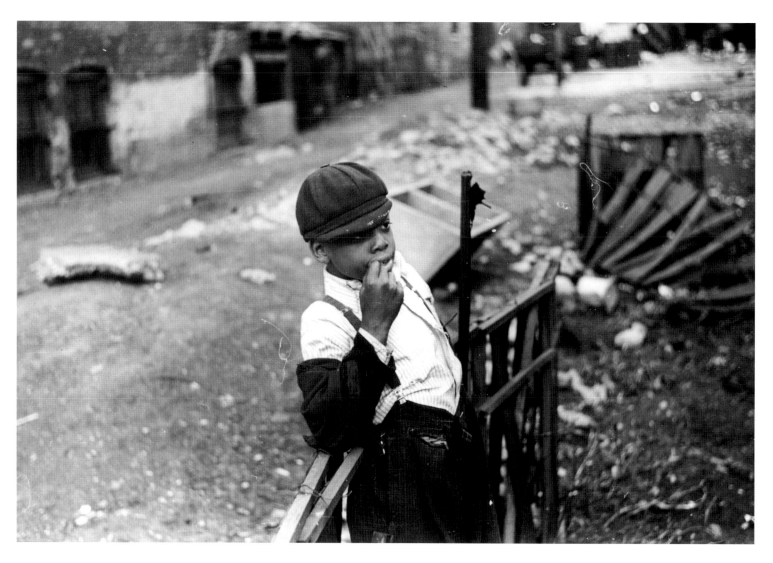

165. Negro boy in an empty lot which is his playground. *Edwin Rosskam, April 1941.*

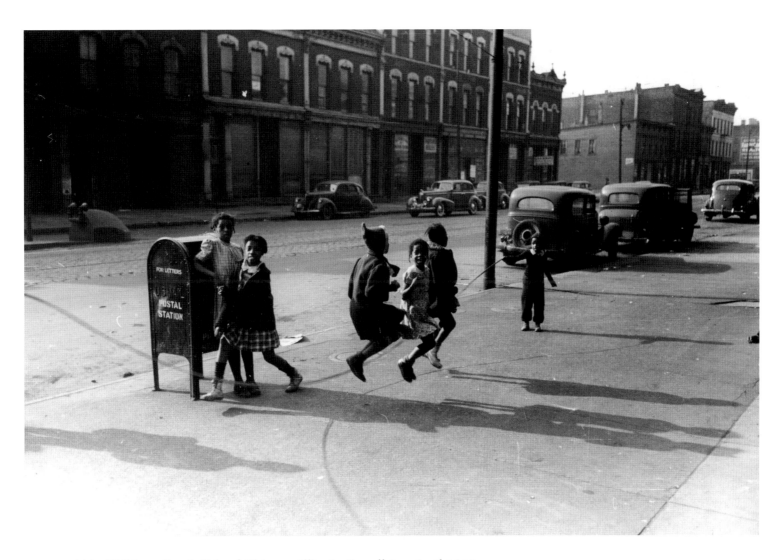

166. Children, South Side of Chicago, Illinois. *Russell Lee, April 1941.*

SELECTED BIBLIOGRAPHY ON THE FEDERAL WRITERS' PROJECT AND THE CHICAGO RENAISSANCE

Bone, Robert. "Richard Wright and the Chicago Renaissance," *Callaloo,* 9:3 (Summer 1986), 446–468.

Bontemps, Arna, ed. "The Negro in Illinois," manuscripts held at the Vivian G. Harsh Research Collection of Afro-American History and Literature, Chicago Public Library, Chicago, Illinois.

Bontemps, Arna, and Jack Conroy. *Anyplace but Here* (first published as *They Seek a City*). New York: Hill and Wang, 1966.

Illinois Writers' Project. *Cavalcade of the American Negro.* Chicago: Diamond Jubilee Exposition Authority, 1940.

Mangione, Jerre. *The Dream and the Deal: The Federal Writers' Project, 1935–1943.* Boston: Little, Brown, 1972.

Motley, Willard F. "Negro Art in Chicago," *Opportunity,* XVIII:1 (January 1940), 19–31.

Russell-Robinson, Joyce. "Renaissance Manqué: Black WPA Artists in Chicago," *Western Journal of Black Studies,* 18:1 (Spring 1994), 36–43.

Sporn, Paul. *Against Itself: The Federal Theater and Writers' Projects in the Midwest.* Detroit: Wayne State University Press, 1995.

Wixson, Douglas. " 'Black Writers and White!' Jack Conroy, Arna Bontemps, and Interracial Collaboration in the 1930s." *Prospects, A Journal of American Culture,* 23 (1998), 401–430.

Writers Program of the Works Progress Administration (Illinois), "Cavalcade of the American Negro" (1940). Manuscript Collection, Schomberg Center for Research in Black Culture, New York Public Library. This brochure differs in content from the published volume of the same title.

NOTES

1. St. Clair Drake and Horace R. Cayton, *Black Metropolis: A Study of Negro Life in a Northern City*, introduction by Richard Wright (New York: Harcourt, Brace & World, 1945), 12; Nicholas Lemann, *The Promised Land: The Great Black Migration and How It Changed America* (New York: Alfred A. Knopf, Inc., 1991), 64.

2. These statistics are drawn from several sources. See Edwin Rosskam, general captions, "The Face of the 'Black Belt,'" and "The Black Belt—An Environment," Chicago, April 1941, RA / FSA / OWI Written Records, microfilm reel 17, Library of Congress; Richard Wright, photo-editing by Edwin Rosskam, *Twelve Million Black Voices: A Folk History of the Negro in the United States* (New York: The Viking Press, 1941), 93, 107; Adam Green, "Selling the Race: Cultural Production and Notions of Community in Black Chicago, 1940–1955" (Ph.D. diss. Yale University, 1998), 33, 34.

3. Richard Wright, "The Shame of Chicago," *Ebony* (December 1951): 24.

4. Wright, *Twelve Million*, 142.

5. I am indebted to Adam Green, "Selling the Race," for this and other crucially useful conceptualizations of the South Side community in the 1940s.

6. Horace Cayton to Richard Wright, April 29, 1941, Richard Wright Papers, Box 95, Folder 1254, Beinecke Library, Yale University. Hereafter Wright Papers.

7. "Project shots" are discussed in Nicholas Natanson, *The Black Image in the New Deal: The Politics of FSA Photography* (Louisville: University of Kentucky Press, 1992), 34, 59. The wide range of FSA subject matter is discussed in Maren Stange, "'The Record Itself: Farm Security Administration Photography and the Transformation of Rural Life," in Pete Daniel, Merry A. Foresta, Maren Stange, and Sally Stein, *Official Images: New Deal Photography* (Washington, D.C.: Smithsonian Institution Press, 1987), 1–35.

8. Quoted in Stange, "'The Record Itself,'" 4.

9. Keneth Kinnamon and Michel Fabre, eds., *Conversations with Richard Wright* (Jackson: University Press of Mississippi, 1993), 43.

10. James Agee and Walker Evans, *Let Us Now Praise Famous Men* (Boston: Houghton, Mifflin, 1941); Dorothea Lange and Paul Schuster Taylor, *An American Exodus: A Record of Human Erosion* (New York: Reynal & Hitchcock, 1939); Archibald MacLeish, *Land of the Free* (New York: Harcourt, Brace, 1938; rpt. New York: Da Capo Press, 1977). Photograph distribution and publication are discussed in Maren Stange, *Symbols of Ideal Life: Social Documentary*

Photography in America, 1890–1950 (New York: Cambridge University Press, 1989), 111.

11. My own work has contributed to this critique. For many relevant citations, see "The FSA/OWI Collection: Selected Bibliography and Related Web Sites." Prints and Photographs Division, Library of Congress, Washington, D.C., December 29, 2001, http://memory.loc/gov/ammem/fsahtml/fabib.html. Sally Stein, "In Pursuit of the Proximate: A Biographical Introduction," in Jack Delano, *Photographic Memories* (Washington, D.C.: Smithsonian Institution Press, 1997), xv.

12. Quoted in *Book of the Month*, February 1942, clipping held in Wright Papers, Box 63, Folder 741.

13. Richard Wright, *Native Son* (New York: Harper & Row, 1940).

14. Interview with Edwin and Louise Rosskam by Richard K. Doud, August 3, 1965, Archives of American Art, Smithsonian Institution, Washington, D.C., New York, Detroit, and San Francisco, 45. Hereafter AAA.

15. Horace Cayton, "Black Voices," in *The Pittsburgh Courier*, n.d., clipping held in Wright Papers, Box 63, Folder 741. Robert L. Reid and Larry A. Viskochil, eds. *Chicago and Downstate: Illinois as Seen by the Farm Security Administration Photographers, 1936–1943* (Chicago: Chicago Historical Society and University of Illinois Press, 1989), xiv.

16. Henry Louis Gates, Jr., "The Face and Voice of Blackness," in *Facing History: The Black Image in American Art, 1710–1940*, eds. Guy C. McElroy and Christopher C. French (Washington, D.C.: Bedford Arts, Publishers in association with the Corcoran Gallery of Art, 1990), xxix.

17. Gates, "Face and Voice," xxix, xliv. See my " 'Photographs Taken in Everyday Life': *Ebony*'s Photojournalistic Discourse," in Todd Vogel, ed., *The Black Press: New Literary and Historical Essays* (New Brunswick, NJ: Rutgers University Press, 2001), 207–227, for discussion of media representations of African Americans in the pre–civil rights era.

18. Ira Harkey, quoted in Carolyn Martindale, *The White Press and Black America* (Westport, CT: Greenwood Press, 1986), 55.

19. Jesse L. Jackson, "Growing Up with *Ebony*," *Ebony* (November 1995): 50J.

20. Henry Louis Gates, Jr., *Colored People: A Memoir* (New York: Vintage Books, 1995), 19, 23.

21. Deborah Willis, *Reflections in Black: A History of Black Photographers 1840 to the Present* (New York: W. W. Norton & Company, 2000), xvi–15.

22. Camara Dia Holloway, *Portraiture & the Harlem Renaissance: The Photographs of James L. Allen* (New Haven, CT: Yale University Art Gallery, 1999), 13. The ways that African Americans remained excluded "as producers of their own image" in the "public sphere of cultural representation" are discussed in Gayle Ward, *Crossing the Line: Racial Passing in Twentieth-Century U.S. Literature and Culture* (Durham, NC: Duke University Press, 2000), 124.

23. Holloway, *Portraiture*, 15.

24. Bolden was discussing the work of photojournalist Charles H. (Teenie) Harris, who worked for the nationally distributed paper from the 1930s through 1950s, in Stephen Kinzer, "Black Life, in Black and White," *New York Times* (February 7, 2001): E3.

25. Natanson, *Black Image*, 68; information officer Trapnell is quoted in Natanson, 57.

26. Ibid., 36.

27. Roy Emerson Stryker to Russell Lee, June 26, 1941, Roy E. Stryker Papers, Series I, University of Louisville, Photographic Archives. Hereafter Louisville. Natanson, *Black Image*, 66.

28. Natanson, *Black Image*, 4; Stryker is quoted in Natanson, 61.

29. From Jack Delano and Edwin Rosskam to Roy Stryker, "Potential coverages in the near future," n.d., Stryker Papers, Louisville.

30. "Memo from Russell Lee," November 14, 1941, Stryker Papers, Louisville.

31. Rosskam-Doud interview, AAA, 13.

32. Lee refers to Chicago as the "terminus" or "terminal point" for migration in two letters to Stryker. See Russell Lee to Roy E.

Stryker, April 1941 and April 9, 1941, Stryker Papers, microfilm reel NDA 31, AAA.

33. Lee to Stryker, April 25, 1941, Stryker Papers, microfilm reel NDA 31, AAA.

34. Cayton to Wright, February 5, 1941, and March 29, 1941, Wright Papers, Box 95, Folder 1254.

35. See Horace R. Cayton, *"Negro Housing,"* St. Clair Drake, *Churches and Voluntary Associations in the Chicago Negro Community* (Chicago: WPA. District 3, 1940); Horace R. Cayton and George S. Mitchell, *Black Workers and the New Unions* (Chapel Hill, NC: The University of North Carolina Press, 1939).

36. Lee to Stryker, April 9, 1941, Stryker Papers, microfilm reel NDA 31, AAA.

37. Cayton to Wright, April 29, 1941, Wright Papers, Box 95, Folder 1254.

38. Drake and Cayton, *Black Metropolis,* 397. Subsequent references are in parentheses in the text.

39. Lemann, *The Promised Land,* 368.

40. See Lee to Stryker, April, 1941, Stryker Papers, microfilm reel NDA 31, AAA. In any case, the photographs show scenes of work only in Bronzeville shops and businesses.

41. Delano, *Photographic Memories,* 50.

42. Lee to Stryker, April 25, 1941, Stryker Papers, microfilm reel NDA 31, AAA.

43. Elder Lucy Smith is described and quoted in Drake and Cayton, *Black Metropolis,* 643–645, 648; Drake and Cayton discuss "lower class" religion generally on pages 611–657.

44. Pilgrim Baptist, where singer Mahalia Jackson got her start, is discussed in Drake and Cayton, *Black Metropolis* 622, and in A. Green, "Selling the Race," 68ff.

45. "Street photography" would flourish in the postwar work of Robert Frank and Helen Levitt, among others, as discussed in Jonathan Green, *American Photography: A Critical History, 1945 to the Present* (New York: Harry N. Abrams, 1984). Its "thoroughbred lineage" descending from 1930s' work is precisely articulated in Max

Kozloff, "A Way of Seeing," in David Featherstone, ed., *Observations* (Carmel, CA: Friends of Photography, 1984), 67–80; Miles Orvell compares the "spontaneity and fluidity" of John Vachon's work to Frank's in Miles Orvell, "Portrait of the Photographer as a Young Man: John Vachon and the FSA Project," in Townsend Ludington, ed., *A Modern Mosaic: Art and Modernism in the United States* (Chapel Hill: University of North Carolina Press, 2000), 319.

46. Lee "took more photographs and spent more time in the field than any of his [FSA] colleagues," notes Robert Reid in Reid and Viskochil, *Chicago and Downstate,* 4.

47. F. Jack Hurley, *Russell Lee: Photographer* (Dobbs Ferry, NY: Morgan & Morgan, 1978), 17.

48. Ibid., 19.

49. Louise Rosskam in Rosskam-Doud interview, AAA, 20.

50. Edwin Rosskam in Rosskam-Doud interview, AAA, 31.

51. Hurley, *Russell Lee,* 14.

52. Cayton to Wright, February 5, 1941, Wright Papers, Box 95, Folder 1254.

53. Dr. Falls is identified in Reid and Viskochil, *Chicago and Downstate,* 150.

54. See August Meier and Elliott Rudwick, *CORE: A Study in the Civil Rights Movement, 1942–1968* (New York: Oxford University Press, 1973). Edwin Rosskam, "Demonstration Area," FSA/OWI General Caption. RA/FSA/OWI Written Records, Lot 1081, Microfilm reel 17, P and P, LC.

55. Rosskam-Doud interview, AAA, 46.

56. See Sherwood Anderson, *Hometown: The Face of America,* photo-ed. Edwin Rosskam (New York: Alliance Book Corporation, 1940).

57. The phrase is used in John M. Reilly, "Richard Wright Preaches the Nation: *Twelve Million Black Voices,*" in *Black American Literary Forum* (1982), 118.

58. Drake and Cayton, *Black Metropolis,* xviii.

59. Reilly, "Richard Wright Preaches," 117. Reilly demarcates the writer's relation to culture, writing that while "the institutional

life developed in the shadow of slavery and the folkways that constitute realization of the meaning in suffering represent the culture that denominates the Black nation," it is "self-conscious literature speaking to and for a Black audience" that can "animate the transformation of Afro-Americans into a modern citizenry."

60. Wright, *Twelve Million*, 98, 99. Subsequent references are in parentheses in the text.

61. Kenneth W. Warren, "Appeals for (Mis)recognition: Theorizing the Diaspora," in Amy Kaplan and Donald E. Pease, eds., *Cultures of United States Imperialism* (Durham, NC: Duke University Press, 1993), 397.

62. Gordon Parks, *A Choice of Weapons* (New York: Harper & Row, 1965), describes the "many times" he had read *Twelve Million* on page 244.

63. Natanson, *Black Image*, 64.

64. D.L., *PM Weekly*, November 2, 1941, in Wright Papers, Box 63, Folder 741.

65. William P. Robinson to Richard Wright, November 30, 1942; Miss Bessie Jones to Richard Wright, January 2, 1942; [anonymous] "a girl that wanted to write" to Richard Wright, January 8, 1942, all in Box 63, Folder 740, Wright Papers.

66. Arnold Rampersad, *The Life of Langston Hughes, Volume II: 1941–1967, I Dream a World* (New York: Oxford University Press, 1988), 128; Gordon Parks, *A Choice of Weapons*, 190, 199.

67. Rosskam to Wright, n.d., Wright Papers, Box 105, Folder 1585.

68. John Field Mulholland, *Christian Century* (February 18, 1942), Wright papers, Box 63, Folder 741.

69. Lee to Stryker, November 12, 1941, Stryker Papers, microfilm reel NDA 31, AAA.

70. Natanson, *Black Image*, 251.

71. Jack Salzman, David Lionel Smith, and Cornel West, *Encyclopedia of African-American Culture and History* (New York: Macmillan, 1996,) 2885; Jacqueline Jones, *Labor of Love, Labor of Sorrow: Black Women, Work, and the Family from Slavery to the Present* (New York: Basic Books, 1985), 233.

72. See Adam Fairclough, *Better Day Coming: Blacks and Equality, 1890–2000* (New York: Viking, 2001); Jones, 253.

73. Carl Fleischhauer and Beverly W. Brannan, eds., *Documenting America, 1935–1943* (Berkeley: University of California Press, 1988), 90.

74. Miles Orvell, "Portrait of the Photographer," 309.

75. Stryker to Vachon, June 27, 1941, Stryker Papers, Louisville.

76. Vachon to Stryker, July 3, 1941, Stryker Papers, Louisville.

77. Fleischhauer and Brannan, *Documenting America*, 91, 92.

78. Orvell, "Portrait of the Photographer," 315; Delano, *Photographic Memories*, 84.

79. Orvell, "Portrait of the Photographer," 326.

80. See Parks, *A Choice of Weapons*, 233–238.

81. Orvell, "Portrait of the Photographer," 328–329.

82. Delano, *Photographic Memories*, 53.

83. Ibid., 85, 86.

84. Ibid., 86.

85. Reid and Viskochil, *Chicago and Downstate*, 124; Rampersad, *Life of Langston Hughes*, 32–33.

86. Drake and Cayton, *Black Metropolis*, 399.

87. The *Defender's* wartime coverage and editorial policies, including participation in the "Double V" campaign, are discussed in Drake and Cayton, *Black Metropolis*, 400–412.

88. Dempsey J. Travis, *An Autobiography of Black Chicago* (Chicago: Urban Research Institute, 1981), 130, 472.

89. Ibid., 128–129.

90. Delano, *Photographic Memories*, 88.

91. A. Green, "Selling the Race," 38.

92. Monty Noam Penkower, *The Federal Writers' Project: A Study in Government Patronage of the Arts* (Urbana and Chicago: University of Illinois Press, 1977), 140.

93. Bill V. Mullen, *Popular Fronts: Chicago and African-American Cultural Politics, 1935–1946* (Urbana and Chicago: University of Illinois Press, 1999), 10.

SOURCES

page xxxi: Richard Wright, "Ethnographical Aspects of Chicago's Black Belt," Box 53, Illinois Writers' Project: "Negro in Illinois" Papers, Vivian G. Harsh Research Collection of Afro-American History and Literature, Chicago Public Library, Chicago, Illinois (hereafter Harsh Collection).

page 3: Edwin Rosskam, "The Face of the 'Black Belt'" FSA/OWI General Caption. RA/FSA/OWI Written Records, Lot 1078, Microfilm reel 17, Prints and Photographs Division, Library of Congress, Washington, D.C. (hereafter P and P, LC)

page 6: O. Winkfield, "Short Tour of Points of Interest on the South Side: 26th to 47th Streets," Box A875, Federal Writers' Project: Negro Studies Project, Manuscript Division, Library of Congress, Washington, D.C. (hereafter LC)

page 8: William M. Page, "A Short Tour of Points of Interest on the South Side," Box A875, LC.

page 16: O. Winkfield, "Housing Conditions, 31st Street to 63rd Street S., State Street to Wentworth Avenue W.," Box A875, LC.

page 23: Edwin Rosskam, "Kitchenette," FSA/OWI General Caption. RA/FSA/OWI Written Records, Lot 1081, Microfilm reel 17, P and P, LC.

page 28: J. Bougere, from "Houses," third draft of an essay summarizing IWP research on African American housing, Box 37, "Negro in Illinois" Papers, Harsh Collection.

page 33: Edwin Rosskam, "Pattern for Growing Up," FSA/OWI General Caption. RA/FSA/OWI Written Records, Lot 1078, Microfilm reel 17, P and P, LC.

page 34: Edwin Rosskam, "Recent Immigrants," FSA/OWI General Caption. RA/FSA/OWI Written Records, Lot 1078, Microfilm reel 17, P and P, LC.

page 45: Edwin Rosskam, "Relief Family," FSA/OWI General Caption. RA/FSA/OWI Written Records, Lot 1083, Microfilm Reel 17, P and P, LC.

page 56: Edwin Rosskam, "The Day of a Negro Doctor," FSA/OWI General Caption. RA/FSA/OWI Written Records, Lot 1083, Microfilm reel 17, P and P, LC.

page 81: Grace Outlaw, "Negro Business in Chicago," Box A874, LC.

page 85: Fenton Johnson, "A Negro Peddler's Song," Box 27, Heritage Press Collection, Harsh Collection.

page 92: [author unknown], "Number of businesses operated by

Negro and white proprietors on 47th Street between State and Cottage Grove, 1938," Box 35, "Negro in Illinois" Papers, Harsh Collection.

page 95: H. Clayton, "Local Policy Barons," and "Miscellaneous Facts About Policy," Box 35, "Negro in Illinois" Papers, Harsh Collection.

page 96: [author unknown], [policy players], Box A874, LC.

page 97: M. Bunton, from "Policy: Negro Business," Box 35, "Negro in Illinois" Papers, Harsh Collection.

page 103: Ardis Harris, from "Negro Employees in Stores and Offices" [South Center Department Store, 421 East 47th], Box A874, LC.

page 103: G. R. Wilson, from "Interview with Dick Jones, Manager of South Center," Box 35, "Negro in Illinois" Papers, Harsh Collection.

page 113: William Page, "The Ben Franklin Store," Box A874, LC.

page 117: M. O. Bousfield, from "Major Health Problems of the Negro [Provident Hospital]," notes on article in *Hospital Social Service,* 1933, Box 36, "Negro in Illinois" Papers, Harsh Collection.

page 121: Dorothy Jones, "The Martha Washington Guild, Provident Hospital," Box 36, "Negro in Illinois" Papers, Harsh Collection.

page 125: Janie Lee Smith, "The Chicago *Defender* Plant," Box A874, LC.

page 129: [author unknown], from "Newspapers" [draft chapter summarizing IWP research on African American newspapers and magazines in Illinois], Box 41, "Negro in Illinois" Papers, Harsh Collection.

page 133: Fenton Johnson, "The WPA Shovel Man," Box 27, Heritage Press Collection, "Negro in Illinois" Papers, Harsh Collection.

page 135: Robert Davis, "The Negro in Organized Labor, Chicago Area, Interview with I. Wilbur Winchester, International Secretary of Brotherhood of Red Caps. History of Local 11, Chicago, Illinois," Box A874, LC.

page 138: Louise Henry, "A History of Negro Music and Negro Musicians in Chicago, A History of Local 208, American Federation of Musicians [interview with George E. Dulf]," Box 48, "Negro in Illinois" Papers, Harsh Collection.

page 140: Edwin Rosskam, "Railroad Worker's Family," FSA/OWI General Caption. RA/FSA/OWI Written Records, Lot 1080, Microfilm Reel 17, P and P, LC.

page 145: Robert Davis, from "The Negro in Organized Labor, Chicago Area, Interview with Wife of CIO Organizer," Box A874, LC.

page 151: Edwin Rosskam, "Negro Church," FSA/OWI General Caption. RA/FSA/OWI Written Records, Lot 241, Microfilm reel 14, P and P, LC.

pages 155 and 158: [author unknown], from "And Churches" [draft chapter summarizing IWP research of churches established by twentieth-century African American migrants to Illinois, and on storefront and other nontraditional black churches], Box 45, "Negro in Illinois" Papers, Harsh Collection.

page 159: H. Bratton, "All Nations Pentecostal Church," Box 186, Federal Writers' Project Records, Manuscripts Division, Illinois State Historical Library, Springfield, Illinois (hereafter Springfield).

page 162: Roscoe Johnson, "Some Folk Song Customs [divine healing]," Box A587, LC.

page 166: Louise Henry, "History of Negro Music and Musicians, Churches," Box 201, Springfield.

page 170: Edwin Rosskam, "Holiday," FSA/OWI General Caption. RA/FSA/OWI Written Records, Lot 241, Microfilm reel 14, P and P, LC.

page 179: L. Jackson, "Music [Pilgrim Baptist]," Box A876, LC.

page 179: H. Clayton, "Survey of Negro Music [gospel song]," Box 48, "Negro in Illinois" Papers, Harsh Collection.

page 189: Margaret Brennan, "Recreation Facilities in Chicago's Negro District," Box A875, LC.

page 191: Edwin Rosskam, "Night," FSA/OWI General Caption.

RA/FSA/OWI Written Records, Lot 1084, Microfilm reel 17, P and P, LC.

page 193: Richard Wright, "Amusements in Districts 38 and 40," Box A880, LC.

page 200: M. Bunton, "Taverns," Box 25, "Negro in Illinois" Papers, Harsh Collection.

page 204: Onah Spencer, "Negro Music and Musicians [Tony's Tavern]," Box 201, Springfield.

page 210: Richard Wright, "A Survey of the Amusement Facilities in District 35," Box A880, LC.

page 222: Grace Outlaw, "Folk-lore [flat foot floogie]," Box A587, Federal Writers' Project: Folklore Project, 1936–39, LC.

LIST OF FIGURES WITH LIBRARY OF CONGRESS NEGATIVE NUMBERS

These images may be viewed online at the Library of Congress's American Memory website, http://memory.loc.gov. Prints of these photographs may be ordered from the Library's Photoduplication Service.

Part One: House and Home

Part Two: Work

103. LC-USW3-001456-D

104. LC-USF34-038623-D

105. LC-USW3-010515-D

106. LC-USW3-000537-D

107. LC-USF34-063113-D

108. LC-USF34-063086-D

109. LC-USF34-063089-D

110. LC-USF34-063103-D

Part Three: Church

111. LC-USF33-013005-M3

112. LC-USF33-005142-M5

113. LC-USF33-005143-M1

114. LC-USF34-038819-D

115. LC-USF34-038803-D

116. LC-USF34-038804-D

117. LC-USF34-038774-D

118. LC-USF34-038743-D

119. LC-USF34-038813-D

120. LC-USF34-038802-D

121. LC-USF33-005159-M2

122. LC-USF33-013010-M3

123. LC-USF33-013013-M3

124. LC-USF33-005152-M1

125. LC-USF33-013016-M5

126. LC-USF33-013009-M1

127. LC-USF33-005152-M5

128. LC-USF33-005146-M1

129. LC-USF33-005147-M4

130. LC-USF34-038814-D

131. LC-USF34-038825-D

132. LC-USF33-013009-M5

133. LC-USF33-013000-M1

134. LC-USW3-000837-D

135. LC-USW3-000828-D

136. LC-USW3-000155-D

137. LC-USW3-000152-D

138. LC-USW3-000163-D

139. LC-USW3-000140-D

Part Four: Going Out

140. LC-USF33-005171-M4

141. LC-USF34-038796-D

142. LC-USF34-038556-D

143. LC-USF34-038758-D

144. LC-USF34-038808-D

145. LC-USF33-005148-M5

146. LC-USF34-038593-D

147. LC-USF34-038587-D

148. LC-USF34-038585-D

149. LC-USF34-038609-D

150. LC-USF34-038570-D

151. LC-USF34-038537-D

152. LC-USF34-038565-D

153. LC-USF34-038580-D

154. LC-USW3-000677-D

155. LC-USF34-038845-D

156. LC-USW3-000072-D

157. LC-USF34-038878-D

158. LC-USW3-000707-D

159. LC-USW3-000702-D

160. LC-USW3-000701-D

161. LC-USF34-038847-D

162. LC-USF34-038875-D

163. LC-USF34-038601-D

164. LC-USF33-005190-M4

165. LC-USF33-005192-M3

166. LC-USF33-012980-B-M3

INDEX

Note: Page numbers in italics refer to photographs.